Josef Sudek

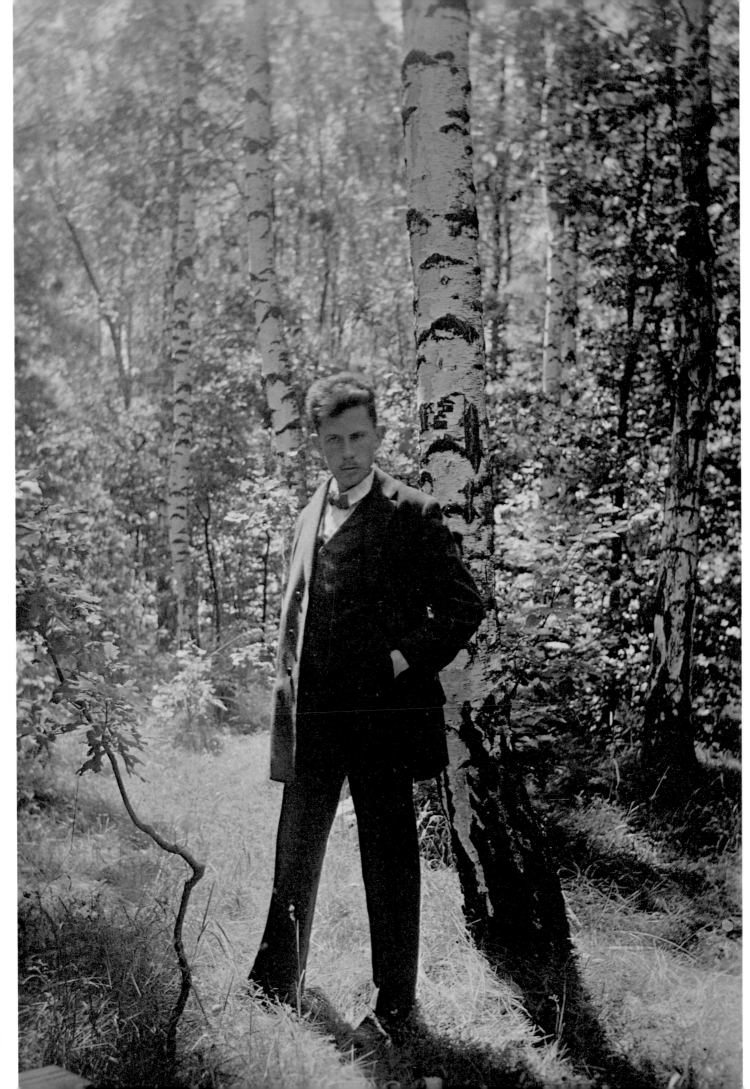

Josef Sudek
Poet of Prague

A Photographer's Life

Biographical Profile by
Anna Farova

An Aperture Book

Self-Portrait, 1920.

The Biographical Profile was adapted from an extensive manuscript on the life and work of Josef Sudek by Anna Farova. Sudek did not always title and date his photographs; captions are provided when available. The quotations which accompany the photographs are by Josef Sudek. These texts were first published in *SUDEK* by Sonja Bullaty and are reprinted with permission of the author.

Preface

Brushed by streams of light and replete with evocative shadows as present and tangible as their source, the photographs of Josef Sudek reveal the mystery and romance of Prague and the surrounding countryside from World War I, in which he lost his right arm, until his death in 1976. Sudek's early photographs explore the streets, architecture, historic sites, and gardens of the city, embracing its contradictions and discovering its harmonies. During World War II, Sudek moved inward, focusing on his studio and the enormous collection of objects and memorabilia he had amassed over the years, as well as on his garden and the gardens of friends. His work in this period became increasingly surreal and idiosyncratic. Later, he began to experiment with a panoramic camera both in Prague and in the nearby countryside.

Throughout his life, Sudek approached his subjects in terms of theme and variation, proposing to understand them as completely as possible over time, in differing light and from varying perspectives. And then there were those moments when the subject, whether St. Vitus Cathedral, the view out his studio window, the faces of his friends, or extraordinary landscapes, would seem to reveal itself for his camera alone.

Although interested in all the arts, Sudek was passionate about music, especially Mozart; and the music of his countrymen, such as Smetana, Dvořák and Janáček (to whom he devoted a whole photographic cycle), reverberates through his images. He was a central figure among Prague artists, many of whom gathered in his infamously messy studio once a week for "music Tuesdays." Sudek lived as a pauper, needing only photographic supplies, a bit of food, and his requisite beer; at the same time, he helped support many of his fellow artists.

Virtually unknown in this country except by a small, loyal following, Sudek is an unsung hero of twentieth-century photography. This publication and the exhibition it accompanies provide the opportunity to see superb examples of his finest photographs, a life's work that takes on a particular relevance now, as Czechoslovakia transforms itself before our eyes.

More than anything, Sudek believed that life goes on, or, as he put it, "music keeps playing." Sudek's photographs are a celebration of renewal and of change. Even in his darkest images are breaths of light.

Michael E. Hoffman

Outward Journey

By Anna Farova

By the end of a long, industrious, and eccentric life, Josef Sudek was called the "Poet of Prague": a one-armed photographer hauling an antique camera across the Charles Bridge. Or into hidden gardens. Or uphill to the cathedral consecrated to Vitus, patron saint of the involuntary dance. Or nowhere, remaining instead in his studio, "a phantasmagoric mess" (as described by Sudek's close friend, the Czech poet Jaroslav Seifert). The old man enjoyed worldwide fame as one of the greatest Czech artists. To his fellow Praguers, he was a familiar character on the streets and in the concert halls.

A wise, stubborn individualist, Sudek was born into the fractious Bohemia of the Austro-Hungarian Empire and lived on his own terms through the upheavals of Europe's twentieth century. He was a man with an indestructible will to life and beauty—like Prague itself, where little has changed between Mozart's 1787 premiere of *Don Giovanni,* and Milos Forman's filming of *Amadeus* two centuries later—a man with a genius for survival. Sudek survived the severely disabling World War I injury of his youth, the Nazi occupation, and the economic and political breakdowns of the postwar Czechoslovak Republic. He survived by being confident yet self-effacing; earning more than enough money but living as a pauper; supporting and exploring all the arts—especially music—with almost obsessive passion, while wearing the mantle of "artist" indifferently, and only near the very end of his life. But mostly, he survived because he was a poet of the camera.

Can one refer to Sudek's photography as poetry? The Czech poet Jan Skácel offers a quatrain:

> Poets don't invent poems
> The poem is somewhere behind
> It's been there for a long time
> The poet merely discovers it.

Sudek believed in the intrinsic poetry of his beloved city—the landscapes, architecture, gardens, statuary, street scenes, as well as a more intimate poetry that could be found in music, in his friendships, and in the objects of his daily existence. He savored the wait and exploration, and lived for that moment of epiphany when the poetry would reveal itself—even if only for an in-

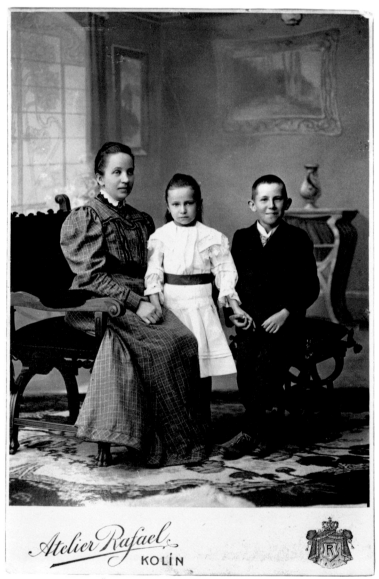

Johanna Sudková, Božena Sudková and Josef Sudek. Photo: B. Bloudilová.

stant—before changing and having to be rediscovered. The photographer's patience was legendary. As if to avoid looking through the camera in terms of his previous photograph, he would often wait months, even years to print a negative. And although he was surprisingly prolific, he would wait years, sometimes decades for a subject to manifest itself, for a particular poem cycle to be fulfilled.

Whereas his Czech contemporary and friend František Drtikol exhausted the symbolic potential of the female figure, and Jaromír Funke consciously strove for a rational, modern expression, Sudek sought, in his photographs, a pure, spiritual space where the ordinary would become extraordinary and shadow and light tangible. He glorified the countryside as did the great Czech composer Leoš Janáček, and expressed the spirit of Prague as did Mozart. In return, Prague's baroque quality seemed a catalyst for Sudek's idiosyncratic romanticism while the city's political and cultural contradictions somehow affirmed his own paradoxical nature. He followed the only piece of advice he regularly offered to other artists: "Hurry slowly!" It was more than a process of working. It embodied his philosophy of life, and it would seem that he hurried slowly even to his death.

Josef Sudek's beginnings were humble and his expectations modest. He was born March 17, 1896 in Kolín, a lovely old town about twenty miles east of Prague on the Elbe River. He was the first surviving child of Václav, a house painter, and Johanna. The Sudeks' first child, a daughter, had died shortly after birth the year before. Josef's younger sister, Božena, was born in 1897, and although the siblings' lives evolved independently for awhile—in different cities, schools, and professional training—they would later converge irreversibly. When Josef was two, Václav died suddenly of pneumonia. Left with no means of support, Johanna and her two small children moved to her native town of Nové Dvory where they lived with childless relatives, a baker named Josef Hylský and his wife. Within a few years, the couple died, naming young Josef as their heir with the condition that he provide free lodging for his mother until her death, and Božena until she married. Sudek was suddenly an eight-year-old owner of a bakery and a house, and had two dependents. It seems that he remained grateful to the Hylský family, always keeping a white sugar bowl decorated with a golden stripe and bearing the name Joseph Hille on his round table, and including it in numerous still lifes from the "Labyrinths" series of the sixties and seventies.

Sudek spent his childhood in Nové Dvory and remembered the village as a blissful paradise, his life as idyllic—yet death always lurked nearby. Describing the family's Christmas Eve for a homework assignment, Josef wrote: "Mommy lighted the candles and said: whose candle goes out first, he will die first," and on the back of the paper he drew two human skulls.

Deeply attached to his mother, Sudek attributed his lifelong passion for music to first hearing her sing as she did the laundry. He disappointed her in only one respect. Johanna had been an excellent student and had academic ambitions for her children. Josef's grades were so poor, he later recalled, that "everybody predicted I'd wind up on the gallows or if I was lucky

I'd become a shepherd." The latter prospect rather attracted him. "What's nicer than to have a job in the open air?" He did, however, have a love for books. Because they were so expensive, he decided to become a bookbinder and in 1908 enrolled in the Royal Bohemian School of Crafts in the nearby town of Kutná Hora. Two years later, he left for Prague to become a bookbinder's apprentice. At seventeen, Sudek received his certificate.

Josef Sudek, Self-Portrait, ca. 1910-14.

Meanwhile, his sister Božena had chosen the photographic path, a fact that Sudek would never mention. At fourteen, she apprenticed with the remarkable Bohumila Bloudilová, a distant relative who was one of the few women in Bohemia operating a photography business. After much training, Božena was certified as a professional photographic assistant with expertise in retouching.

Whether or not Sudek's inclination toward photography came consciously or subconsciously from his family, he began experimenting with a simple box camera while he was still an apprentice bookbinder. He was particularly fond of self-portraits, and displayed a sort of impishness in these photographs

that he retained throughout his life. And there are signs, too, of a gift for assuming a multitude of distinct identities, or perhaps for masking his own. He photographed himself variously as a neatly dressed "good boy," a cigarette-smoking hooligan, a country lad, and a citified dandy. And there were also the subjects that would engage him for decades to come. Just before being called up for military service in 1915, Sudek began creat-

Josef Sudek, By the Castle Steps, ca. 1915-16.

ing an extensive album of 156 ca. 1 5/16 x 2″ photographs. About half were landscapes, the other half images of Prague, including the Hradčany Castle, the Charles Bridge, the National Theater, palace interiors, and statuary. The character of Sudek's vision is encoded in these small prints, and therefore, it is almost inconsequential that he became handicapped in the war and thus unable to devote his life to bookbinding. One way or another, he would have found his way to photography. It was not the case of a devastating accident changing the course of his life, as most biographers would assert; rather, the amputation of his arm accelerated his greater destiny, while paradoxically making each task more arduous, more protracted.

It was the *Götterdämmerung* of the 300-year-old Hapsburg Empire, and it was a splendid twilight. In those last years before World War I, much of the mind and art of the twentieth century was being born in Vienna. Arnold Schönberg's new and alarming atonal system caused riots in the concert halls. The Secession artists challenged not only the conventions of the *Akademie,* but public mores and notions of "decency" as well, and their official journal, *Ver Sacrum,* published writings of Rainer Maria Rilke, among others. Meanwhile, Sigmund Freud and his fellow pioneers in psychoanalysis created a new vocabulary of human experience. Some 190 miles to the northwest, Prague retained its artistic and intellectual life, independent from Vienna. Alfons Mucha, for example, the superb Czech exponent of the French art nouveau, declined to join the Secessionists as a protest

against Austrian oppression. Politically, however, Prague was as volatile as ever, with Bohemia's population becoming increasingly hostile toward the Hapsburg rule. Then the assassination of Franz Josef's heir to the throne—the Archduke Franz Ferdinand—by a Serb patriot in Sarajevo in June 1914, thrust all of Europe into war.

Edward Beneš and Tomáš Masaryk (the country's future presidents), with fellow exile Milan Rastislav Štefánik, led the Czech independence movement during the war. Štefánik stated in a 1917 interview: "The Allied public knows little of the martyrdom of the Czechoslovak nation in this war. Its political leaders are in prison. Old men, and even men stricken with critical illness, were impressed into military service. Newspapers were suppressed. A revengeful government ordered especially severe requisitions in the country, while its inhabitants were intentionally forgotten in the distribution of state aid. No nation ever revolted under more trying and difficult conditions."

On March 20, 1915, Josef Sudek was issued a draft card stating he was unfit for combat duty for medical reasons that remain unclear (although he was examined later on for a heart condition). Nevertheless, he was ordered to report for military duty on December 15, and five weeks later he was stationed with an infantry unit at Kadaň. Sudek recounted many of his experiences in letters home; perhaps most telling in these were his continuous, attentive, and considered observations of everyday circumstances, often capturing their mood, their luminosity: "The moon was so bright it was like daylight . . . and I kept wishing I were back in Kolín. . . . On my name day at 1:30 a.m., we reached the outskirts of Prague and I saw the silhouette of the Castle, the Star Pavilion and the White Mountain. The night was beautiful, with lovely moonlight."

The correspondence wasn't always so poetical. He sent his laundry home for his mother and sister to wash, and was constantly requesting various wartime luxuries—brandy, cigarettes, a chess set with an oilcloth board—as well as photographic supplies (he had taken a primitive reflex camera with him), and his prints, to show other amateur photographers in the army. In 1916, Sudek's unit was posted to the Italian front where the Austro-Hungarian armies were mounting an offensive that ultimately would result in one of the greatest Allied defeats of the war.

Sudek's letters home shielded his family from the grimmer realities of the war, although many years later, he vividly described his experiences at the Italian front to his friend, Dr. Petr Helbich:

In . . . *the trenches, I was taking it easy, hanging as far back as I could. As punishment, I was assigned the worst placement. It was a hole next to the latrines, wet and reeking. And we were the last to get chow. Naturally, by the time food reached us, it was cold. But*

when the tenth offensive took place, I was happy to find the place had a great advantage. When the "Eyetalians" (sic) started a barrage, the shells kept flying above the hole, ending in the latrines. We were quite safe there. The next day when we got our rations, they were hot, because the poor buggers who had come first were all dead now.

And with his customary matter-of-factness, Sudek continued:

I lost my arm during the eleventh offensive. We were ordered "forward" and as we charged our own artillery started shelling us from the back. I screamed, "Down!" at the boys but they never listened. As I was lying there I felt as if a rock hit me in the right shoulder. I started looking around but all the guys who had been standing were now dead. I crawled back to our own lines, and as I was getting into a dugout, I slipped and it started to hurt. Then I lost consciousness.

Sudek underwent several operations to no avail and the doctors eventually took off his right arm. The night of the amputation, he had a visitation:

I remember seeing Death then. I was running a high fever, it was late at night, and there was this gas lamp burning above my bed, hissing strangely. Suddenly, a door opened across the room and a headless figure walked in. Well, I guess it must have had a head, but it was probably all bandaged in white, and the body was draped in a sheet like a shroud. I knew it was Death, so I grabbed a glass from the bedside table, and flung it against her, and screamed that I didn't want to die! The glass smashed to pieces, the figure disappeared, and a nurse rushed in and wanted to know what I was raising such hell for. In the morning I had no fever at all But those trench nights in Italy, they were kind of magnificent, you know. . . .

Josef Sudek, Hradčany, 1915.

Sudek informed his mother and sister about the amputation as gently as he could. Shifted from hospital to hospital, he sent home a series of postcards that at first minimized his loss. "Dear Mommy," he wrote in early June 1917, "I have been wounded in my right shoulder. It was a shrapnel but the fragment went clean through. . . . This is why I must write with my left hand. . . . The wound is not big at all. . . ." Then on July 6, 1917: "Dearest Mommy, forgive me for not writing for so long, but I had an operation some days ago. I will be allowed to return to Kolín in about 5 or 6 weeks, however, dear Mother, without my right arm. . . ."

Many years later, Sudek told an interviewer, "The war destroyed my arm, later I lost it. Of course I did not enjoy that, but at least I was consoling myself that I did not lose my head. That would have been worse." But he would also tell close friends that he wanted to show them photographs of himself with both arms, show them how good he had looked before. It is easy to speculate, impossible to know how wounding the loss

was to his psyche, its effect upon his art and sense of his physical self. He is not known to have had any romantic attachments in his life, he never married.

Ironically, yet somehow predictably for Sudek, the war was productive even though it was crippling. During the almost three years he was in the service, he produced three albums of photographs which were comprised of several landscapes, including a panorama composed by splicing together two separate

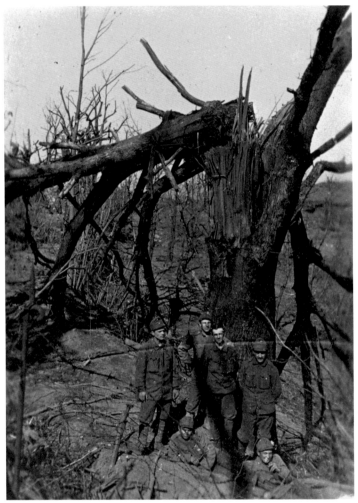

Josef Sudek, Tree, ca. 1916-17.

photographs (taken with this intention); scenes of soldiers, including one of a giant tree mangled by artillery fire with four soldiers standing in front of it as if it were a trophy; family portraits; still lifes, such as an image with mortar and rounds, and a coffin in the background; and ruins. The albums became almost prophetic, pointing to the genesis of Sudek's unique vision. A panorama, a still life, a maimed tree: 1916, the middle of World War I.

By the end of the war, the Czech lands, Bohemia and Moravia, had been joined to Slovakia to form a democratically governed republic. The new borders brought new ethnic and linguistic difficulties, yet Czechoslovakia faced them courageously,

resiliently and tolerantly, led by its idealistic, liberal first president, Masaryk.

All over Europe, the postwar decades unleashed tremendous energy among artists and intellectuals. Ideas and imagery flowed westward from Moscow, where Stanislavsky revolutionized theater, and Sergei Eisenstein, like his American counterpart D. W. Griffith, transformed motion picture film into a canvas for stunning visual epics. From Weimar, the Bauhaus sent shock waves through every medium, especially architecture and design. The painters, sculptors, composers and choreographers of Paris, who had already outraged Europe with works like *Parade* (1917), continued to perpetuate what Guillaume Apollinaire had dubbed *"l'esprit nouveau."* Other writers as well set about shattering established forms as surely as the war had destroyed the *ancien régime*. Novels such as Jaroslav Hašek's *The Good Soldier Švejk* made mockery of the old monarchic authority, and of the war itself.

In his own way, Sudek too would constantly question and manipulate authority. Having returned from a series of hospital stays and started his rehabilitation treatment at the Veteran Hospital and Home at Invalidovna in Prague, both he and his mother set about finding income from every possible source, and here, at least, he could use his war injury to some advantage. A small government pension was awarded for disability and "total incapacity of self-supporting," and Johanna bombarded authorities for tax reductions, pensions, and other forms of financial aid. At this time, Sudek also began to search for his place in the sun.

About his homecoming, Sudek later reminisced with his publisher Jan Řezáč: "When I got back from the War, I found my mother had meanwhile moved to live with an uncle's family in Kolín. This is where I visited her while I lived in the Veteran Home at Invalidovna. I had an awfully cheap camera then. . . . The country is quite ordinary in those parts but I always found something to photograph." One spring day, he was walking along the Elbe River near Kolín when a farmer shouted at him that he, too, was an amateur photographer. He suggested a meeting with a fellow amateur named Jaromír Funke. Sudek later recalled the meeting in the town square. "It was getting dark already when I saw someone coming, all arms and legs. It was Funke. We hit it off immediately. We agreed to meet the next day to do some pictures. I carried a camera on a tripod, he trundled his two hand cameras."

The early days of their friendship were devoted to photographing together by day, carousing by night: "Whenever Funke and I went on a spree, I used to come home late, sometimes only for breakfast. I guess I didn't look wonderfully well. I felt like a stranger. My sister always said I looked seedy and gave me a good talking-to, while Mommy pretended not to hear it. Funke and I never chased girls, though. Mostly we went to

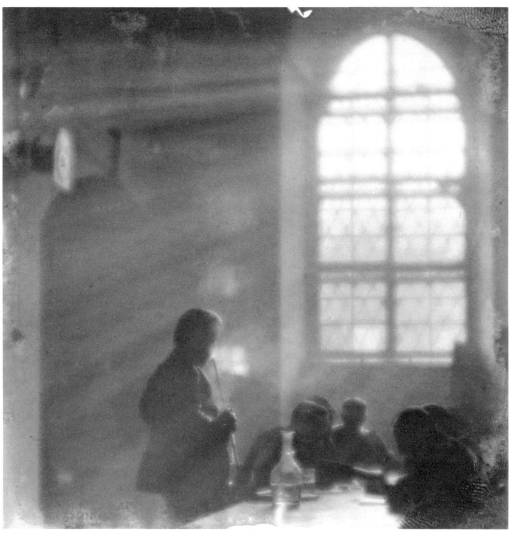

Josef Sudek, Veteran Hospital and Home at Invalidovna, 1922-27.

pubs." Their friendship meant a great deal to Sudek, although it seems that Funke's attitude toward him was somewhat patronizing. Funke was an educated man, and his critiques of Sudek's early work tend to manifest his assumed superiority. While Funke was ultimately an intellectual, programmatic photographer, Sudek approached his work more emotionally, not only recognizing but celebrating the references inherent, for example, in his still lifes—especially in the "Glass Labyrinths" of forty years later which echoed Funke's far more abstract compositions of illuminated glass objects from the 1920s.

However, Funke was a good friend, helping Sudek in his daily life—taking his laundry to Kolín or bringing it back to Prague, advising him on business matters, introducing him to the artists who frequented the Union Café and were part of the artists cooperative that they would eventually join, and accompanying him on his walks in the environs of Kolín Island, where Sudek made one of his earliest series. There, from 1924 to 1926 he produced diffused views of picnickers and strollers, gentlefolk at leisure. Equally compelling is the self-contained cycle

from the veterans' home at Invalidovna, 1922–27. The scenes are simple and not arranged, the contours hazy. The figures seem to be waiting, stilled by the unearthly light that streams through the high windows. Other early postwar work included a series of romantic and painterly landscapes around the Elbe and Vltava Rivers, the Stromovka Park series, as well as images of Prague that demonumentalize the city into beautiful ordinariness.

In the midst of this work, Sudek applied, in 1921, to the newly established State School of Graphic Arts. Admitted for the following year, in typical fashion he argued for tuition-free studies, and subsequently received a scholarship by obtaining an official document certifying his destitution. It stated that he and his family were "unable to support themselves due to total poverty, with no real property or moveable assets." Meanwhile, Johanna had just sold Sudek's inherited house in Nové Dvory for what was then a large sum. Clearly, Sudek was never as needy as he pretended to be when dealing with the authorities; on the other hand, he was generally extremely generous both

with charities (especially those which aided maimed veterans, the blind, and cultural preservation programs), and with his artist friends—virtually a Czech Robin Hood, taking from the rich institutions, and giving to the poor. Sudek helped his artist friends with money, they responded by giving him their works; in this way, he acquired his vast art collection. Curiously, there was never the quality of transaction or purchase in these exchanges; they were more like tangible expressions of a spiritual reciprocity.

Two other events in 1921 were significant for Sudek. He was admitted to Prague's Bohemian Amateur Photography Association and won first prize in the landscape category at a members' exhibition: his first public recognition. He also formally informed the Catholic Church that he was no longer a member, although he remained religious to his death, and according to Božena, considered Jesus Christ one of the most interesting people. His action was not a renunciation of faith, but part of a mass postwar reaction against the institution of the Catholic Church, which was associated with three centuries of Hapsburg rule over Bohemia.

At the School of Graphic Arts, Sudek studied with professor Karel Novák whose methods he admired, although he rather disliked Novák's photography. Novák insisted that his students photograph still lifes in a way Sudek found objectionably artificial, an opinion he voiced quite freely. At the same time, Sudek appreciated that Novák, a cultured, intelligent gentleman of the old school, tolerated his salty soldier's vocabulary and his outspoken views. Even more, he was grateful to Novák for bringing into classes Edward Weston's photographs, as well as the work of others who were transforming the medium in Europe and America. "He would show a collection of photos and say nothing," Sudek recalled. "Isn't that beautiful when one doesn't say anything about the photographs?"

Other influences were also at work during Sudek's student days. The Czech-born American amateur photographer, Dr. Drahomír Růžička, visited Prague, showing his own work and that of his mentor Clarence White. White advocated the use of the soft-focus lens, which was incorporated into the pictorialist sensibility early in this century. Růžička's pictorialist concepts were rooted more deeply in objective reality, and according to Funke, stipulated the inviolability of the negative. Funke defined pictorialism, in retrospect, as a photographic document of a romantic subject produced by a distinctly photographic technique. For Sudek, who regarded reality as the first prerequisite for a good photograph, pictorialism "was an extended phase because it suited my romantic disposition . . . I satisfied myself with strict photographic composition which encompassed my documentary concept of photography, shrouded in the magic of romanticism. This period culminated in my pictures of St. Vitus." Sudek incorporated this documentary notion into his

portraits as well, maintaining that they must express both the modeling of the face and the character of the subject.

And there were the new painters, especially the Cubists, generating particular excitement among Prague's artists, including Sudek, who earlier had been interested in the nineteenth-century Czech romantic landscapists, such as Adolf Kosárek and Antonín Navrátil. "I went to the painter [Emil] Filla," he said. "He understood painting and art in general, so once I admitted

Josef Sudek, Božena Sudková(?).

to him that at first I used to like patriotic kitsch and only later did I come to Picasso. Filla smiled and said, it would have been worse the other way around." Sudek's relations with his friends ranged from peer to patron to protector. His relationship with Filla, however, whom he met in 1930, was that of a disciple to a master.

By the time Sudek graduated in 1924, he was proficient not only in technique—about which he was deceptively casual, claiming, for example, that he never used a light meter, only guesswork—but also had a solid grounding in the business of photography. Courses in optics and chemistry had alternated with training in business administration and typography. His intention was to master a craft, not to be an "artist." Later he

would say: "photography is not art," but rather, "just a beautiful trade requiring certain taste. It cannot be an art because it is dependent on things that exist without it and apart from it, i.e. the world around us." In 1923, he entered twenty-nine pictures in the first exhibition of the Czechoslovak Association of Amateur Photography Clubs in Prague. Edward Weston and Clarence White were among the foreign photographers who contributed to the show, along with seventy-one Czech photographers. As would become his practice, Sudek priced his prints five times higher than his Czech colleagues.

Together with Funke, Sudek became more vocal about his unconventional views on photography, and as a result both were expelled from all the amateur societies and clubs. "We were too aggressive and critical," he commented. In response to their ostracism and discontent, the two friends joined with another like-minded colleague, Adolf Schneeberger, to found the Czech Photographic Society in 1924. They were waging the battle being fought by a new generation of photographers on both sides of the Atlantic. In essence, it was a rejection of all the artistic artifice—transfers, fine print processing and heavy retouching—associated with the earlier generation. However, unlike their counterparts elsewhere, the Czech photographers were not trying to redefine the medium as an art form.

The first members' exhibition of the new society opened in December, 1926. Sudek had meanwhile begun contributing prints to international photographic salons in the United States and Europe, and his entries had been favorably received, winning him a modest measure of fame abroad. In 1923, he travelled to Austria, Switzerland, France, Belgium, Germany, and Italy, presumably to acquaint himself with new currents in European art. Three years later, he made an especially poignant trip when members of the Czech Philharmonic Orchestra, knowing his passion for music, invited him to travel along during an Italian tour:

We travelled down the Italian boot until one day we came to that place—I had to disappear in the middle of the concert; in the dark I got lost but I had to search. Far outside the city toward dawn, in the fields bathed by the morning dew, I finally found the place. But my arm wasn't there—only the poor peasant farmhouse was still standing in its place. They had brought me into it that day when I was shot in the right arm. They could never put it together again.

Sudek disappeared for two months, so alarming the members of the orchestra that they sent the police looking for him. Eventually he turned up in Prague. "From that time," he said much later, "I never went anywhere anymore and I never will."

From the beginning of his professional career at age thirty-one, Sudek was extraordinarily successful. In 1927, he leased a studio at the base of Petřín Hill surmounted by Hradčany Castle.

The studio was rented in partnership, although with whom it is difficult to determine. It was Schneeberger, however, who made the repairs, adapted the building for business and even had electric lights installed—a rarity in photography studios at the time. Here at Újezd, "in the backyard of an old tenement house . . . where horse chestnuts grow and among them a dwarfed, twisted apple tree," recalled his friend and onetime assistant, the painter and graphic artist Václav Sivko, "stands a

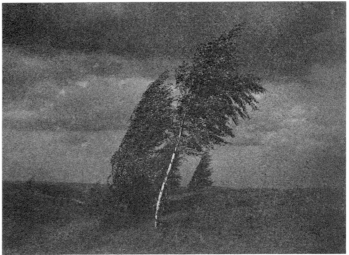

Josef Sudek, Landscapes.

small wooden shack which Josef Sudek has made his studio. He lives there, surrounded by things he loves: the boxes with precious negatives are stacked against the walls in a picturesque chaos and only Sudek himself knows where to look for what, the deep drawers of a small counter hiding countless art objects and bric-a-brac, black and grey photographer's backdrops, a large studio camera, cupboards crammed with gramophone records, walls covered with pictures, paintings, statuettes, reliefs, fragments of large statues on the floor. . . ." He would live, work, and entertain there for over thirty years. *Continued on page 75.*

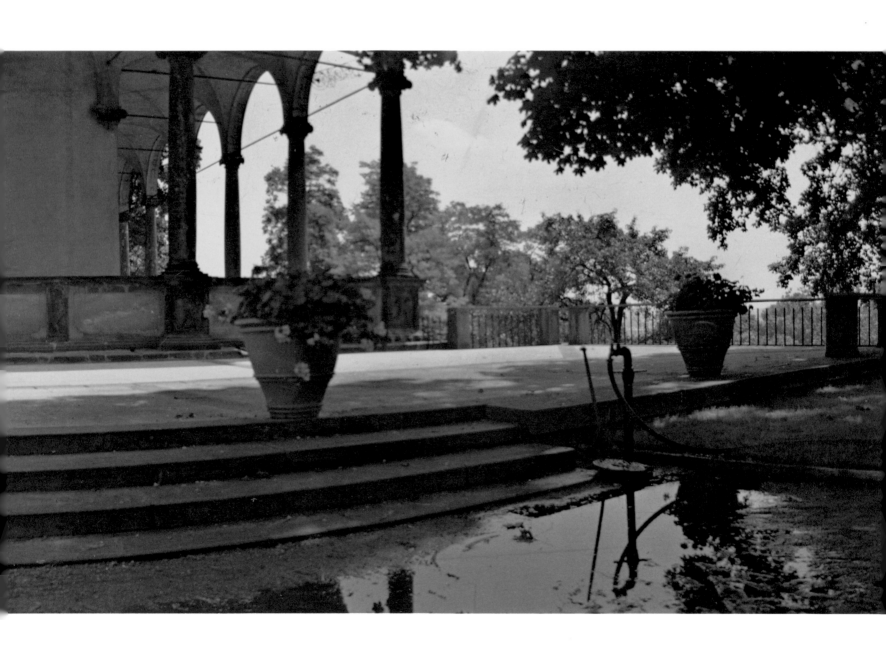

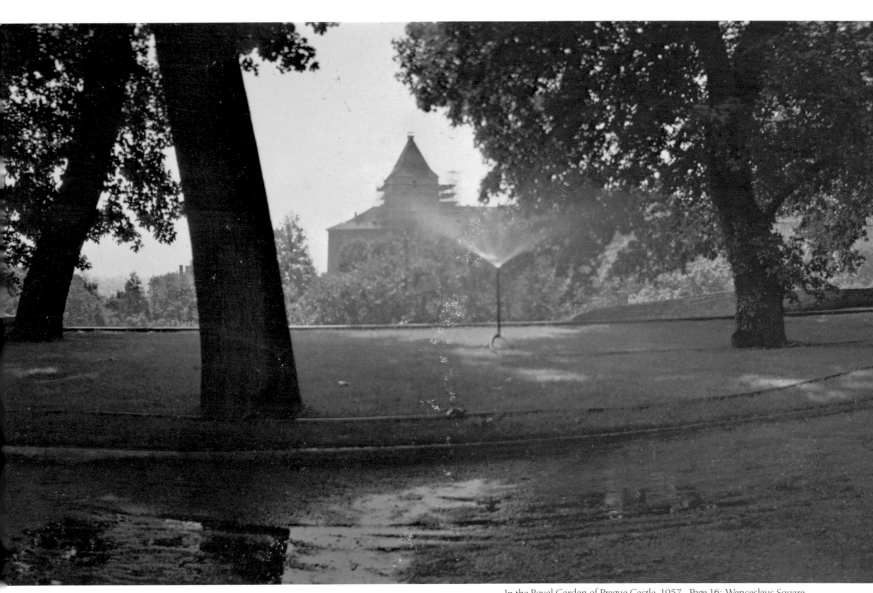

In the Royal Garden of Prague Castle, 1957. Page 16: Wenceslaus Square.

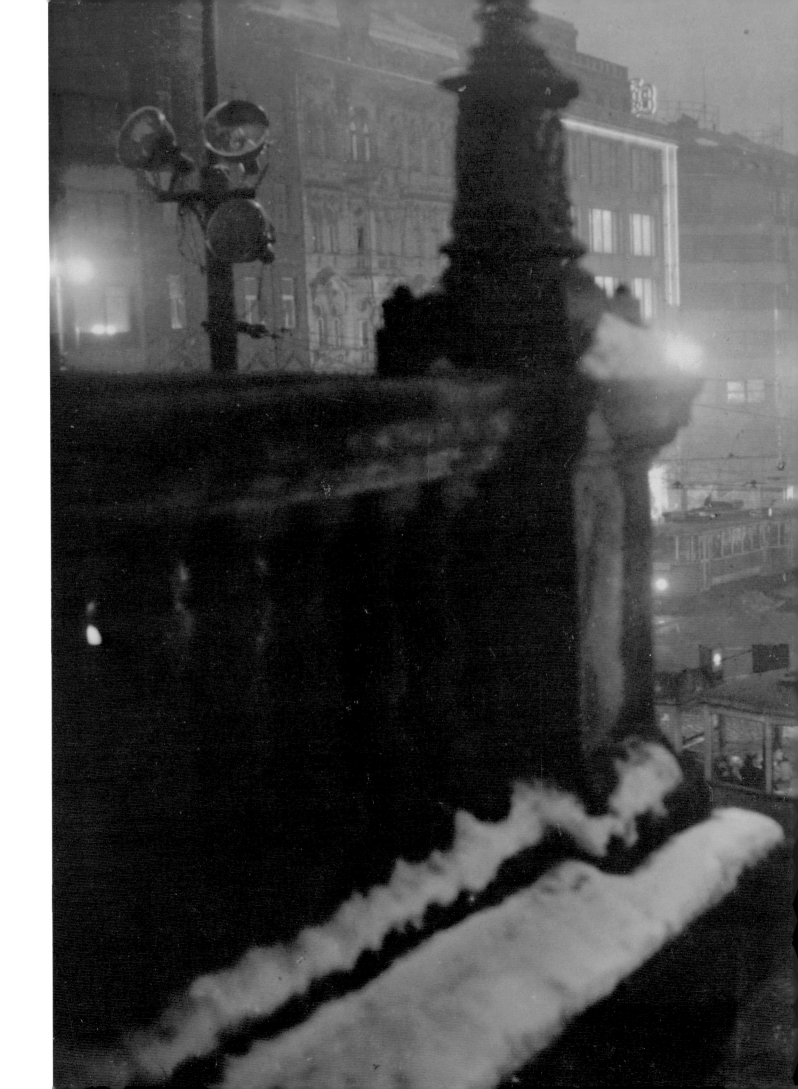

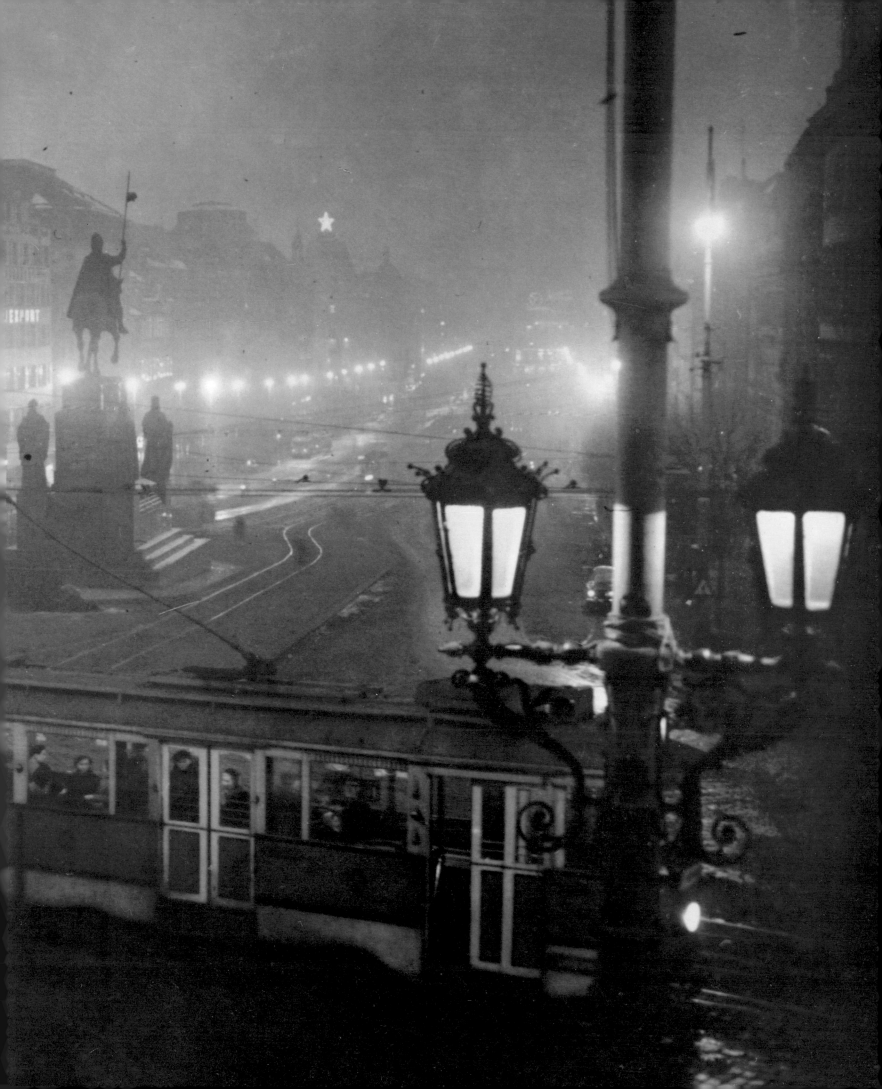

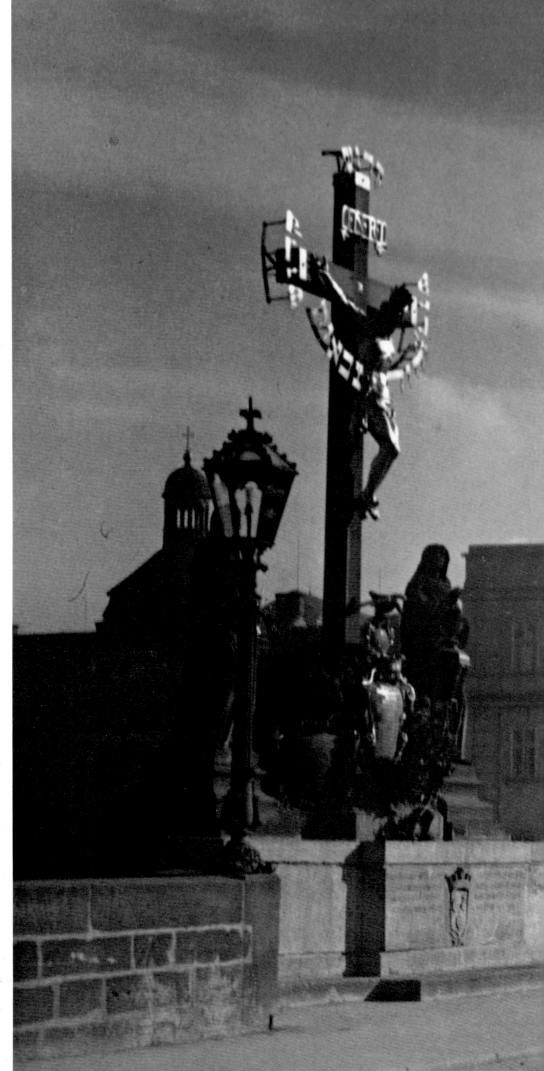

Charles Bridge.

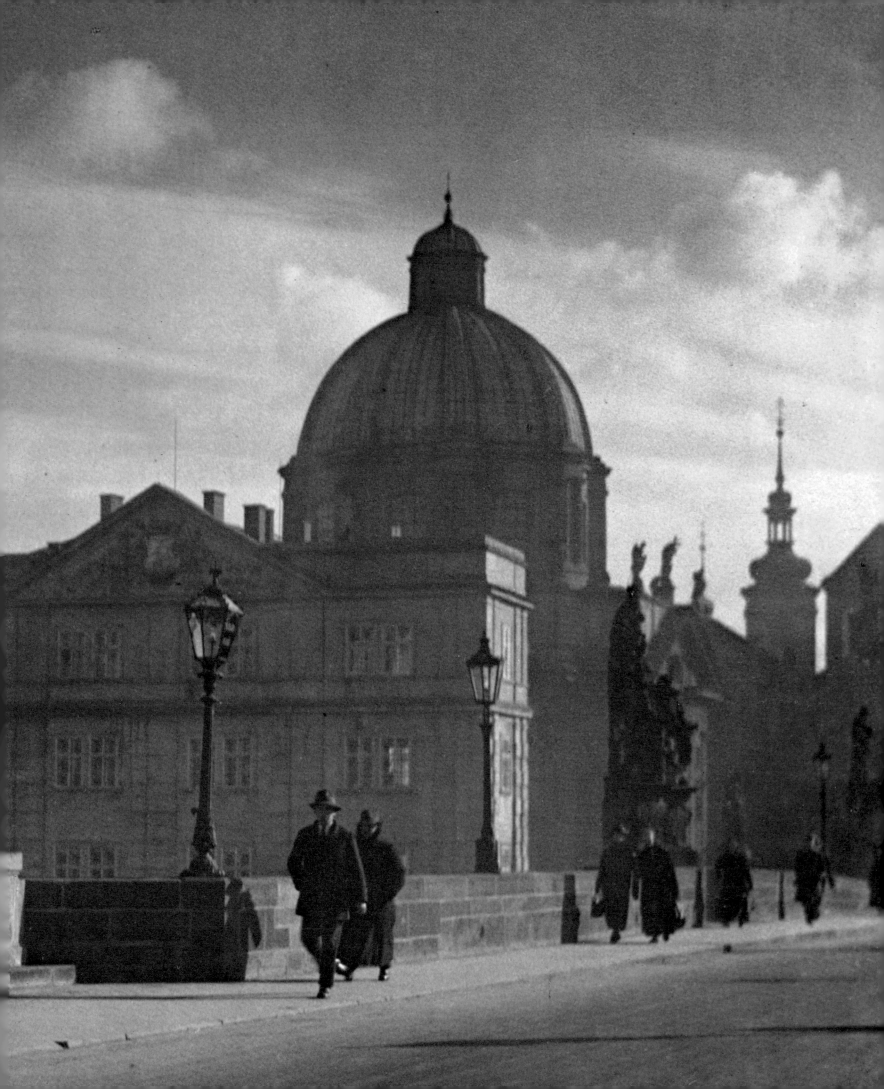

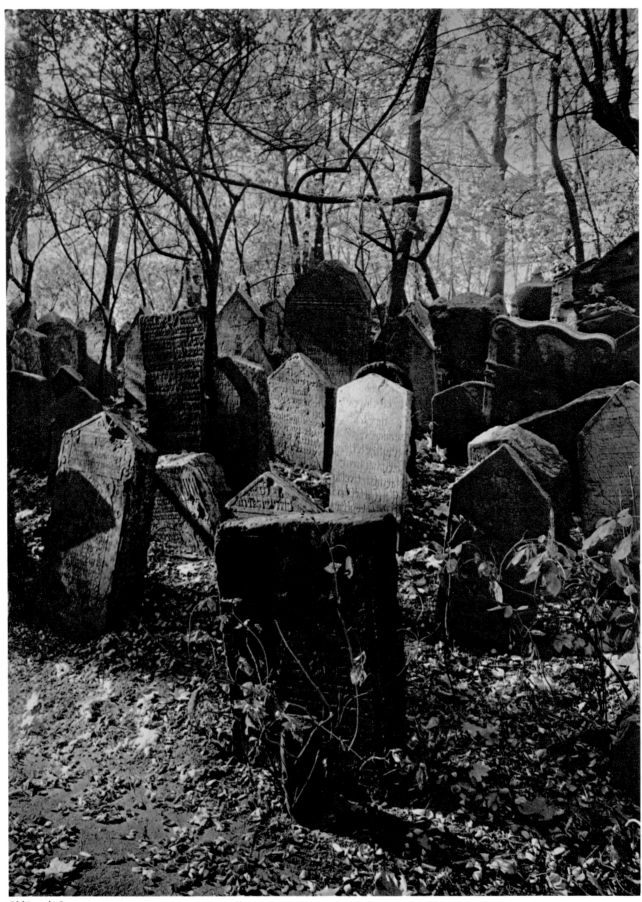

Old Jewish Cemetery.

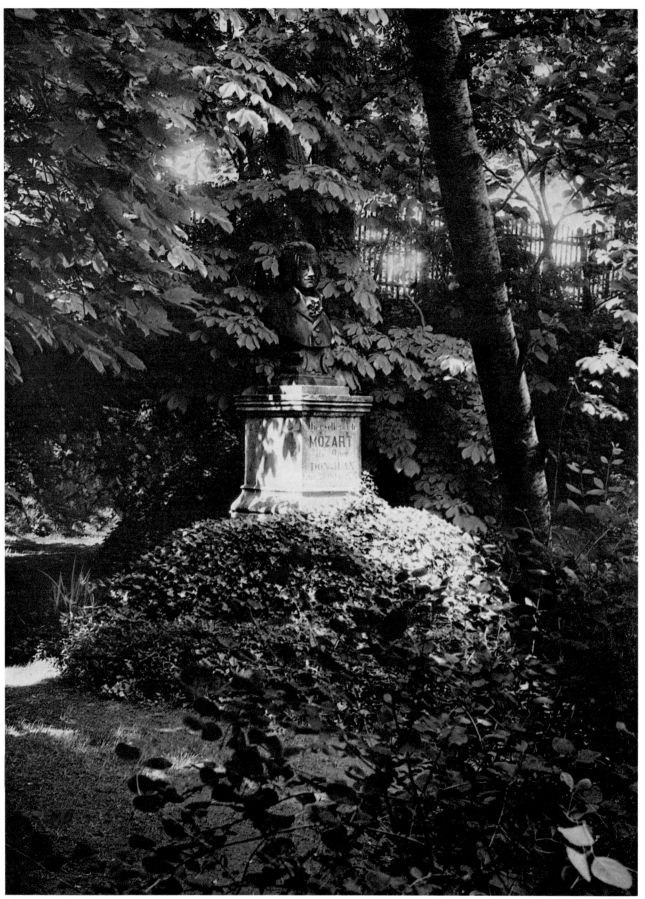

Villa Bertramka – Mozart Memorial.

One cannot escape being influenced by others, but these influences were only good to the extent that they forced me to go my own way. I met the Czech-American Ruzicka early in my life and through him the photography of [Clarence H.] White. At the time I did not yet know that all mystery lies in the shadow areas. When Dr. Ruzicka arrived from the U.S.A. he told me often: expose for the shadows, the rest will come by itself —he was right. . . . But how to master the technique, that I did not know yet.

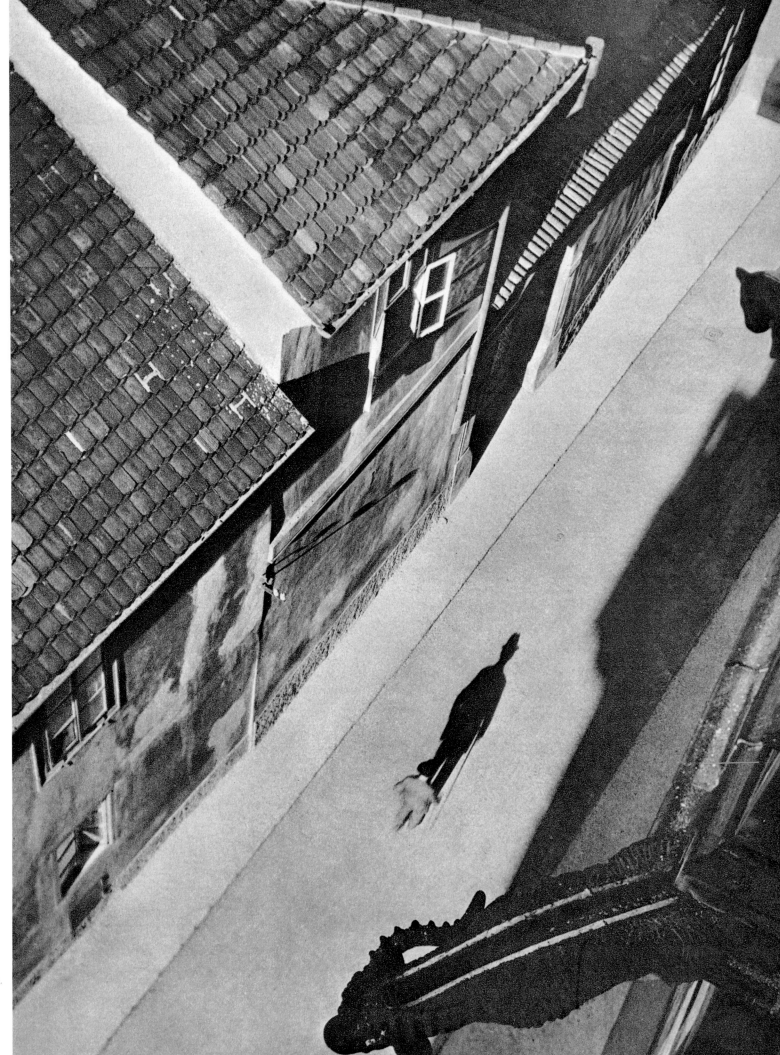

Vicar's Lane.

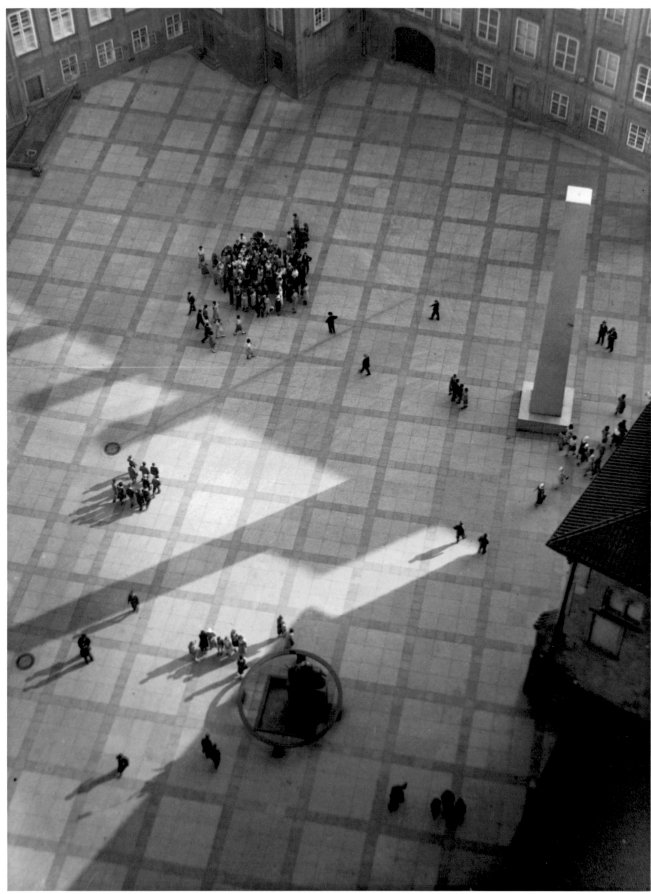

View of the Third Courtyard from the Tower of St. Vitus Cathedral, 1948. Opposite: The Noblewomen's Residence Seen from the Cathedral Roof.

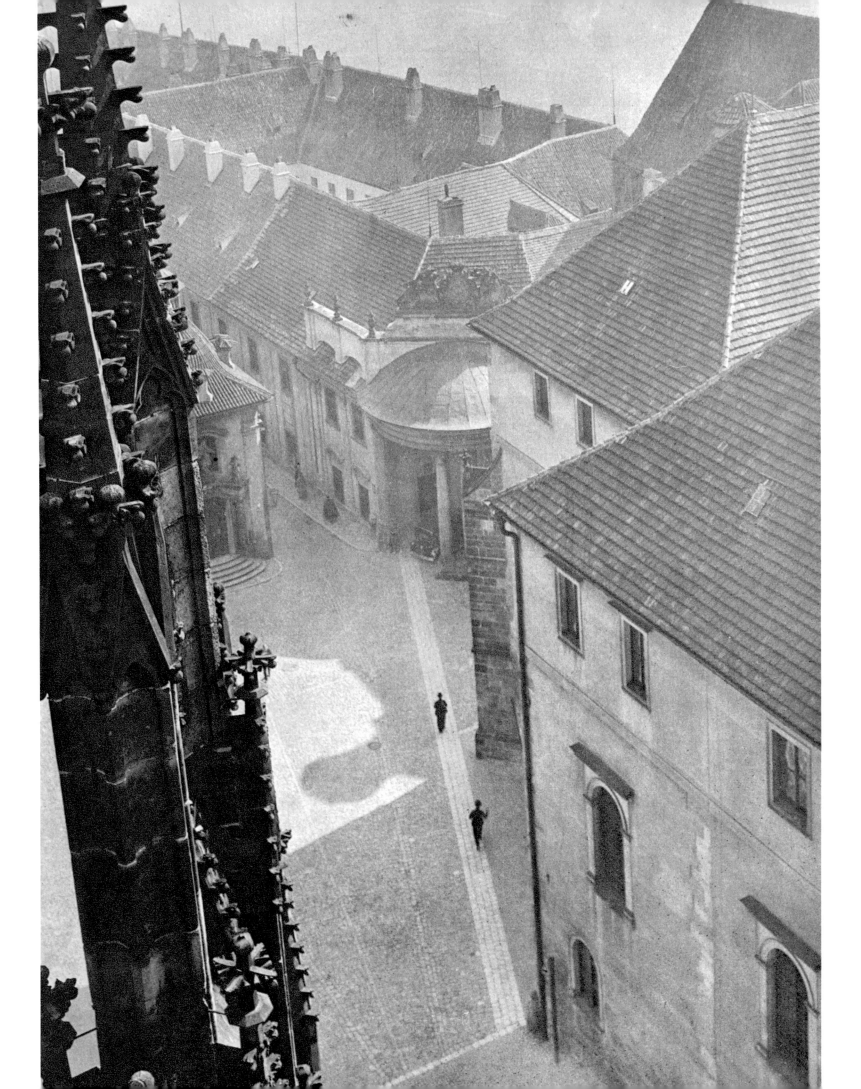

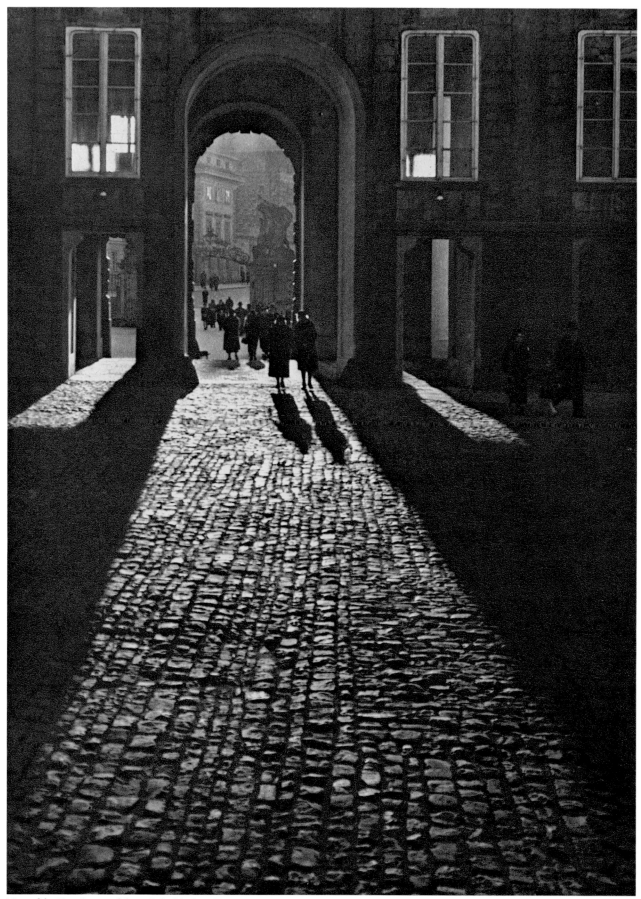

View of the First Courtyard through the Matthias Gate.

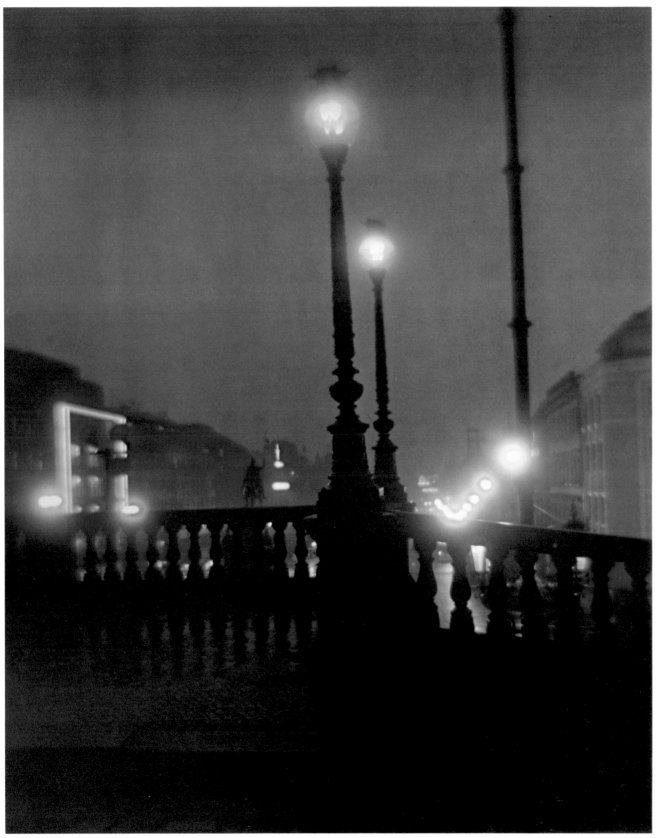

Prague at Night.

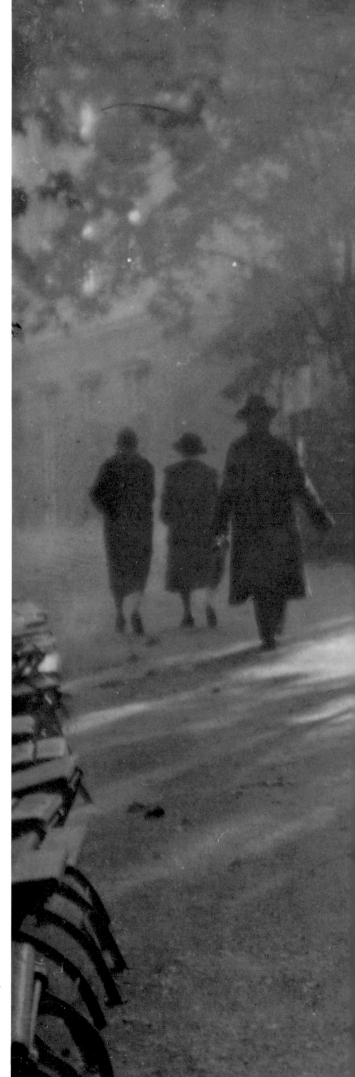

Sunday Afternoon on Kolín Island, 1924-26.

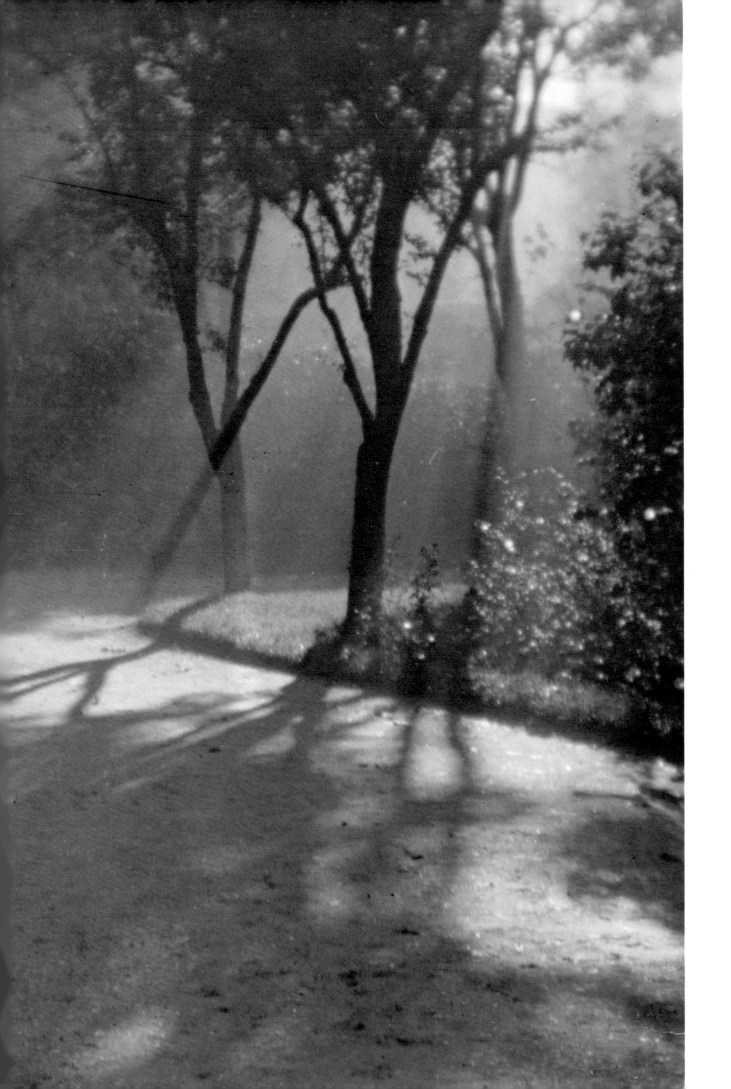

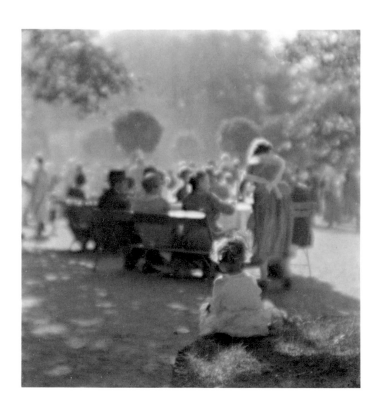

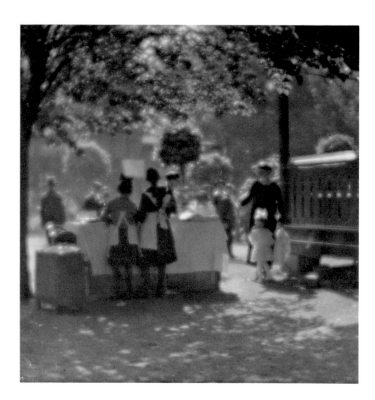

Sunday Afternoon on Kolín Island, 1924-26.

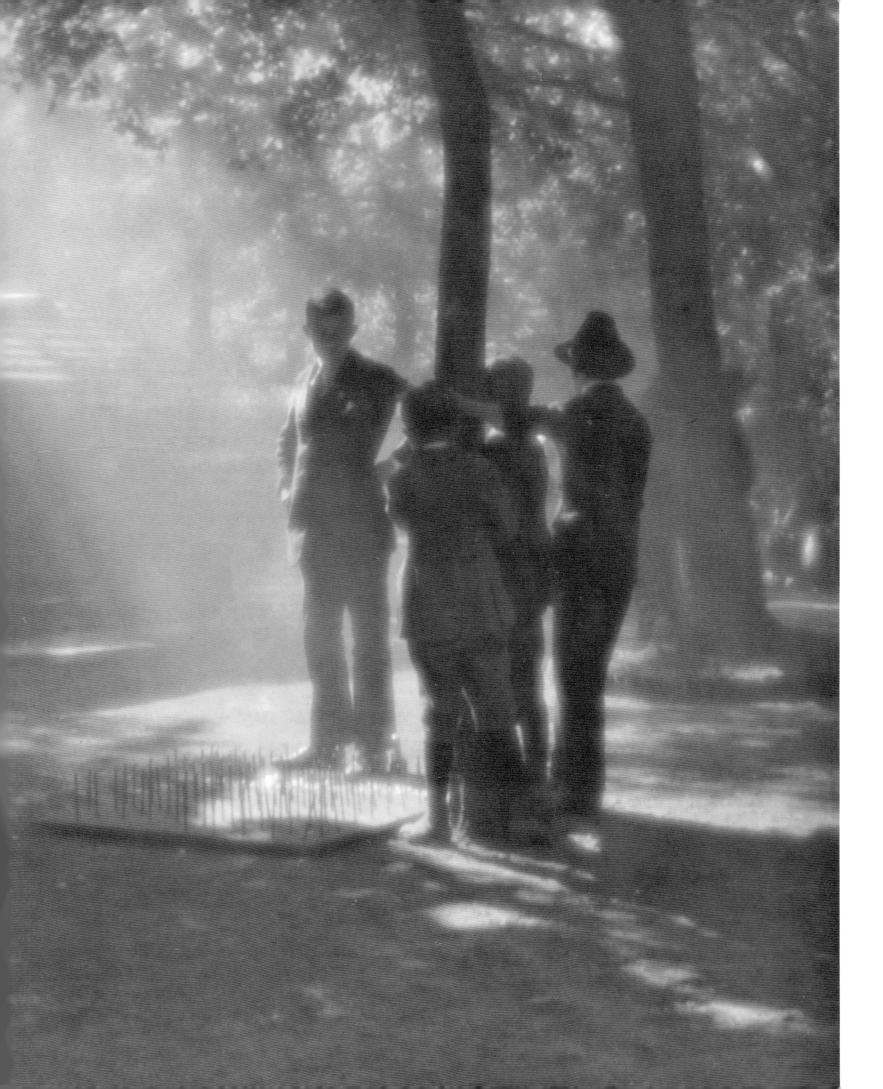

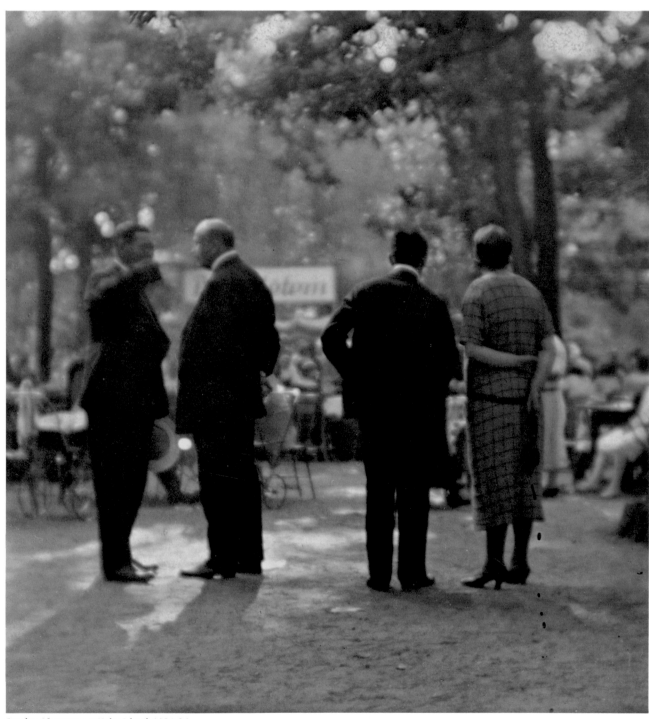

Sunday Afternoon on Kolín Island, 1924-26.

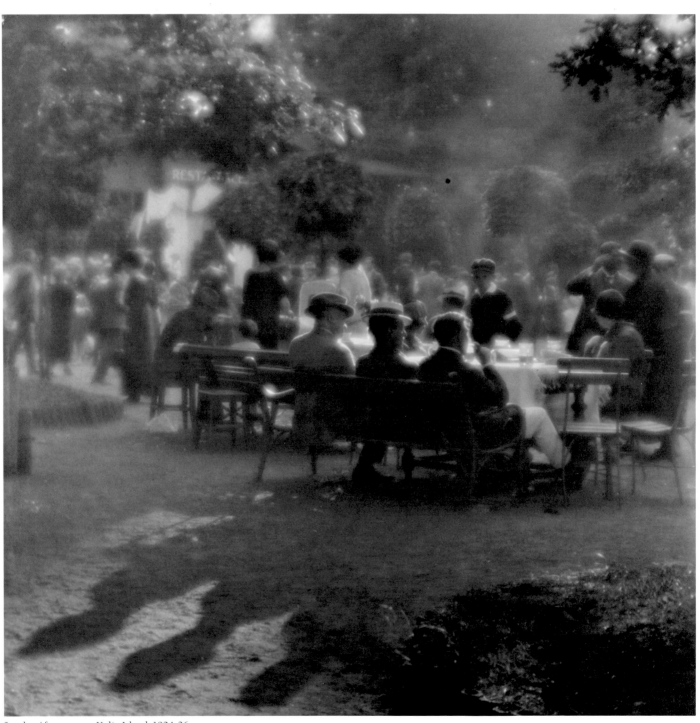

Sunday Afternoon on Kolin Island, 1924-26.

Discovery—that's important. First comes the discovery. Then follows the work. And then sometimes something from it remains.

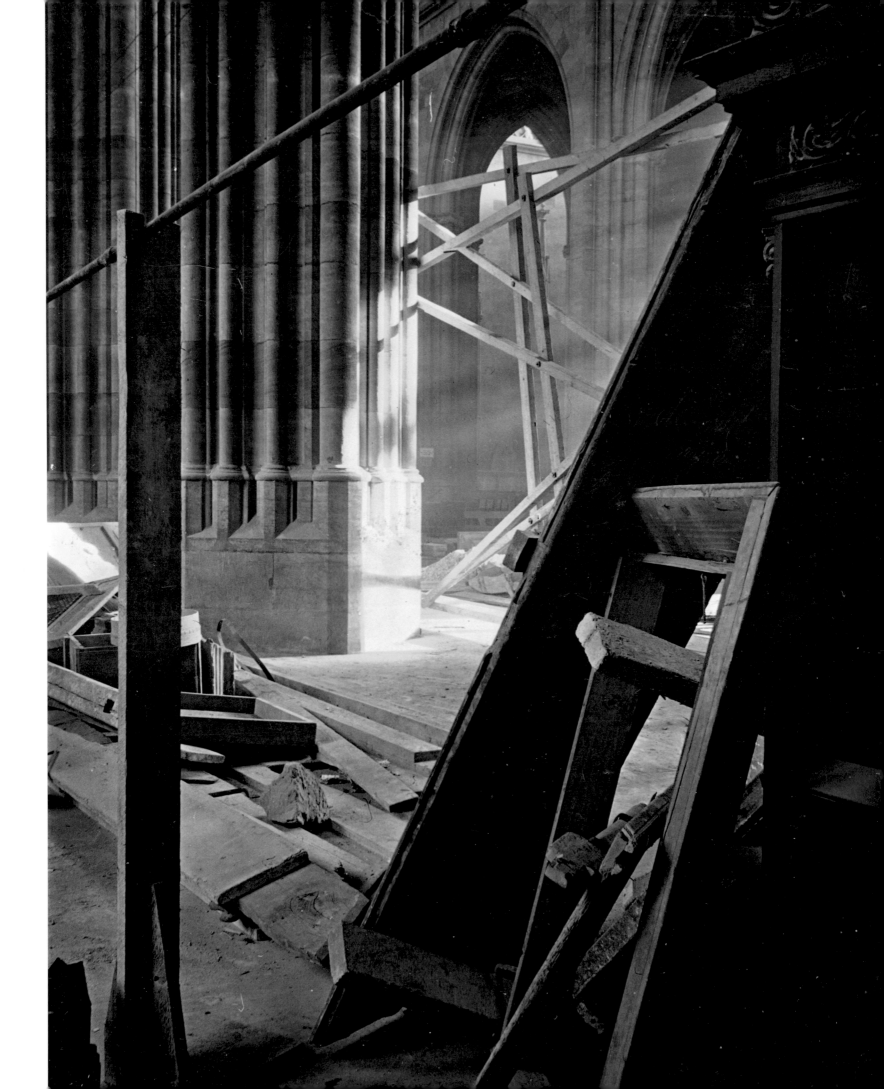

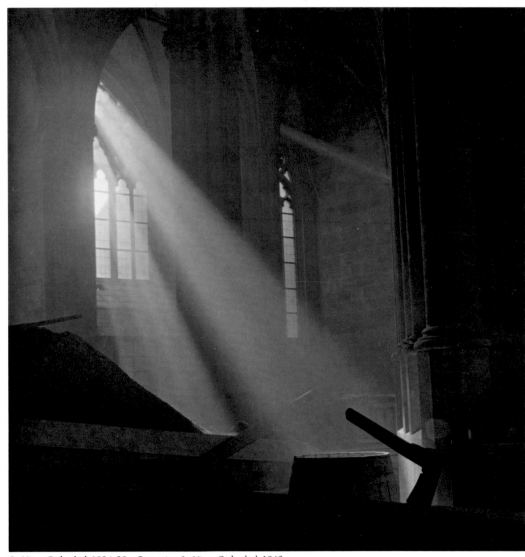

St. Vitus Cathedral, 1924-28. Opposite: St. Vitus Cathedral, 1942.

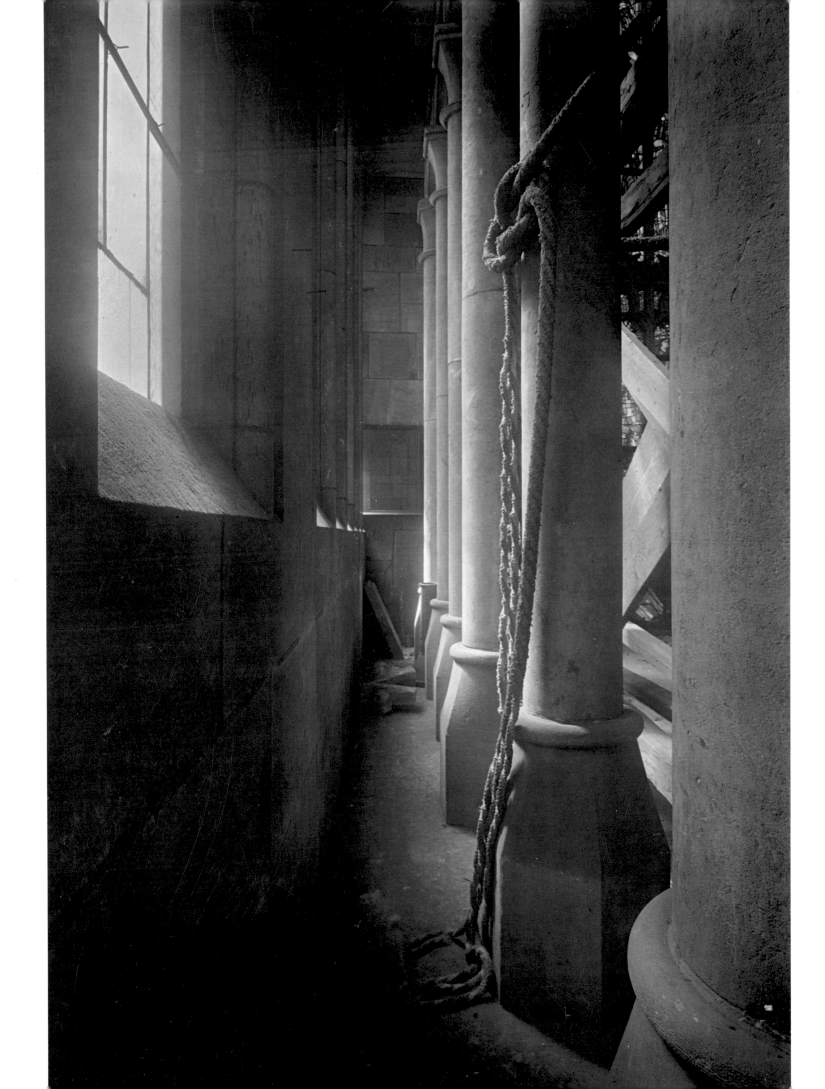

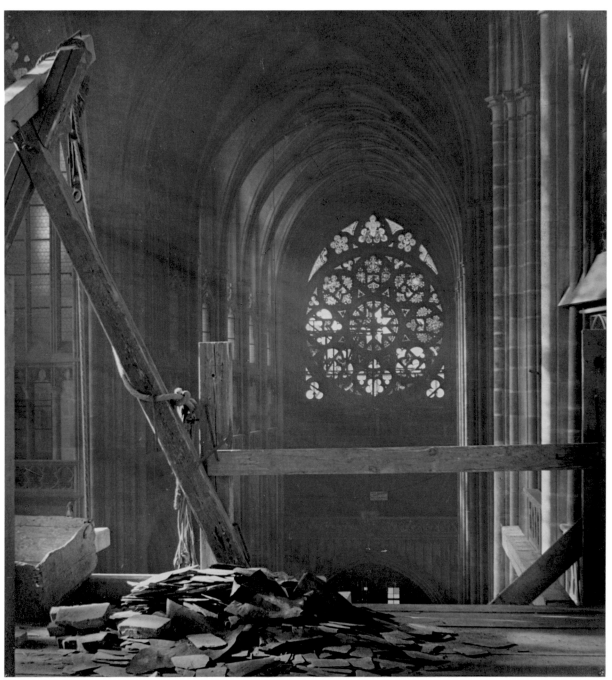

St. Vitus Cathedral, 1924-28. Opposite: St. Vitus Cathedral, 1924-28.

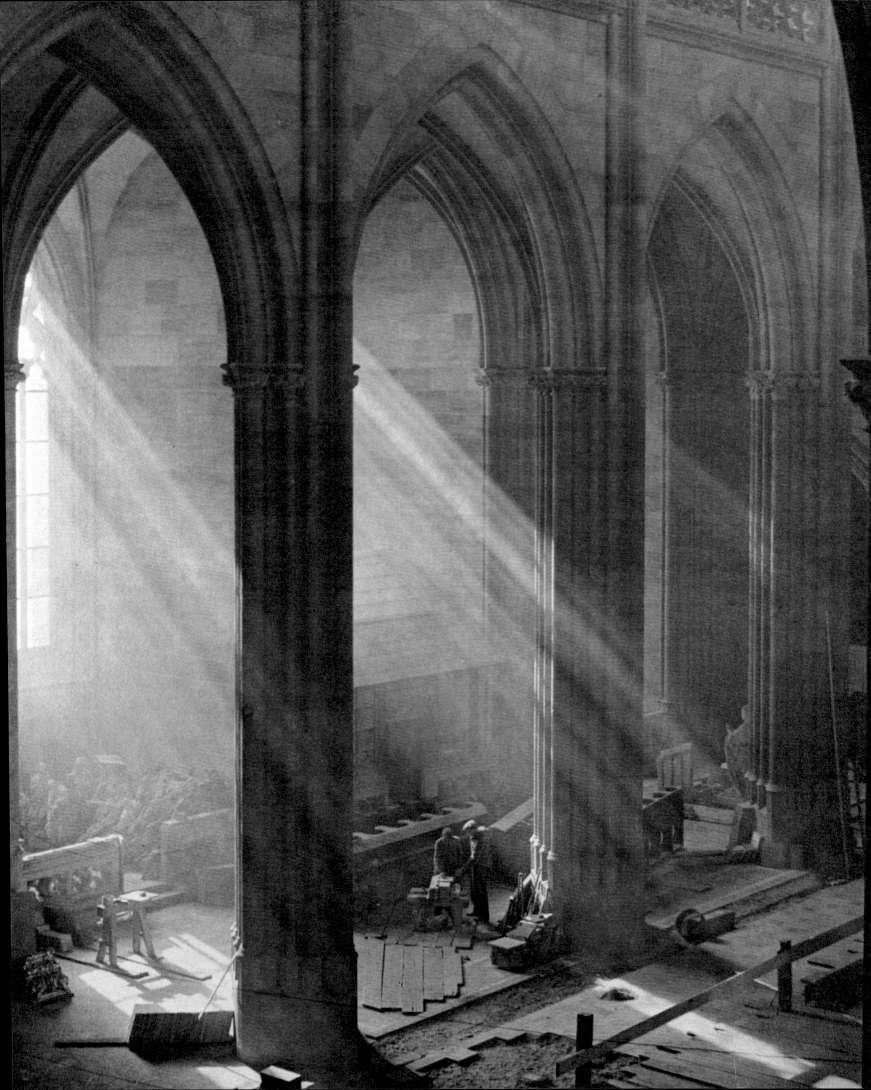

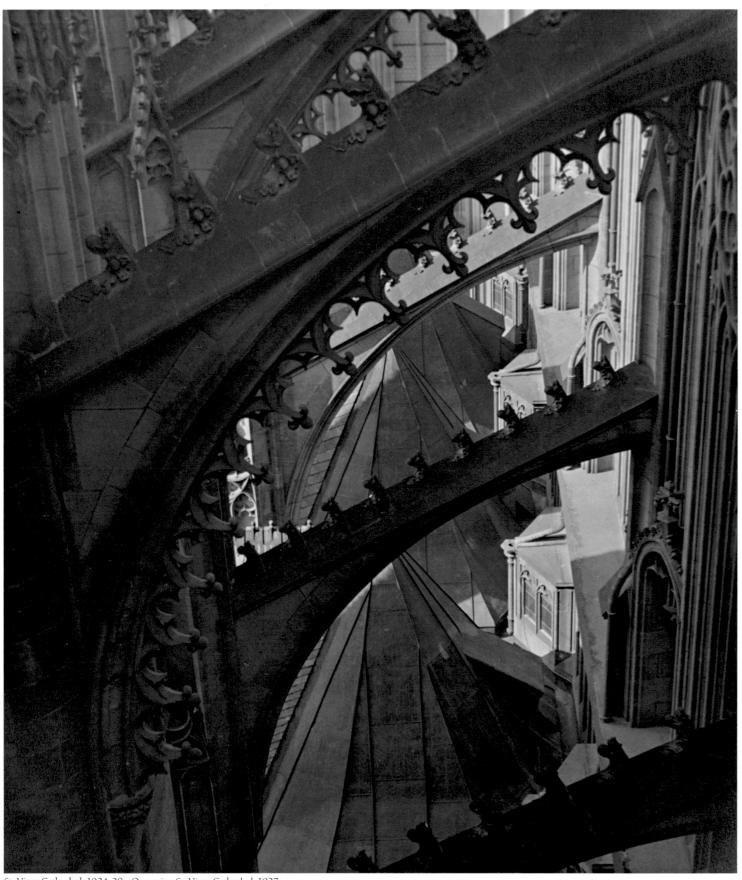

St. Vitus Cathedral, 1924-28. Opposite: St. Vitus Cathedral, 1927.

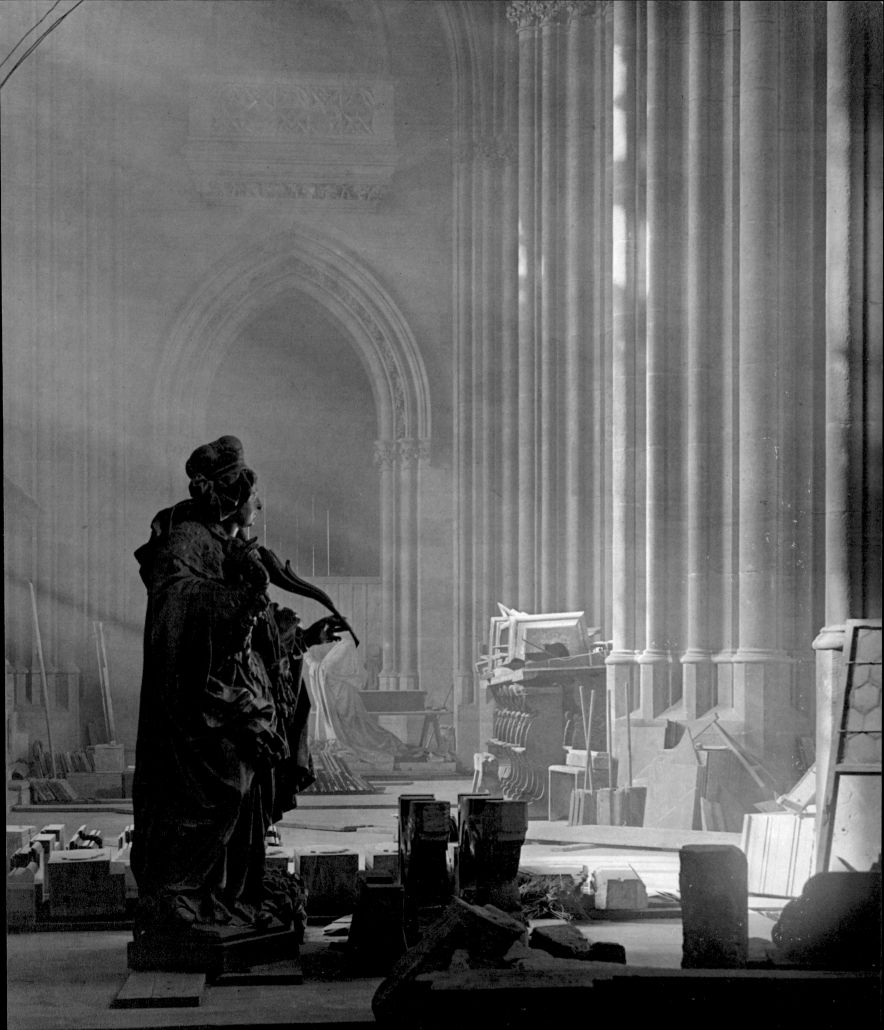

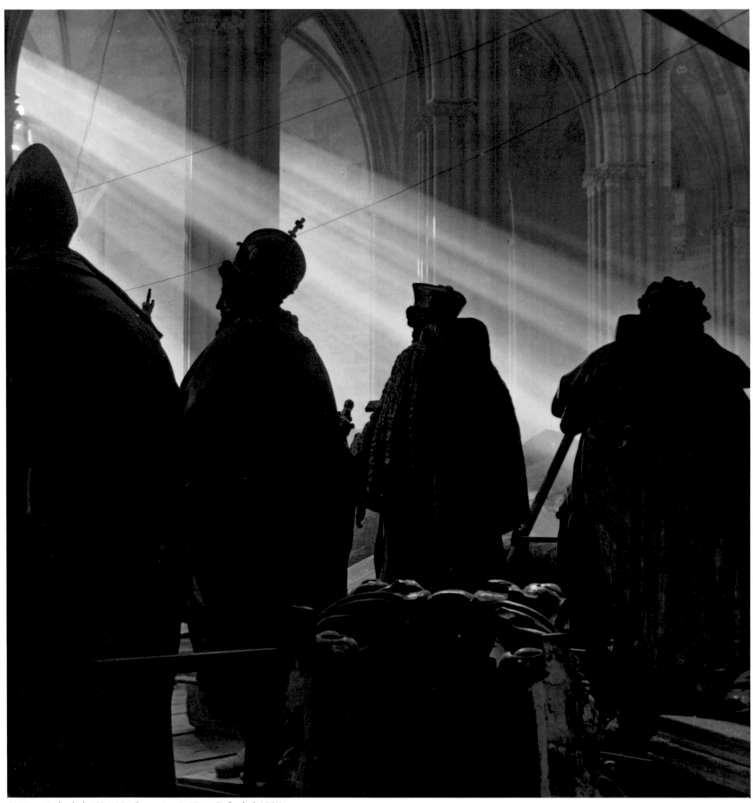

St. Vitus Cathedral, 1924-28. Opposite: St. Vitus Cathedral, 1927.

It would have bored me extremely to have restricted myself to one specific direction for my whole life, for example, landscape photography. A photographer should never impose such restrictions upon himself.

Detail with a Baroque Wing, 1951-54.

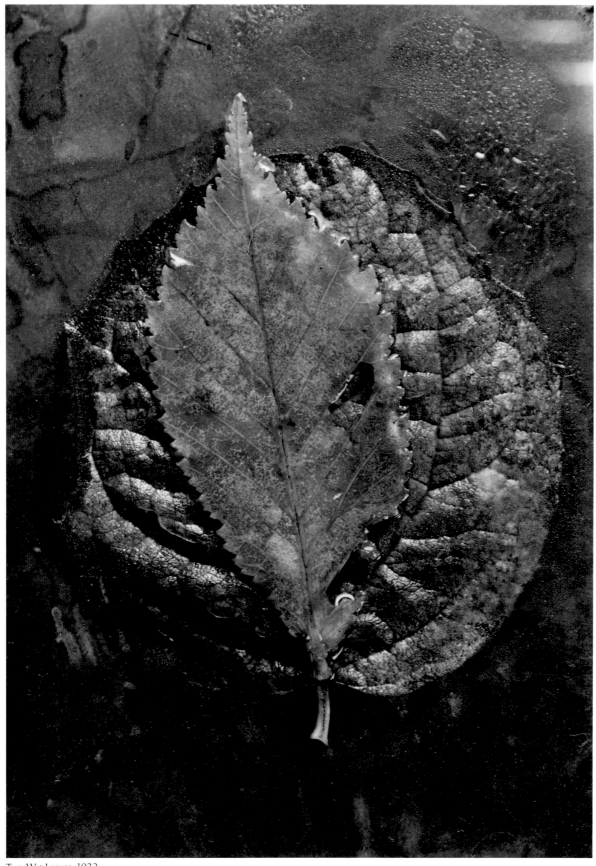

Two Wet Leaves, 1932.

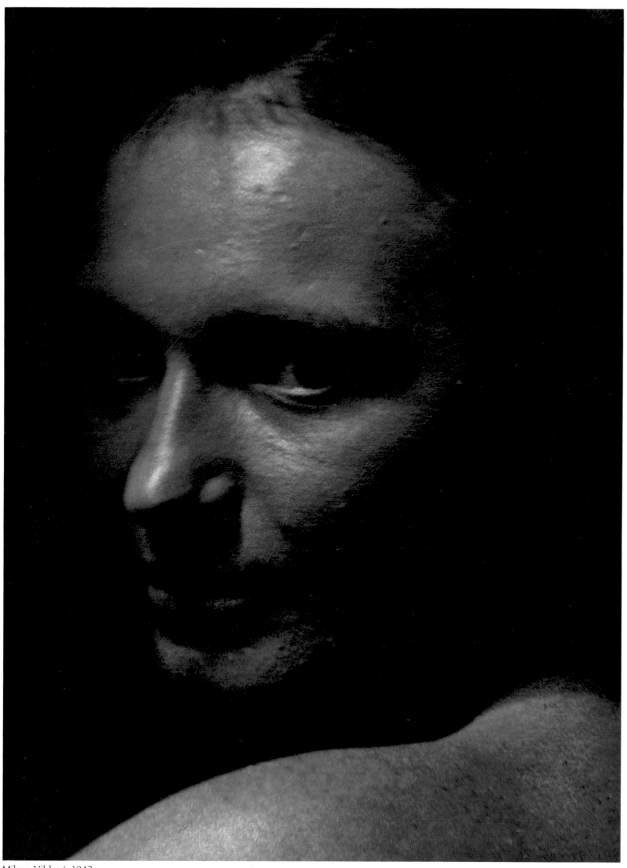

Milena Vildová, 1942.

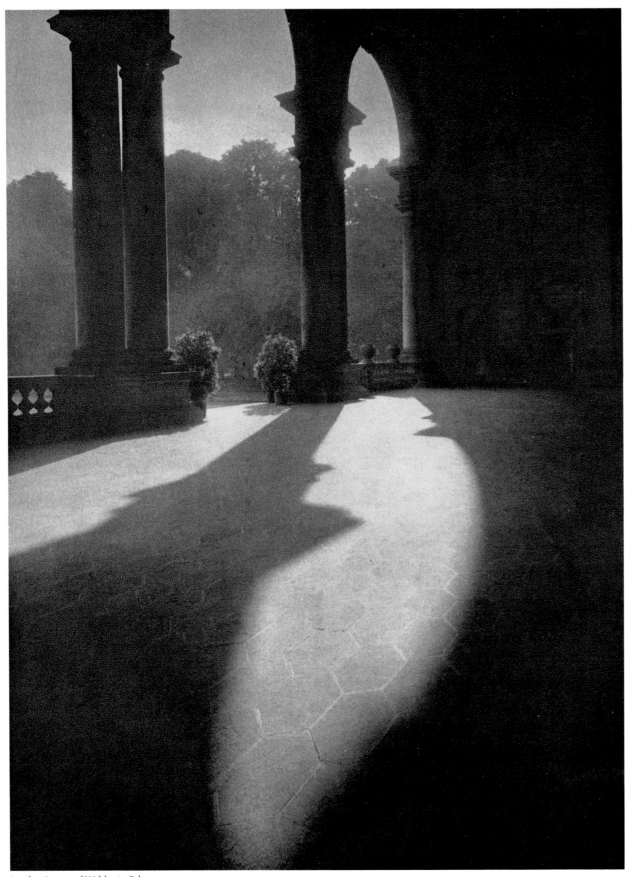

Inside a Loggia of Waldstein Palace.

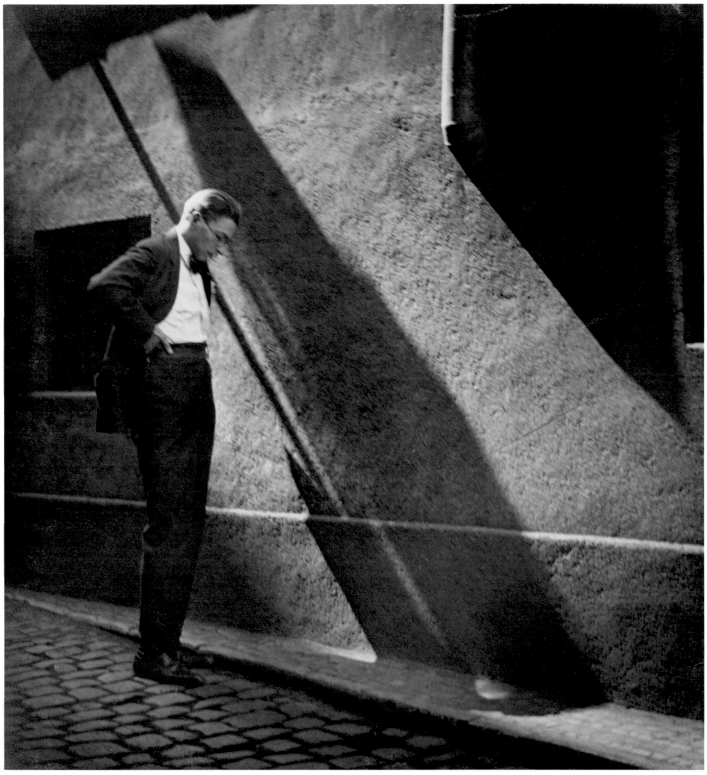

Jaromír Funke, 1928.

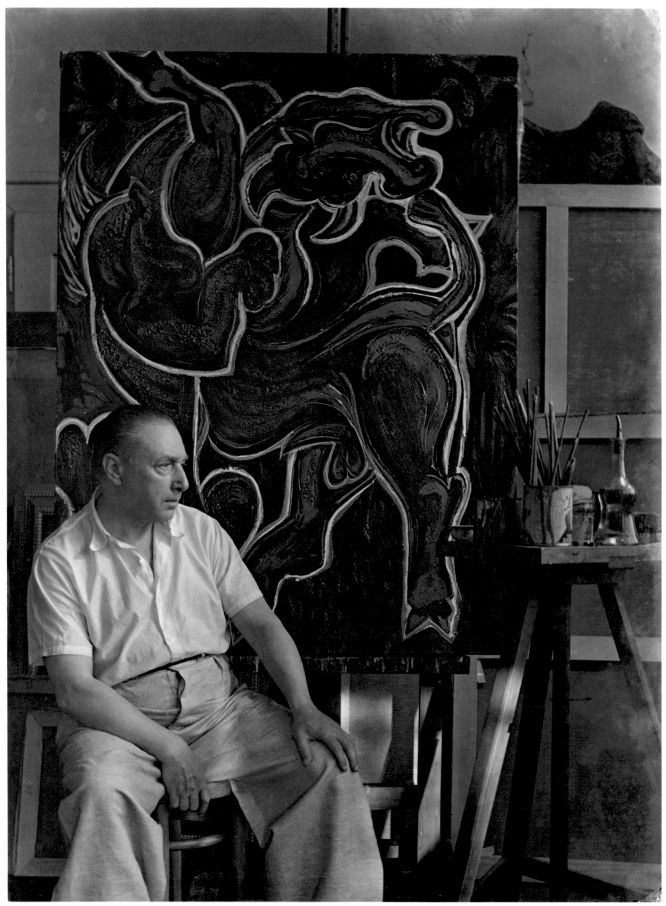

Emil Filla, 1927-33

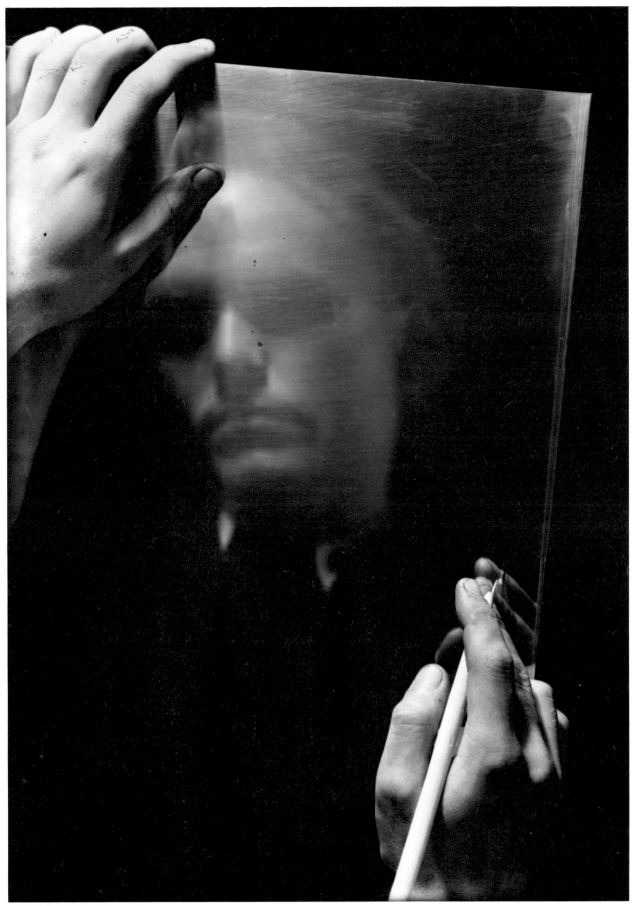

Václav Sivko, 1955.

Everything around us, dead or alive, in the eyes of a crazy photographer mysteriously takes on many variations, so that a seemingly dead object comes to life through light or by its surrounding. And if the photographer has a bit of sense in his head maybe he is able to capture some of this—and I suppose that's lyricism.

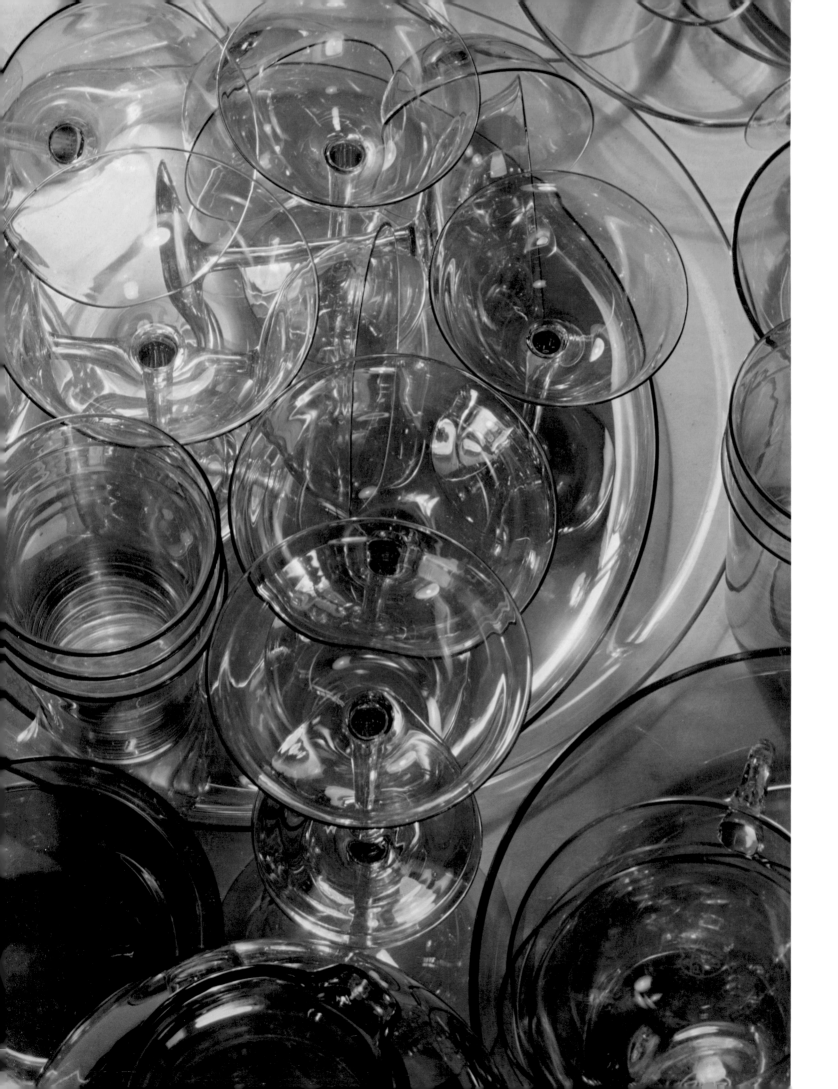

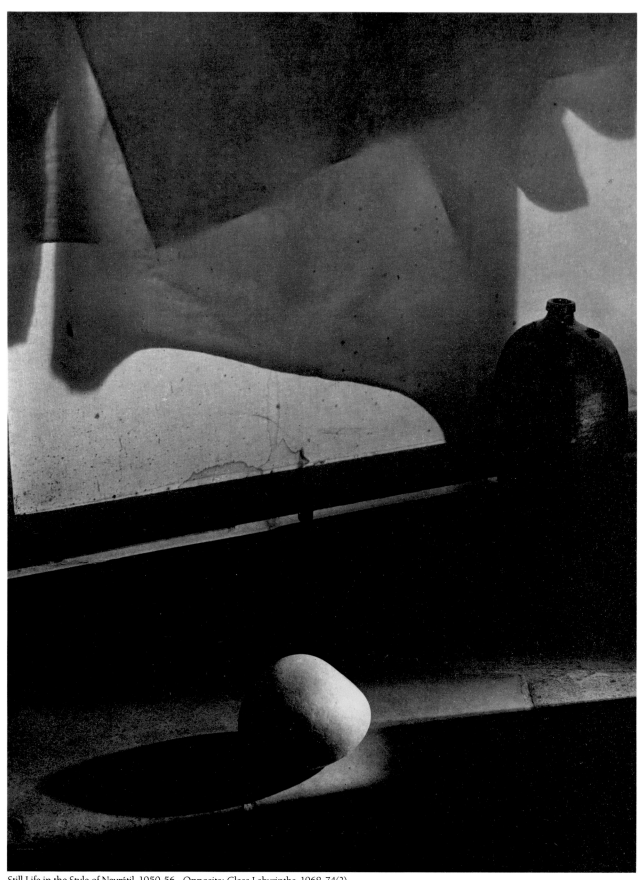

Still Life in the Style of Navrátil, 1950-56. Opposite: Glass Labyrinths, 1968-74(?).

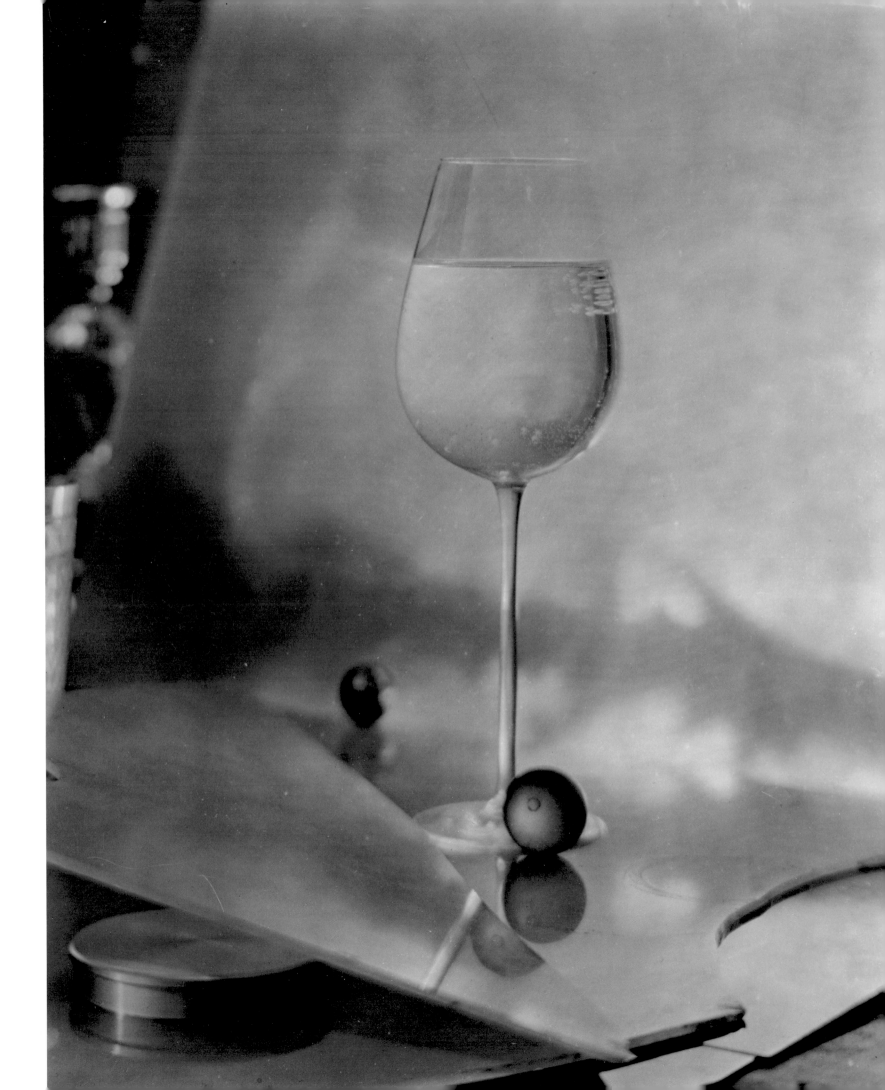

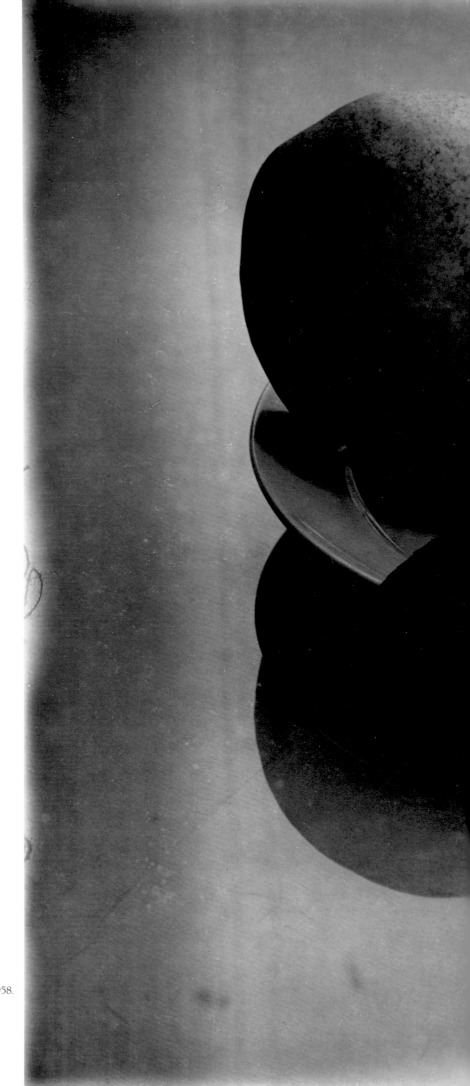

Still Life in the Style of Navrátil, 1958.

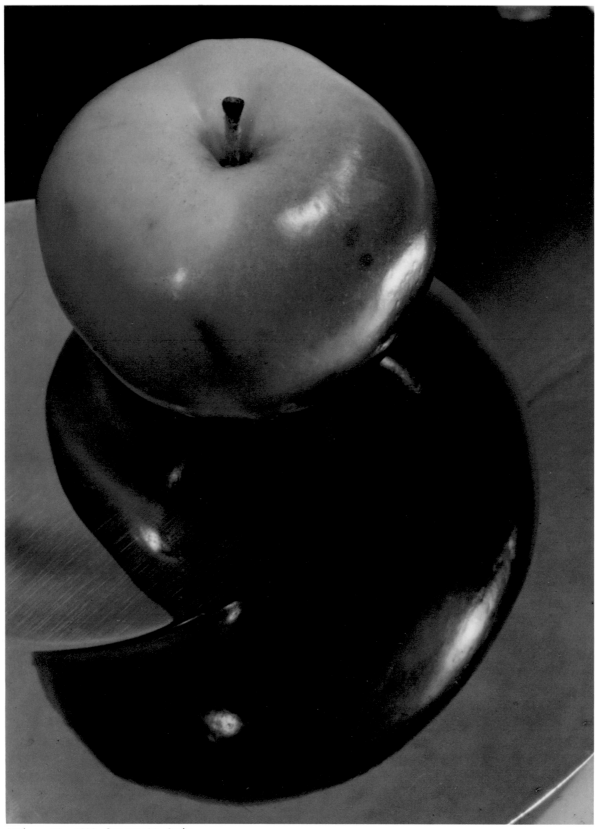

Apple on a Tray, 1932. Opposite: My Studio.

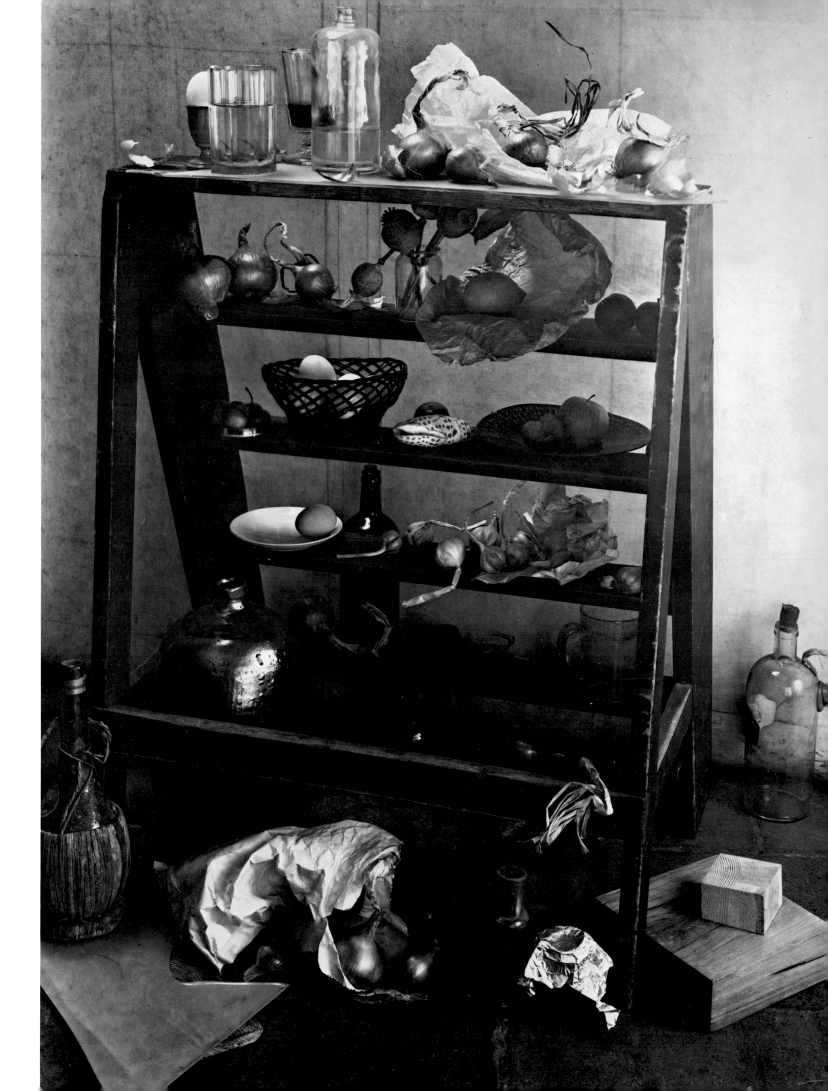

Glass Labyrinths, 1968-74.

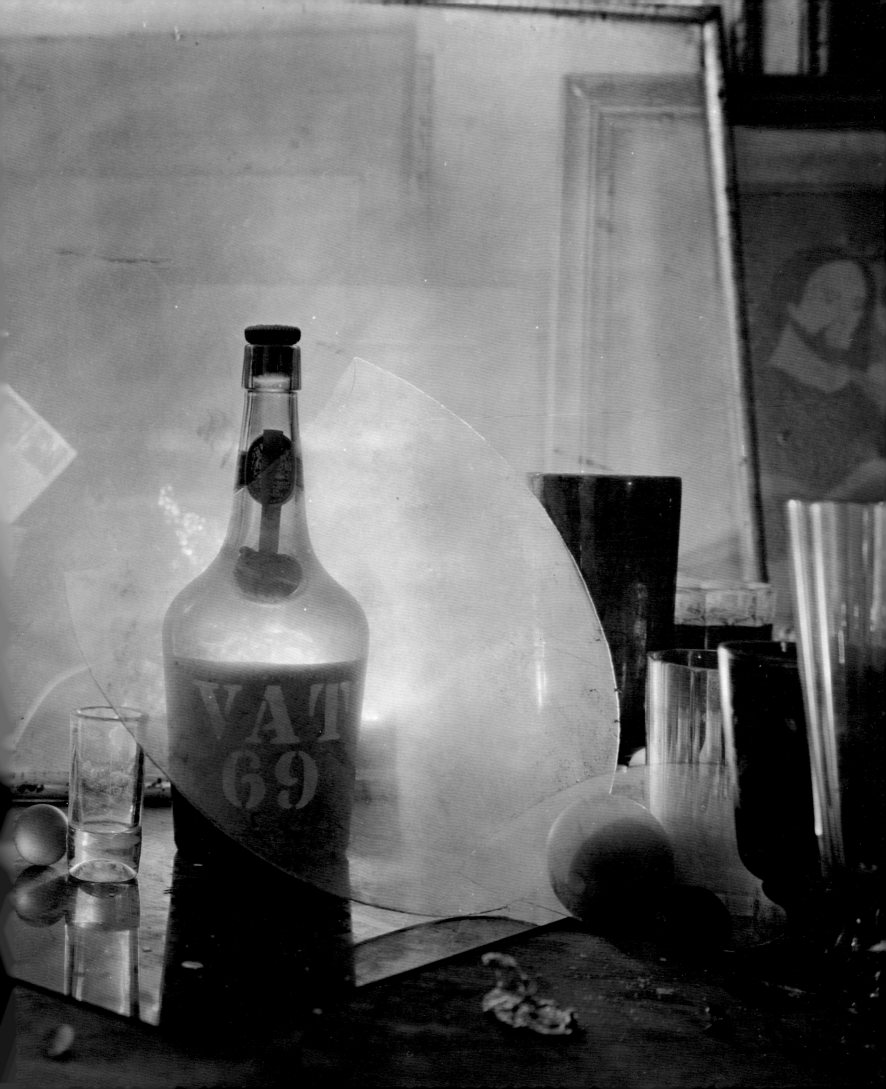

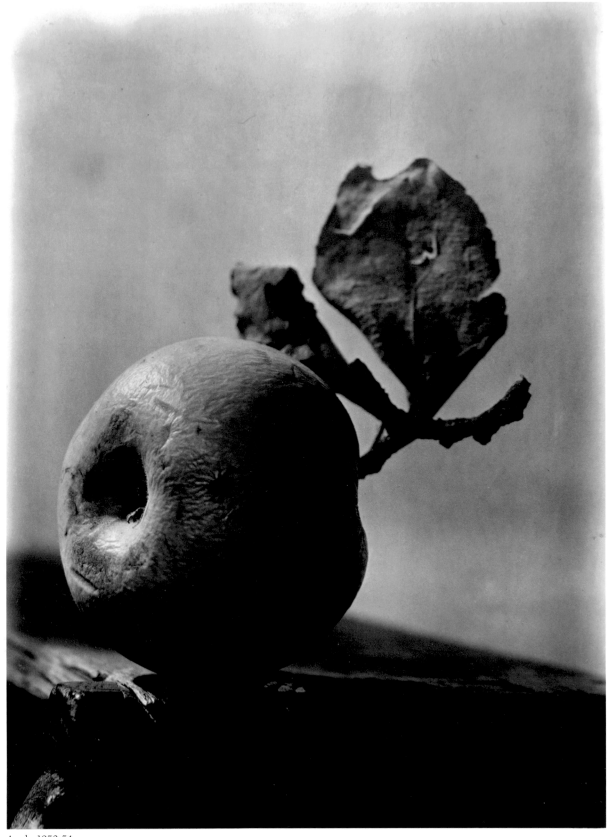

Apple, 1950-54.

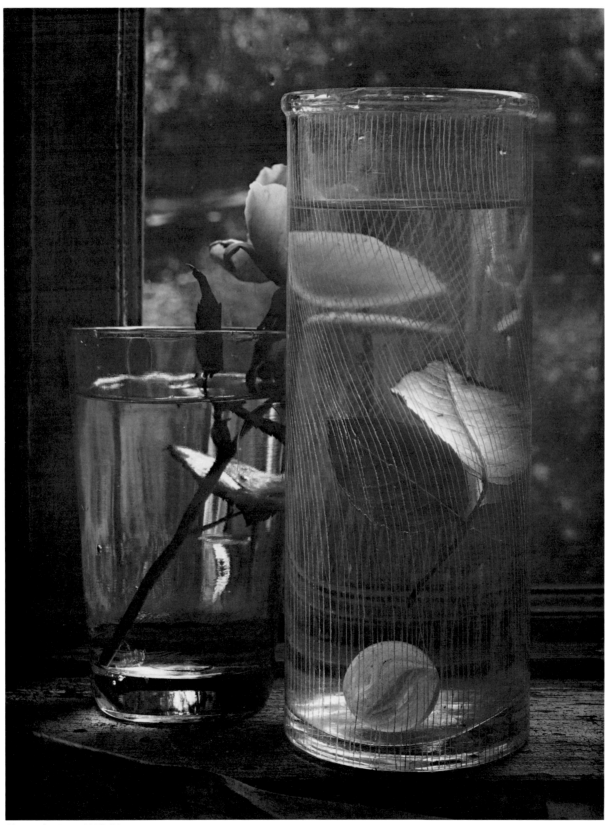

Glass with a Rose, 1950-54.

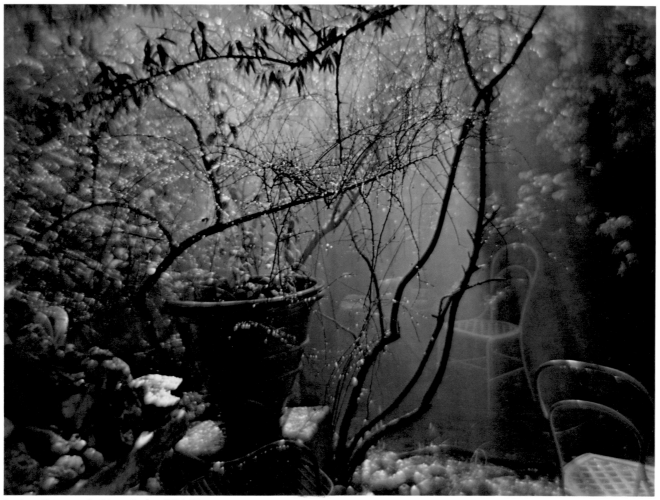

Summer Shower in the Magic Garden, 1954-59.

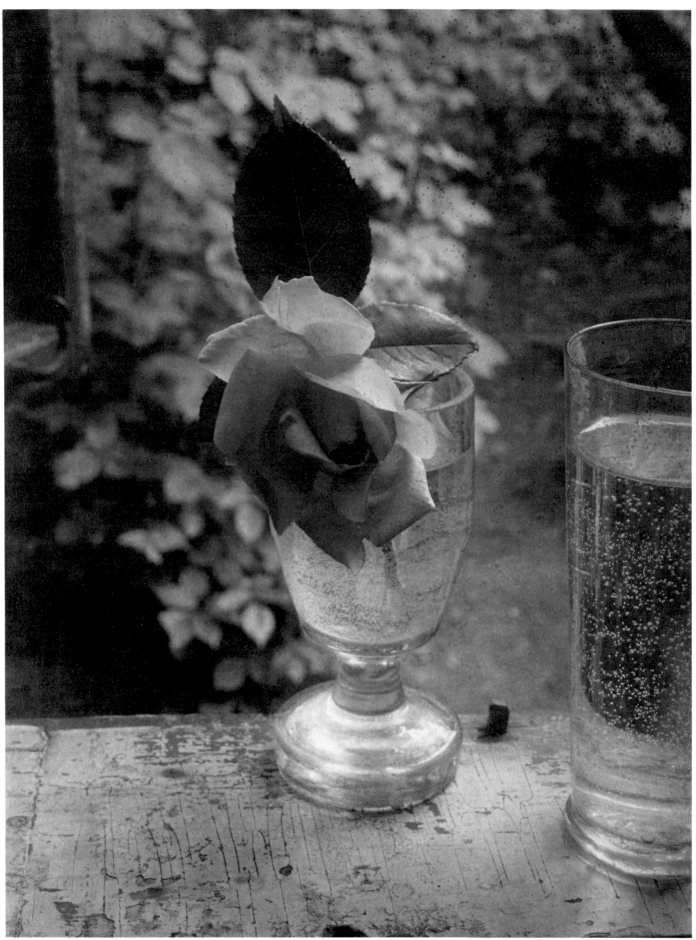

On the Windowsill of My Studio, 1951.

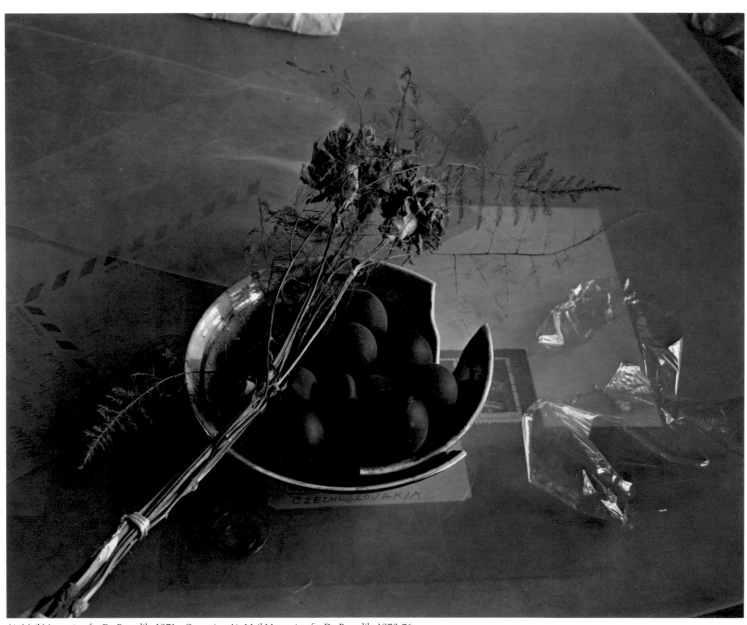

Air Mail Memories, for Dr. Brumlik, 1971. Opposite: Air Mail Memories, for Dr. Brumlik, 1970-76.

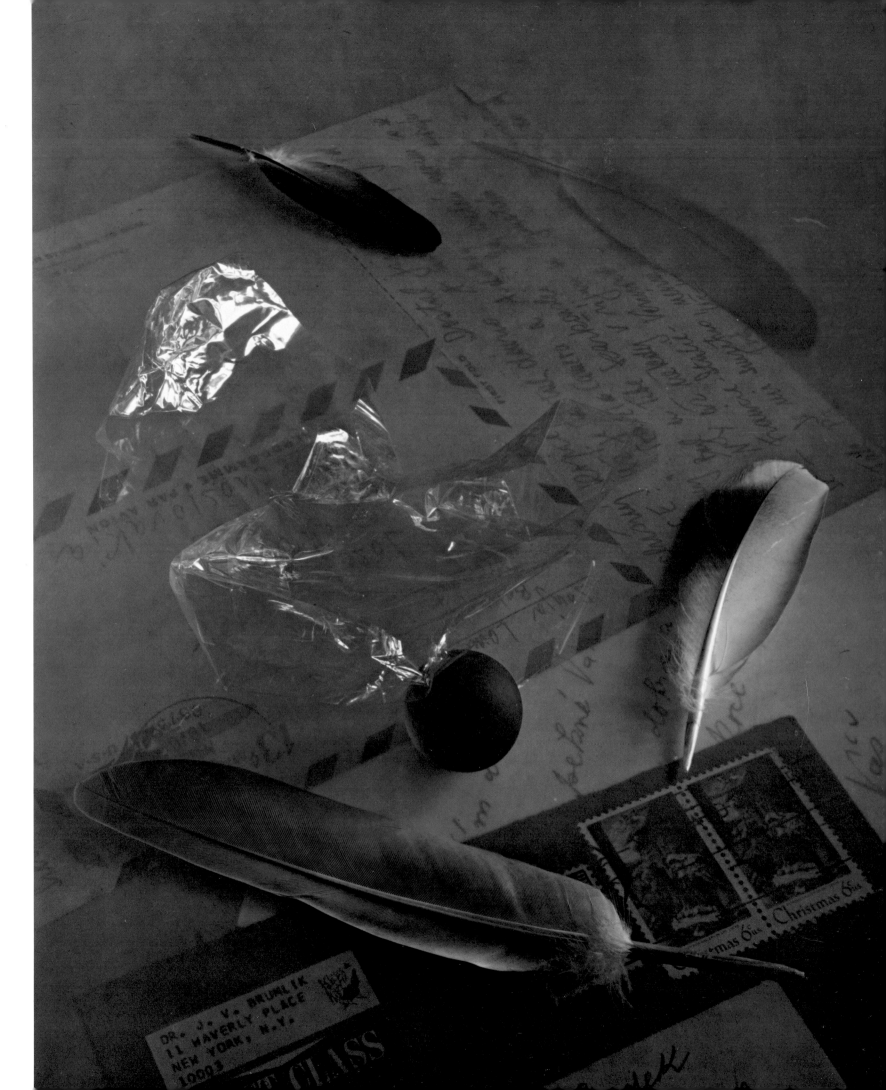

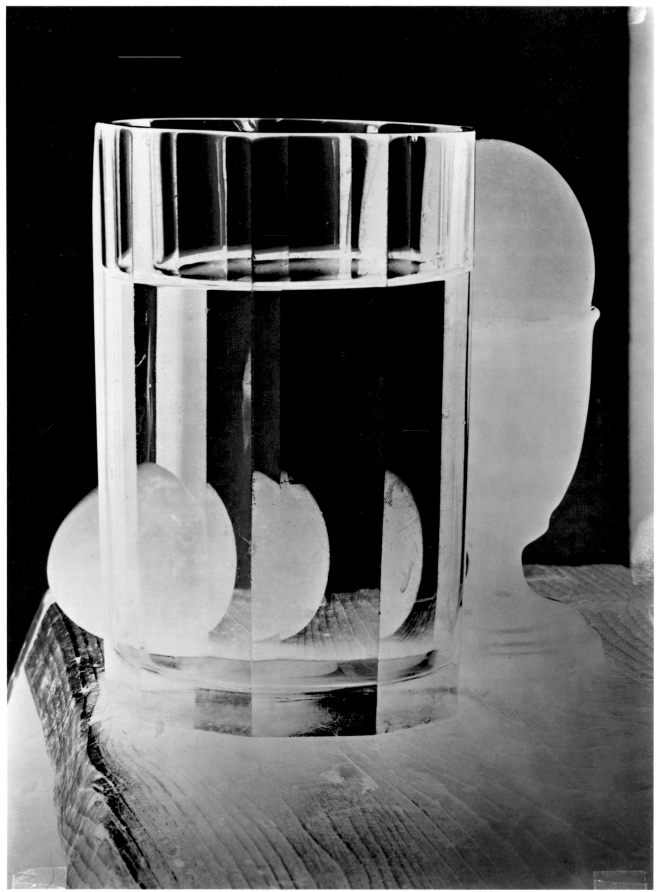

Negative, 1950-54.

On the Windowsill of My Studio, 1950-54.

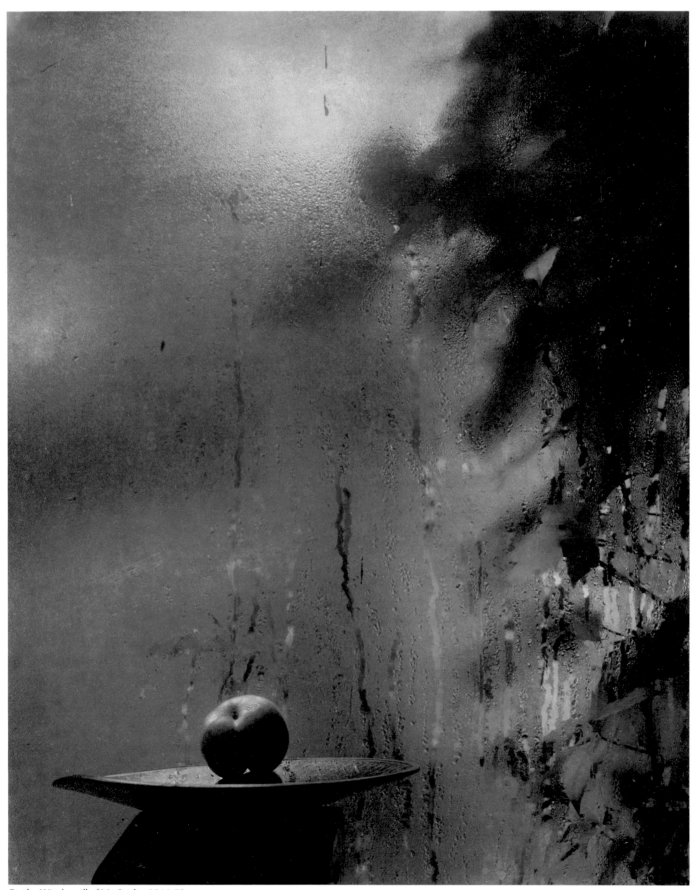

On the Windowsill of My Studio, 1944-53.

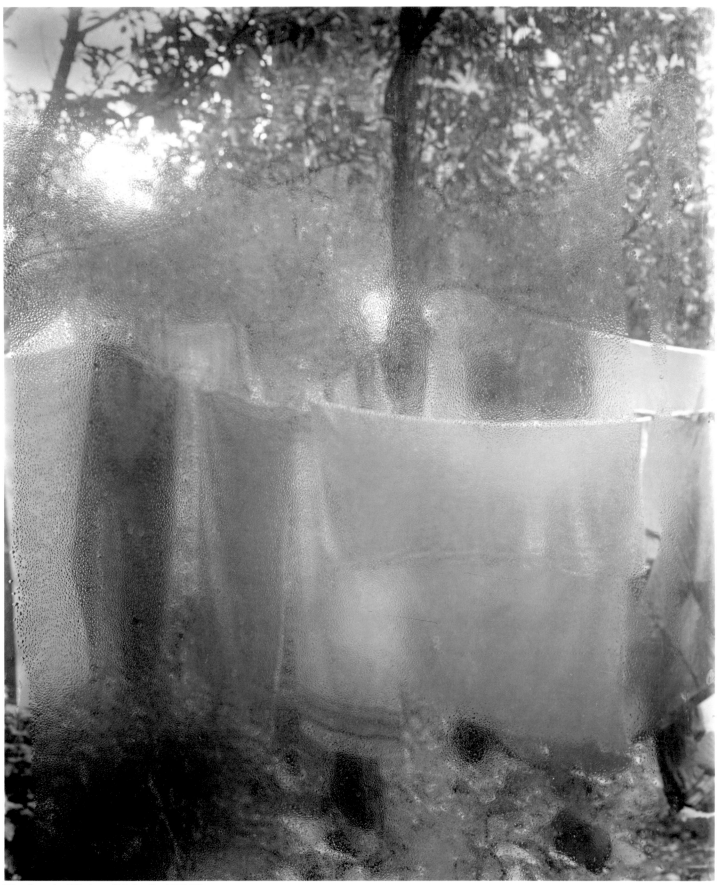

View from the Window of My Studio, 1940-54.

Clockwise, from top left: Adolf Schneeberger, Josef Sudek, Jaromír Funke.

Adolf Schneeberger and Jaromír Funke, 1926. Photo: Josef Sudek.

Besides getting the studio, one of the most decisive steps in Sudek's early career was joining the *Družstevní práce* artists' cooperative, a wide-ranging collective of artists, writers and craftsmen. Under the guidance of Emanuel Frinta, the cooperative not only published the highly respected magazine, *Panorama,* but also operated a shop that exhibited and sold members' paintings, graphics, glassware, ceramics, and textiles, among other artifacts. Many of the cooperative's projects were conceived and discussed at the Union Café, a popular gathering spot for Prague artists. As in Paris, Berlin, and later New York, the bars and cafés of Prague became the alembics where new ideas were exchanged, distilled, and transformed by the artists/ alchemists. Perhaps it was during one of the late nights at the Union Café that Frinta first suggested publishing a portfolio of Sudek's images of St. Vitus Cathedral.

Almost exactly a millenium before Sudek began photographing its interior, St. Wenceslas had dedicated a round chapel on the site to St. Vitus. In 1344, Charles IV began construction of the great cathedral. Remarkably, it was brought to completion six centuries later in Sudek's lifetime, under the eye of his camera. Few people have ever known the great building as he did. The fifteen photographs comprising the album, done between 1924 and 1928, are quintessentially Sudek: a blend of monumentality and intimacy; magic illumination and perfect composition; atmosphere and spirituality; grand plan as well as poignant detail and fine tonal harmony. In a sense, Sudek became one of the cathedral builders himself: he infused the photographs with a sense of toil, a sense of the cathedral's evolution. Details of the construction in progress, heaps of amorphous material within ordered space, extrinsic objects like ropes, a wheelbarrow full of sand—these all breathed life into the antiquity.

An apprentice who once accompanied the photographer described how he would arrive at a certain day, knowing it was one of the two or three days each year when the light would pour through the windows at exactly his desired angle. He would wait patiently for hours. Sensing the moment was near, he would run around fanning dust into the air to give the light a yet more palpable existence. While he might shrug off his technique to friends, Sudek's studies of the Cathedral reveal painstaking thoroughness, including, for example, minute sketches of the apse illuminated by natural light, accompanied by notes on film exposures under artificial lighting. His missing arm did not prevent Sudek from scrambling up ladders and across scaffolds to get the perspectives he wanted. And although he occasionally smashed an exposed plate, he simply went back for fresh ones and returned to his vantage point.

Sudek's accomplishment is a landmark in world photography. Only Frederick H. Evans rivals his ability to catch the monumental stillness enshrined by cathedral light, and none has surpassed Sudek's penetration of the intimacies peculiar to such monuments. Statuary and tomb figures, the stones themselves seem to possess an inner life. Sudek reflected years later: "the architecture still remained a fact, yet one made more mysterious, refined and complicated by shafts of light and chiaroscuro. It was while I was working on the St. Vitus portfolio that I first faced the question of how one is to photograph sculpture and relief. . . . It was reproducing both old and modern painting, and mainly sculpture, that helped me to begin to distinguish an objective fact (matter, mass) from a romantic vision."

Družstevní práce issued the portfolio in an edition of 120, designed by Frinta and with an introduction by the Czech poet, Jaroslav Durych. The edition was an instant success, viewed not only as an artistic accomplishment but also as an emotional patriotic statement in celebration of the Republic's tenth anniversary. Durych summed up the Cathedral's meaning for his countrymen in one simple passage: "St. Vitus is a whole realm of light and shadow, which the nation started building at the dawn of its history: a tomb erected for all its dead. Its faces are as innumerable and the richness of its forms are as inexhaustible as the nation's own . . . seeking profundity as well as soaring heights." The portfolio's success even led to an agreement for Sudek to photograph President Masaryk. Although that sitting never took place, Sudek later photographed Masaryk's wife and documented the drawings and paintings of his son.

With his newfound recognition, Sudek's photographic business truly flourished. He was available for all the routines of his trade: official documents, advertising, weddings, portraits, family groups, postcards. He was also the official house photographer of *Panorama,* which printed his portraits of the cooperative's authors, and photo-essays on its metal crafts shop, bookbindery, and handmade rugs. Some of the most striking photography from his commercial assignments were still lifes of Ladislav Sutnar's set of stemware. Sutnar had designed the glasses for the cooperative, and had apparently hoped "to have everything in straight lines like an architect." Sudek's response was a kind of organized chaos, ingeniously playing with the reflective, illusory quality of glass, shadow and light.

Schneeberger, listed as Sudek's apprentice-cum-business partner, had negotiated for the studio and its inventory to become part of a large commercial firm, Melantrich Printers and Publishers. The cooperative management was immediately worried that the arrangement would compromise Sudek's search for artistic purity, and one of its leaders, Václav Poláček, remonstrated:

It would probably be senseless to try to make you change your mind, especially as you have been offered such generous conditions. . . . With respect to freedom of the arts I consider it a very sorry fact indeed that you have been heavily persuaded and promised conditions much rosier than they could ever be. Allow me, please, to ap-

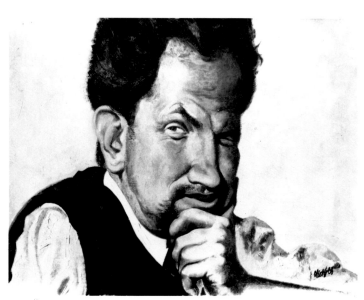
František Tichý, Portrait of Sudek, 1936.

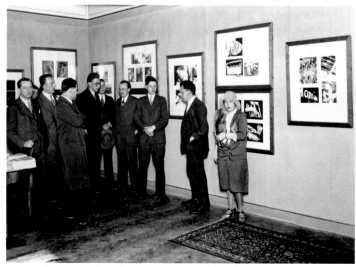
Opening for the Czech Modern Photography exhibition, May 1930. Josef Sudek, second in from the right. Photo: Central European Photopress.

peal to you to reconsider your decision and remain independent and an artist.

Poláček's fears of compromised integrity were groundless—Sudek worked for Melantrich only for three months, but it was not the first time Poláček had taken Sudek to task. Not long before, he had written:

If you want to continue working for our able and agile firm, you should be at least as able and agile in your work. Otherwise, we might be forced to send our authors elsewhere. While it has certainly been agreed that we should send them to you Saturday afternoons, Mr. Vlček unfortnately must leave as early as this Sunday. . . . Please go and see him at the Šroubek Hotel and if he is not there, wait for him as patiently as you did for sunlight in St. Vitus.

For some unclear reason, Sudek's friendship and partnership with Schneeberger also began to dissolve. Whatever the source of the conflict, which ended in a lawsuit, Sudek terminated their relationship in a letter that concluded:

I hereby gladly sever all friendly relations with Mr. A.S., hoping the gentleman will indeed be civil to the undersigned, refrain further from adorning himself with borrowed plumes, remain honest and veracious and stop needlessly talking claptrap about things that are definitely not his concern.

The rupture did not prevent Sudek's images from appearing in the first volume of Schneeberger's project on Czechoslovakia, *Prague, 1929.*

Again independent, Sudek reopened his business in 1930 and continued his string of both commercial and artistic successes. Or he continued in abject poverty. His customers and admirers saw him in one light; the tax collectors in another. Explaining a delay in filing a tax return, he complained to a Prague district office:

It is unthinkable and even impossible that as an invalid missing his right arm and a beginner in the photographic trade, unknown and with no publicity, a poorly equipped studio located in the back court-yard at 432 Újezd, a hard find for customers, and with no professional help, I should have had a turnover of some 30,000 crowns in six months from opening the business in 1930, a year very low in business, or earned a new sum of 12,000 crowns, the amount on which I have been taxed by your office.

Again Sudek's business acumen, as well as his proclivity for haggling with the authorities, surfaced. In fact, he had helpers, including his sister, Božena, as maidservant, secretary, photographic assistant, and general factotum; he had published two portfolios and a book, and he was still working with *Družstevní práce.*

There was, perhaps, a practical side to his repudiating both photography and his work as "art." A tradesman is expected to work for money: the greater his skill, the higher he sets his fees. The artist, for reasons that baffle economic common sense, is popularly supposed to labor for a less mundane objective than money. Sudek's customers, however, knew that money was indeed the object and his correspondence is peppered with complaints about his prices. Sudek was unfazed. As his business grew, he even hired a lawyer to manage his finances, pursue collection of debts, and undertake lawsuits as necessary. The photographer worked hard, met his deadlines, and wanted to be paid well and promptly for obvious reasons: he had a mother and sister to support, and he needed resources for his personal work. But he also enjoyed his commercial business, especially advertising photography. He appreciated the technical challenge of photographing shoes, and he later expressed outright delight in photographing underwear—women's more than men's.

If, as Sudek claimed, his advertising photography published in *Panorama* began earning him a name, his one-man show in October, 1932 won it. Sponsored by *Družstevní práce*, on display were sixty-four images, including landscapes, portraits, St. Vitus Cathedral, and scenes of Prague—exploratory, sensitive, exquisite examinations of his beloved city, which in their intentness are reminiscent of Atget's considerations of Paris. The reviews in Prague's magazines and newspapers reached new heights of hyperbole in their praise of Sudek. The exhibition went on tour in several of the larger cities, and the cooperative produced yet another prestigious project: its 1933 calendar. Printed in editions of 10,000, the calendar previously had been devoted to lush color reproductions of paintings. This first acceptance of photography as its own medium again attracted wide press attention, and again the reviews were favorable. Sudek's 1933 Christmas cards for the cooperative, however, roused the ire of one purchaser who wrote to the editor of *Panorama*: "What Sudek's Christmas cards lacked most is the glittering beauty of snowbound mountains. The home scenes shown to illustrate the feeling of the season's greetings feel strange and depressing, especially to us who live in the mountains."

As the thirties unfolded, Sudek was clearly established as a leading Czech photographer. He continued contributing to international photographic exhibitions, and participated in an enormous six-man show of 372 prints sponsored by Prague's Mánes Artist Association in 1938. He also plunged fully into the cultural life of Prague—joining museum societies, artists associations—and becoming a fixture in his beloved concert halls. Sivko mused:

Sudek's greatest love is art and beauty in all their forms wherever they are to be found, so that if the "boss," as he is affectionately called by his close friends, is not at a concert or "shooting" in the Seminary Gardens or somewhere in the Little Quarter, he will be found at home, developing his pictures while, as he says, the music keeps playing.

Sudek attributed his affinity for music to his mother, confiding in Řezáč that "to go to the National Theater was something like a pilgrimage to her, so when I came to Prague, I immediately went to the National Theater." The turning point, however, was when he experienced, twice in one day, *Madame Butterfly*: "I didn't like it too much the first time, I felt the singing parts were funny. But in the evening, during the second act, it happened. Just like that. It was like a razor blade." From that moment on, his interest escalated and expanded, embracing more and more composers, and so began the "music Tuesdays." Before, during and after World War II, friends would gather in his studio, and Sudek, "kneeling by the gramophone," recalled Seifert, "played the best and the most inspiring music . . . from Bach and Vivaldi to Stravinsky and Webern." About the concertgoers, Sivko added: "some visit regularly, others come by chance, but all invariably grow fond of the simple, picturesque place and the man himself." One such person was the actress Milena Vildová, whose curiosity had been aroused by Sivko; she too wanted to hear the music. To her, "Sudek was an alchemist who could transmute the soul, but only those who came with honest intentions . . . stood a chance with him." In 1942, Milena would be the subject of Sudek's most intriguing female portrait: her face emerges defined, tactile, yet through a dusky blur, the kind one meets as eyes slowly adjust to darkness. And there are also photographs of František Tichý, Funke and Filla, as well as portraits of Sivko, such as the 1955 image where the artist's face, like a specter, is eerily reflected on a copper plate which he holds in front of his face like a magic mirror.

Sudek's friendships often seemed tempestuous, building to crescendo, then waning. There were intense compatibilities, disagreements and often breakups—sometimes reconciliations. But this volatility was in line with, or perhaps a product of the photographer's apparent contradictory nature—benevolent yet controlling; accepting yet critical.

If consistency and contradiction (albeit consistent contradiction) was the rhythm of Sudek's life, his art progressed to the cadence of theme and variation—endless variations. While nothing could ever be fully known, answered, or revealed, he constantly searched for the truth of his subjects—beyond his preconceptions, beyond artifice. At first, his exploration led him through the streets and sites of Prague, working, it would seem, from the outside in. With the onslaught of World War II, he began orchestrating from the inside out, concentrating on private subjects—the window of his studio, the garden outside, simple still lifes within.

Opposite: The Wind, 1918-22.

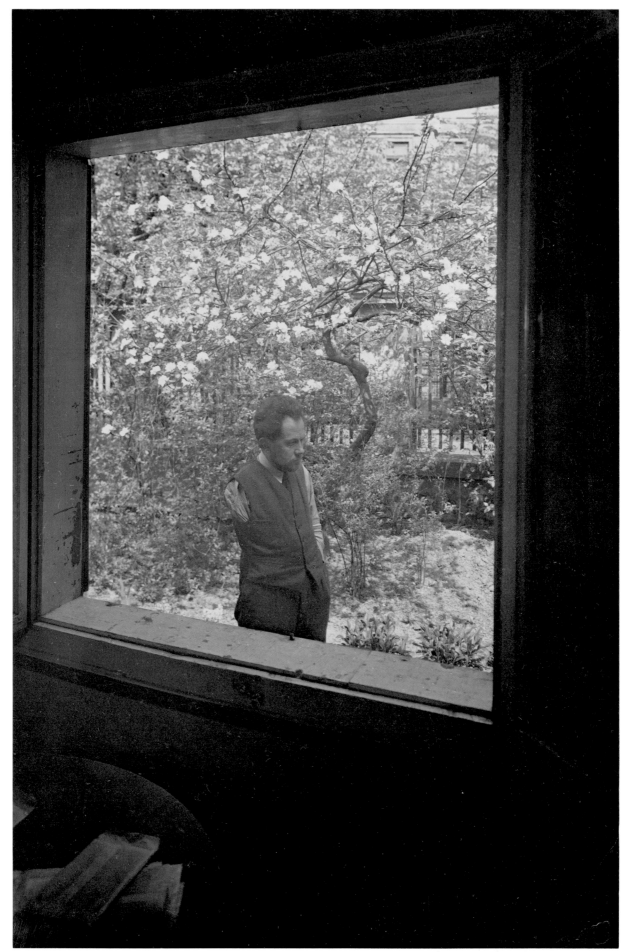

Self-Portrait, 1930s.

A Deepening Vision

If you take photography seriously you must also get interested in another art form. For me it is music. This listening to music shows up in my work like a reflection in a mirror. I relax and the world looks less unpleasant, and I can see that all around there is beauty, such as music.

Josef Sudek needed to tap every possible source of beauty as the 1930s drew to a close, and his homeland fell victim to a savagery unequalled in its long bloodletting history.

Czechoslovakia was created as a democratic republic by the victors of World War I, and it was sacrificed in 1938 by its "allies"—Great Britain and France—in an attempt to preserve peace. The Munich agreement of September 1938 ceded to Nazi Germany all districts of Bohemia and Moravia with a German population of fifty percent or more. As President Beneš resigned and left the country in exile, Poland and Hungary also received portions of Czech territory. In the month after Munich, Czechoslovakia lost one third of its population; after six months, the defenseless remainder was declared a Protectorate of the Third Reich. In March of 1939, German troops marched into Prague.

Hitler permitted the sham of a Czech president and cabinet, but power was wielded by the "*Reichprotector.*" Of several who held this viceregal position, the most notorious was Reinhard Heydrich, whose assassination in 1942 unleashed furious reprisal. The Czech economy was plundered for the Nazi war machine. By scores of thousands, Czech patriots were deported to concentration camps, impressed into slave labor, or executed. Ninety percent of Czech Jews were annihilated. In the Old Quarter, a centuries-old vibrant Jewish community had once earned Prague the title of the "Jerusalem of Eastern Europe." Here, Nazi occupiers designated the old Jewish Museum as a museum of an extinct race, filling it with treasures confiscated from synagogues and private homes across the country.

Sudek knew the horrors of war from his soldiering youth at the Italian front, but he had survived the carnage with the gusto and conviction that characterized his entire life, believing that no matter what, "the music keeps playng." As the nightmare of World War II descended upon Prague, Sudek, for the most part, retreated into his studio and into his art. During this period, his work became completely independent of all trends, and instead, spun magically along its own trajectory.

While photographing paintings in a gallery sometime around the beginning of the war, Sudek discovered a photograph dating from about 1900. Admiring the reproduction quality, he realized it was a contact print. From that time on, except for some of his commercial work, he rarely made en-

largements again. As when he first experimented with the process from 1918–22, contact prints were closest to Sudek's ideal of the photographic image. Fine grain, sharp contrasts and delineations didn't interest him, and he began to use tinted papers which enhanced the slightest gradations of tonality, while retaining the blurry contours of his forms. The images deepened, dark tones became almost unintelligible and shadows merged with the blackness of the borders.

Sometimes, he would make the borders white, entirely altering one's sense of the photograph's space, as did the placement and size of the image on the paper, and whether or not the paper was cut or torn—all new considerations for Sudek. Yet it was not *l'art pour l'art.* He was simply subjecting his photographs to the same scrutiny as his subject matter. Whereas he revealed St. Vitus, for example, in all its manifestations (almost in terms of its changes, its cycle of variations), so he subjected his photographs to the same exploration, presenting the images in all possible guises, and in this way, rendering the objective reality he valued so dearly.

In 1940, Sudek discovered yet another point of view through the glass pane of his studio window, into the fog, mist, trees and hidden mysteries (not to mention Božena's interminable laundry) of the garden, and then back inside, to the ever-changing tableaux of his window ledge. This cycle juxtaposes two worlds, inner and outer, separated, united and mediated by the ever-present glass. Although one might interpret this as a "realist's" return to romanticism, another reading could be that as Sudek focused on his own, self-created, immediate environment, he moved closer to representing his inner being—windows to the soul—and approached a truer realism, or as Apollinaire had originally described this condition in 1917, "a kind of *sur-réalisme.*"

The window ledge became a stage for another kind of narrative, a theater of ordinary objects: an apple, or a piece of crumpled paper—anything could crystallize into an extraordinary still life—a term which for Sudek had an enchantingly literal meaning Sudek used to say that like Hans Christian Andersen, he desired to get at what was beyond the objects themselves. He created a world where the objects' possibilities seemed limitless, where strange juxtapositions cast them into unexpected realms, but where their references, at the same time, were also specific, often intimate.

In a sense, Sudek began this rather ethereal juxtapositioning early in his career, and on a grand scale with his photographs of St. Vitus Cathedral. Within its immense interior, he had revealed spiritual majesty fused with a millenium of haunt-

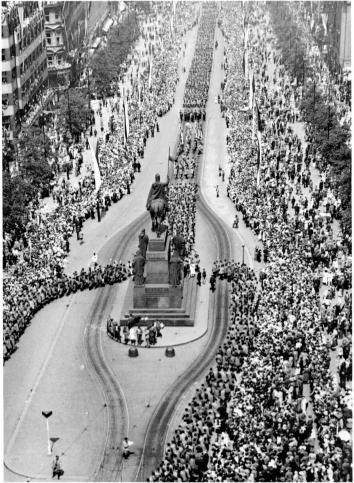

Josef Sudek, Wenceslaus Square.

ing presences: statuary, architectural detail, and workmen's debris. That vision reawoke powerfully within the cramped spaces of the little wooden shack where he lived and worked. Here, nothing was ever thrown away. Paintings, photographs, phonograph records, and heirlooms shared the space with old crockery, shopping lists, stacks of correspondence, and every conceivable "banal" object. Over the years, this jungle of things became more and more lush, and he and his sister barely had room to unfold their camp beds each night. For Sudek, it also became a laboratory of artistic sorcery, of objects configured by his imagination and by his camera.

Some still lifes were composed as homages to his friends; others were conceived in terms of admired painters, a twist on his practice of photographing his favorite paintings. There are photographs made after Caravaggio and Navrátil, and several echo Chardin and seventeenth-century Dutch painting. For his constant experiments in the genre, Sudek kept a stepladder overflowing with still life arrangements: a plate with an egg; a lemon on a piece of tin foil, a goblet half obscured by a wine glass. Intrigued, his artist friends soon began sketching arrangements placed on the window sill.

Although Sudek had retreated, he had not become a hermit. He still carried his camera into the streets, and up to the castle and the cathedral. It was in the castle gardens that he met a kindred spirit, the architect Otto Rothmayer, who would in the postwar years be party to some of Sudek's eeriest work, and also to one of his few public misadventures.

The war was coming to an end. The Czechs took to the barricades against their Nazi oppressors four days before the Red Army reached the city. Sudek had survived, he had grown as an artist—and yet there was one particularly painful loss. Jaromír Funke had been his closest friend, beginning with their photographing and drinking days during Sudek's convalescence after World War I. It was a friendship that grew as they battled the old school and forged new territory in photography. And in 1945, Funke died; he was not yet fifty-one, and was still primarily viewed as an intellectual photographer. Among future generations, some would judge Funke as never having reached his full potential as an artist. He would ever after be known as "the experimenter"; Sudek, who would live another three decades, would come to be called "the harmonizer."

There were new friends though. "After the war, unexpectedly, a new face showed up at Sudek's studio," wrote Vladimír Fuka, Sudek's assistant during the war years. "A Jewish girl. A scarf tied around the pretty, still almost childlike face. She had lost her hair in German concentration camps. She had no one, nobody had returned." But she knew she wanted to be a photographer. Sonja Bullaty became Sudek's assistant, apprentice, and friend; she would eventually be a critical influence in bringing his work to a wider audience in the West.

In her own beautiful monograph on Sudek, Bullaty wrote that she did not recall her first meeting with her mentor. She asked him about it later, and he said; "You were much too preoccupied with what you had gone through to bother much

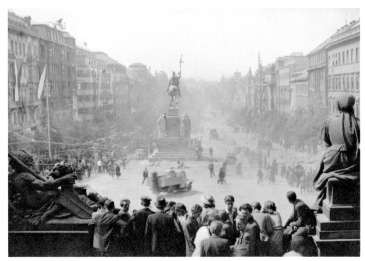

Josef Sudek, Wenceslaus Square, 1945.

about any of us or to take in your surroundings." Bullaty continued, "Perhaps there was an immediate understanding between us and neither spoke of what was too painful. It was good to face each day at a time, to just be. . . ."

Bullaty witnessed the frenetic pace Sudek maintained while climbing the hills of Prague, photographing with old cameras on heavy tripods. "Somehow the fact that he had only one arm never seemed a handicap." After she emigrated to the United States, their ties, as well as Sudek's ties with other emigré friends continued. In many ways they grew even closer through exchanges of letters, photographs, and phonograph records. In the 1960s, Sudek would incorporate some of the letters and objects he received into "Air Mail Memories." Several of his letters written to Bullaty in the early 1950s portray the always original, and sometimes baffling mix of characteristics that made up Josef Sudek's personality.

One of these ambivalent characteristics concerned his personal relations. Sudek was always known as a caring, generous man and a sympathetic listener. He also seemed to many to be aloof because he possessed a will to shield himself—and others—from painful emotional shocks. And with losses of loved ones and friends, the emotional shield strengthened. After a death, he might not even mention the name of the deceased for a year. Or, as in the often laconic way he referred to the loss of his arm, the tone might seem almost too impersonal and matter-of-fact. One letter to Bullaty, for example, included the following, rendered to reflect Sudek's whimsical orthographic idiosyncrasies:

. . . then Mother decided to dye on us (she was 84 yrs of h). She had too reasons: first, her own father dyed at 84 him self, and second, she felt it wasn't worth her while to go on living. And as she wished it very much, she managed to dye with in too weaks and didn't have to spend much time lying and waiting. Then my friend [Emil] Frinta dyed as well which brings us to the end of 1953.

In that same letter, Sudek was agitated by the drastic devaluation of currency that cost Czech citizens virtually their entire savings:

My finansial circumstances have been some what better lately, butt it was really bad after the big bankruptcy. Luckily enough some friends got me a few commissions, other wise I would of had a terrible time. It was a big crash all right: to liquidate all private and state property and all capitol with it in a mere 5 yrs, devaluating the currency at 1:50 takes some doing. The only advantage is it affected everybody including the workers and I hope it helped everybody sober up. Naturally, the rallies in factories and the newspaper leaders hailed it loudly. . . . I was worse off than when I had started 26 yrs ago. Butt what the hell, we shall see. My sister and I live quite modestly butt still have trouble scrounging enough for food and my photography.

Despite the difficulties, Sudek was full of plans for photographic projects. He wrote to Bullaty:

Last yr we had Janáček's anniversary and friends kept telling me to submit my photography of Janáček's Hukvaldy where I spent three summers taking pitchers. I didn't want to, knowing it would be senseless with the situation being what it is, butt they kept insisting I should at least try and so I gave in butt the publishing house returned my work saying it was too exclusive. I am sure if I coughed up portraits of some steel workers, it would be a different story all together butt thank God I'm too stupid to do that. So you can sea things ain't what they may seem. Talking shop, I'd like to do more of those sausage-long views of Prague.

Sonja Bullaty and Josef Sudek, 1945-46.

Josef Sudek's 50th birthday party, 1946. Sudek, top row, fifth from the left.

Sudek's fascination with the panoramic image dated back to his early youth, when he had first created a wide-angle landscape by pasting two prints together. He also remembered an American-made panoramic camera he had seen in a catalogue

during those years, and immediately after World War II began his search for what was now an antique. Sudek was then visiting and photographing Frenštát in the Beskyd Mountains, and was obsessed by the possibilities of the panoramic landscape. Finally, he chanced upon the camera, old and neglected, sitting on a shelf in the home of an acquaintance. Sudek received the camera as a gift, and then used all of his legendary patience to make it workable.

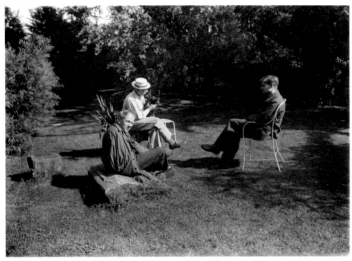
Rothmayer's Garden.

After months spent finding a replacement for the moth-eaten leather on the camera, Sudek then discovered there were no film rolls to fit the format. Kodak, which had made the camera in 1894, had long abandoned its film. Using German stock, Sudek created his own film by cutting and splicing. A shipyard welder devised a metal plate that had to be knocked into place to hold the film, and could only be unloaded by knocking it free—which meant Sudek had to return to his studio to unload. Rothmayer then suggested Sudek have a large bag made for unloading. Sudek gradually brought the archaic instrument under control, coordinating his one good hand and arm, and his teeth. It was an extraordinary feat, but given his descriptions of those early attempts, it was clear that this challenge was only the beginning:

Using this box camera completely changed the space. The perspective was different . . . what had been intended as a dominant suddenly wasn't the most important thing at all . . . I found out I had to look as if I were the camera.

Sudek's technique for learning to see as if he was the camera found him peering through his left hand which he held like a kind of funnel over his eye. The gesture was as original as it was unsettling—to at least one passerby:

Let's say I was walking along and suddenly I turned back. One day this thing happened to me. I walked up Neruda Street, stopped and quickly turned back twice. There was this old lady passing by and she became frightened, thinking I was off my rocker.

Reorienting his vision—manipulating sight and mind to emulate a camera manufactured two years before he was born—yielded yet another transformation in Sudek's work. Rendering his panoramic images in both horizontal and vertical formats, he revisited the streets of Prague, travelled to forest preserves, and began a fresh study of trees. In a few instances, Sudek even used it in the narrow confines of Rothmayer's garden, where he embarked on one of his most original series. Asked to photograph chairs Rothmayer had designed for his garden, Sudek immediately accepted—admittedly with the ulterior motive of gaining access to the garden itself. "A Walk in the Magic Garden" remains one of Sudek's strangest, most perfectly fulfilled poetic cycles. Rothmayer was an actual collaborator, helping set the stage for many images in the series. Sudek was in complete sympathy with the architect's feeling for old tree trunks, unusual garden lights made from rusty concrete reinforcing rods and bits of found glass, and the almost Japanese composition of rocks, branches and greenery. And glass eyes and other disturbing incursions—bits of magic—were also brought into the garden.

Sudek's photographs have often revealed a bizarre imagination. As early as the war years, he had started a series first with veiled women, and then a cycle of portraits in which the women's faces were entirely wrapped so that the features were barely readable. With Rothmayer, he extended this idea and among other works made *Lovers,* two relief masks, one white, the other black, posed gazing glassy-eyed at each other on the architect's desk, and photographed under varying lighting conditions.

As Sudek approached sixty, it seemed that time was still his ally. From 1940 through the 1950s, he initiated the greater part of his artistic masterworks, following his own philosophy of "hurry slowly." Aside from "A Walk in the Magic Garden," on which Sudek worked during the fifties until Rothmayer died in 1966, and many book projects, he continued with the windows series, portraits of friends, Prague parks and gardens, as well as the simple still lifes—which from 1950–56, he did in pigment. During this period, he also began an extraordinary cycle on the Mionší Forest Preserve, located a few hours from Frenštát. Sudek's friend Dr. Petr Helbich had taken him there, thinking, correctly, that he would be inspired. The preserve was entirely untouched, an almost autonomous landscape in a ghost-town-like atmosphere. Sudek had an affinity for solitary, old, damaged trees, and in the Mionší Forest, he discovered something primitive and wild, even brutal—unlike the groomed parks and gardens of Prague and the gentler quality of the city's surrounding countryside. Helbich recalls journeying with him through Mionší:

We climbed to the top, always taking the same path. . . . As usual, Sudek walked with his head down. Suddenly he stopped. Perhaps he had just glimpsed the right light by his feet. Shaping his left hand into a funnel, he looked about and ordered: "Hey, Assy! [Sudek's nickname for his assistant] Here! Set 'er up!"

The poet Jaroslav Seifert also accompanied Sudek on some of his expeditions, and offered a similar description of the photographer at work, probably on the slopes of Petřín Hill:

He was coming. His camera was already attached to the tripod, and he was carrying both, along with a heavy bag on a strap, over his left shoulder. In the shoulder bag he had several additional lenses and other equipment. For a single arm, it was quite a load. . . . Sudek positioned the tripod in the sand of the path, looked around him for a while, and then carried it to at least three different places. All that with his left hand. The empty sleeve was dangling from the right side of his coat. When he was getting the camera ready, he helped himself with his teeth. At the moment, he was holding in his mouth a piece of a soiled black cloth, and with his tousled lock of hair looked like a lion dragging a piece of meat. I wanted to help him. All right then, I was to hand him the first plate. He rounded his palm and fingers to form a telescope of sorts in front of his eye. . . . He waited for a long time for the right light. Maybe half an hour, maybe an hour. When it did not materialize, he picked up the camera and we moved to a higher place. And we waited again. He wrestled with the light like Jacob wrestled with the angel. . . . He did not speak. . . . Only from time to time he whispered to himself his favorite saying, "the music keeps playing". . . . The entire ceremony was very slow, but severe and exact.

After 1948, Sudek's intuitive, imaginative, individualistic photographic vision was incompatible with the collectivist fervor of the Czechoslovak Socialist Republic. As he had predicted, his early submissions to publications were rejected. And yet, it was the most prestigious socialist publishing house that issued the first monograph devoted to the photographer's work, *Josef Sudek - Fotografie*, with an introduction by Lubomír Linhart, poetry by Vladimír Holan and Jaroslav Seifert, and graphic design by František Tichý.

It was not easy to publish a book of this kind in the mid 1950s. Art as a reflection of reality—in this case, a prescribed reality—was the primary tenet of Socialist Realism, and Sudek's work did not in any way fit that directive. In his essay, Linhart praised Sudek, and at the same time apologized for the photographer's "formalism . . . erring ways and disputable tenets . . . apologetics of Cubism . . . obsolete principles of photogram . . . photography gone astray . . . erroneous return to vision foreign to today's perspectives . . . evasion of life. . . ." Nobody will ever know what Linhart's real intentions were, whether he really believed this party-line position of a Marxist-Leninist dialectician,

or whether he simply wanted to ensure the book's publication. Whatever the truth, Sudek could not have cared less about its ideological implications: "After all, it is the author who signed underneath the article; the photography is mine, and only time will tell."

As it turned out, Jan Řezáč, the editor-in-chief of State Belles Lettres Music and Art Publishers, which issued the mono-

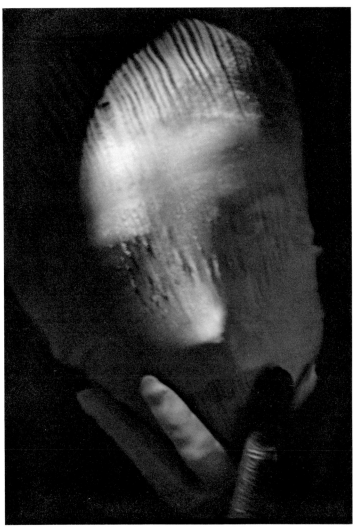

Josef Sudek, Veiled Woman.

graph, was an enlightened and tireless supporter of the photographer. In the four years following release of the monograph, Řezáč published three more Sudek books, including the magnificent *Prague Panoramas*.

Prague Panoramas is one of the landmarks of world photography. Sudek had achieved absolute mastery of his old and patched-up camera. With it he had revisited the city he knew in all of its majestic and intimate perspectives, all of its arcane and homely detail. *Prague Panoramas* offered a new, symphonic vision, one that had been neither seen by the eye nor conveyed by the camera. The book had also involved three of Sudek's

closest friends as collaborators: Řezáč, Seifert, and Rothmayer as designer. It was in every sense a work of love.

Sudek's books were issuing forth and official honors began to accrue as well. The Deputy Mayor of Prague announced that Sudek had won the annual Municipal Prize, to be awarded in April 1955. Sudek declined, explaining only that he could not participate in any meeting, and sent in a photograph of Prague, "in lieu of myself." The next year, the Czechoslovak Union of Artists nominated him to the art photography commission. Two years later, the Union pronounced that Sudek was "an outstanding art photographer and as such enjoys our society's full support and protection of his rights." Almost simultaneously, Sudek was named to the editorial board of State Belles Lettres Art Photography Edition. And so in one of those paradoxes that mark Sudek's career, this least ideological of photographers became a powerful voice in shaping photographic standards in the Socialist Republic.

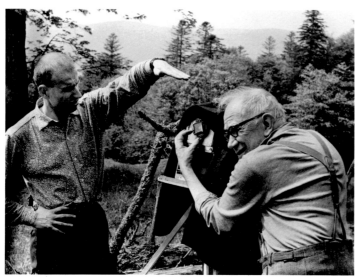

Photographing in the Mionši Forest Preserve, 1970.

At home, however, circumstances were forcing a great personal ordeal. The ever-accumulating objects were driving him out of the now dilapidated shack where he had lived and worked for thirty years. The situation had been difficult but manageable because his sister had spent several days each week caring for their mother in Kolín. After Johanna's death, the difficult became the impossible. Božena brought to Újezd as much of her mother's furniture and other possessions as could possibly be made to fit, storing the considerable remainder with a loudly complaining landlord in Kolín. And then there was Sudek's relentless accumulating. Besides housing his photographic materials, negatives and prints, the studio became a pulsing repository of those inanimate objects that Sudek endowed with life. And it hummed with echoes of the dead: Božena kept a curious necrology, recorded on odd scraps of paper stuffed here and there. Sudek had to move.

Throughout his life, Sudek was a feisty, persevering haggler with authority. He had plagued bureaucracies during the Hapsburg rule for exemption from combat duty, fought for financial aid and tax relief in the Czechoslovak Republic. Now, he marshalled friends, institutions, and his own considerable energies to wrest a decent space in which to live and work from authorities who were trying to deal with an acute shortage of housing. Enlisted in the cause, the Artists' Union attested to the fact that his studio was about to collapse, the roof leaked, neighbors raided the garden, and the concierge had even appropriated Sudek's cellar. Sudek's own applications, documents, and correspondence piled up—including a compelling appeal to the Academy of Sciences observing that his negatives and photographs would one day constitute an invaluable resource for art historians. Although Sudek never obtained a real apartment through the authorities, he eventually found a former jeweler's shop at 24 Úvoz which would be his home and workplace the rest of his life. At Újezd, Božena cooked and laundered for her brother, attended to a myriad of chores in support of his photography, and unfolded her camp bed each night to sleep in solitude amidst the mountains of things. Sudek, although no longer living with her at Újezd, continued using the studio as a laboratory and darkroom, and Božena remained there alone until 1985 when a fire forced her to move out.

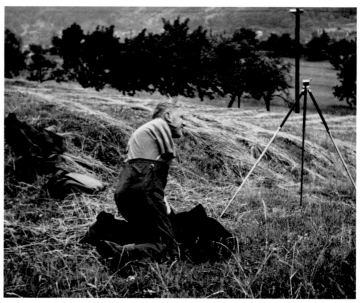

Josef Sudek in the 1950s.

Sudek's new quarters were exceedingly simple, modest, and functional—two rooms with vaulted baroque ceilings, adapted to include a miniscule bathroom with a shower. The larger room contained a gas range, some shelving, a safe left over from the jewelers shop, a huge round table with strong curved legs, and tin tubs originally intended for a darkroom. The tubs, however, remained in the room, never reaching their

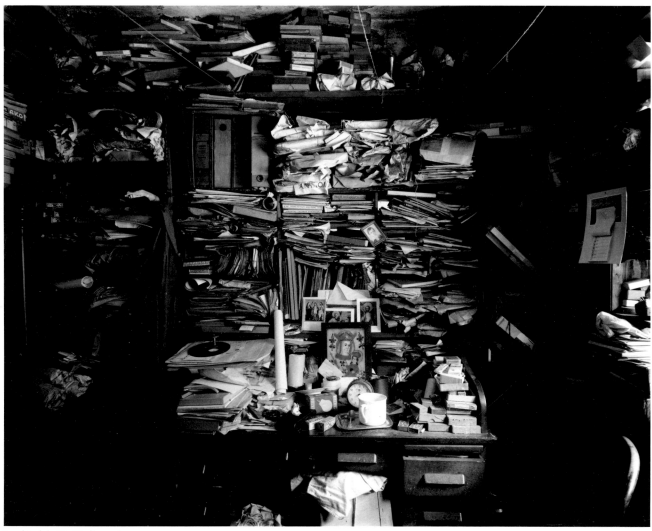

Josef Sudek, My Studio.

destination. Once again, things began to rule, usurping the table, overflowing the tubs, jamming the shelves. Perhaps it was a family curse, perhaps it was Sudek's need to create a world with an independent life of its own—unlike anything known from painting or photography—that nourished his imagination. Gifts from friends, things forgotten by visitors, bundles of papers, glass, small sculptures, regular souvenirs, and more—were all heaped side by side, and orchestrated later into the "Labyrinths" series, 1948–73.

In 1961, at the age of sixty-five, Sudek was awarded the honorary title of Artist of Merit. He was the first photographer ever to receive such a high honor from the Czechoslovak Socialist Republic. Through his books, calendars, commercial photography, and other work, he had acquired a following drawn from all walks of life. To his fellow Praguers, Sudek was a down-to-earth, dauntless character, always ready with an adage, a joke, or one of his famous curses. He was one of them until his exhibition opened at the Czechoslovak Union of Writers Bookshop in January, 1963 and his public was dismayed by what it saw.

That the exhibition took place at all was out of the ordinary: previously the space had only been used for paintings and graphic arts. Everything, it seemed, appalled the viewers. First, there was the design of the exhibition and the presentation of the prints—a collective effort by Sudek, Rothmayer, J. Tintěra who was an expert on paints, and R. Biskup, a glazier who created lead framing strips. The photographs were presented in ancient frames, with backing of unusual structure, fabric, or tinfoil; also, images were placed between two sheets of glass, bound together with lead strips, and backed by gold foil, bookbinder's endpaper, handmade paper, and other unusual matting. The effect was artificial, even decadent, and sophisticated in the extreme. The groups involved 112 images arranged in eight themes: "Views from the Windows of My Studio"; "A Walk in the Magic Garden"; "Garden of the Lady Sculptor"; "My Garden"; "Prague"; "Still Lifes"; "Memories of Arbes, Poe, Stevenson, Wells, and Wilde"; and "Notes."

The images included some of Sudek's most subjective, deeply personal explorations—not the fashion at the time. The

final insult, perhaps, was Sudek's printing. Most of Sudek's public—even his fellow photographers—knew his work from press, periodicals, or books. With his exquisite mastery of technique, he differentiated greatly between prints for display and those destined for publication. In the exhibition prints, dark greys almost fused with borders so that tonal values were all but imperceptible. It was precisely that infinitesimal control over tonal gradations that had drawn Sudek to contact prints, and precisely this quality that irritated the public who felt betrayed. The exhibition register shuddered with rejection: "too skeptical . . . can't make head or tail of his still lifes or what they're supposed to mean . . . very fetishistic . . . we want to see something dynamic and dynamism is what is missing here. . . . My feeling? Sadness, gloom, dejection, depression . . . whoever knows Sudek is in for some very big surprises . . . especially at these times, one would expect much more from an artist of Sudek's reputation . . . the framing is horrible. . . . Keep up the work, Mr. Sudek, but do try to see contemporary life." There was much more. Only Sudek's closest friends were enthusiastic, and only they knew that he had never marched in step with the times. The 1963 exhibition, however, was the first time the courageous photographer had publicly stepped to the music he heard.

Sudek was shaken by the experience. While he might battle or avoid authority, and refuse to cowtow to wealthy patrons, the rejection by his public and fellow photographers hurt. He was a popular informal speaker at amateur photography clubs, but when members of his audiences saw the exhibition prints which they had previously known only through reproduction, the enthusiasm faded. Some clubs even refused to exhibit his work because of its "poor technical quality." Although saddened by the lack of understanding, Sudek's response was true to form. He launched into the most uncompromising and unearthly series of his career: "Labyrinths," his crowning achievement.

Labyrinth . . . 1. A structure consisting of a number of intercommunicating passages arranged in bewildering complexity, through which it is difficult or impossible to make one's way without guidance. (Oxford English Dictionary)

Where does one find the entrance to Josef Sudek's labyrinths? There is no precise entry point in time, for the maze twists and turns through his life and threads back into his childhood. Nor is there an exact place, not even Prague, because the imagery has no counterpoint in reality. The labyrinths—like the true archetype Daedalus wrought—are of mind and spirit. Even with Sudek as guide the follower must rely upon a deep understanding of music and art, a chorus of muses, to find the way. One might as well begin with pigeon feathers.

"Air Mail Memories," a series that extended from 1960 to 1973, was a tribute to friendship. One intimate cycle included pigeon feathers sent to Sudek by Bullaty in the course of her travels. Exotic stamps and postmarks from the envelopes of letters sent by friends from abroad and the unusual typography and design of foreign record album covers intertwined with a growing forest of items and light-sensitive papers atop the huge

Josef Sudek at his retrospective exhibition, a few months before his death in 1976.

round table. The maze changed constantly as minute objects were shifted here and there in a tangle of magazines, catalogues, strings, and religious objects. From this animate tabletop emerged other cycles—"Memory of Hofman", "Easter Reminiscences"—and the series wove through memories of lost friends and childhood, following the passages of a grand design.

In connection with his own work, Sudek first used the term "labyrinths" in 1968. Perhaps it was an inspiration or, just as possibly, he cheerfully appropriated it from an artist friend, Vladimír Fuka, who used it in his own work as early as 1964. As Sudek was fond of saying, everyone has to "pick his plums somewhere." In his sweeping overview, Sudek's "Labyrinths" extended from 1948 through 1973, virtually until the end of his photographic career. Within these were various other groupings, such as "Paper Labyrinths" and "Glass Labyrinths" from 1968 to 1972. "Labyrinths" is a monumental autobiography of memories, dreams, relationships, moments of beauty heard and seen: a narrative of intimate, shimmering symbols scaled to a mythic universe.

By the mid sixties, fashionable trends that had dislodged the public's loyalties were spent. In 1964, Prague's Artia Publishers issued an international edition of a monograph of ninety-six of Sudek's most poetic images from the "Windows," "Gardens," "Still Lifes," and "Prague Parks" cycles. Translated into French, German, and English, Jan Řezáč's introductory essay described Sudek as:

One of the artists to humanize the inanimate objects of his nonconforming environment and thus to overcome man's alienation. . . . Society's problems and struggles, without which modern sensibility would be sterile, are transformed by him into wonder and admiration for life's simple things, whose elusive beauty is almost impossible to capture. Josef Sudek transports us to the long-lost magic of childhood, love, and poetry. Sudek's photographs are a certain dark uncertainty.

Řezáč also unabashedly called Sudek "one of the greatest photographers of all time." That claim slowly, inexorably gained support, first in the United States and subsequently in Europe.

In June 1967, Sudek was invited to participate in the exhibition *Five Photographers,* organized by the University of Nebraska, along with Eikoh Hosoe, Bill Brandt, Ray K. Metzker, and John Wood. Bullaty helped with this show, and also with the publication of his photographs in *Infinity* magazine. Other major magazines in the United States and Europe soon opened pages to Sudek's images, and he was called upon more and more to send prints for exhibition.

He also continued an active commercial business that included photographing the works of painters and sculptors as he had always done, as well as commissions for calendar photographs, and other projects. No other photographer in the country enjoyed his official status, and perhaps no other worked as hard, well into his seventies. And still, after a long day's shooting, he would attend a concert. There, in some favorite hidden spot, he entered into a trancelike state, waving his hand or even humming along with the music to the occasional annoyance of his less entranced neighbors. The next morning, he would be preparing for exhibitions, or out shooting again, working on a last gift for his countrymen, at home or in exile.

For twenty years, Sudek had been photographing in the great, untamed Mionší Forest Preserve. But it wasn't just the decaying trees, their sculptural quality and otherworldly resonance that drew him there, it was the haunting music he felt coursing through the landscape—especially the music of Leoš Janáček. Sudek had widened his photographic expeditions to include the countryside around Janáček's village, Hukvaldy, and ultimately, the composer's home. His greatest tribute to this composer was published as *Janáček-Hukvaldy,* in 1971. Discussing his introduction to Janáček's music, Sudek reminisced with Karel Soukup around his eightieth birthday in 1976:

With Janáček, I wasn't sure whether the orchestra was just tuning or playing for real at first, but I kept telling myself: "Listen, if it's considered so great, maybe it's you who is stupid. There must be something in it!" And so I went to see Jenufa again and again. And then, the fifth time in a row, it was as if the curtain rose in the middle of the second act and the musical mess was gone. . . . Suddenly I began to hear all those melodic lines and I told myself: "Hell, so this is what's so great about it!" And I became quite obsessed with Janáček.

Janáček-Hukvaldy, according to the musicologist Jaroslav Šeda, was not a book, "but a poem inspired by Sudek's love of Janáček and his engrossing, enrapturing music. When he first visited Hukvaldy and the pastorally balladic, tender, as well as rough and wild countryside, he immediately knew it was the visual image of Janáček's music."

Springtime was Sudek's favorite season, and as the trees burst into leaf and Prague came into flower, the music, by 1976,

Josef Sudek at his retrospective exhibition, a few months before his death in 1976.

was flowing into a graceful coda. The Tuesday evening salons had come to an end, and although friends still called, Sudek's strength was ebbing: drop by drop he was bleeding to death from a small internal tumor. Still he was full of plans for exhibitions and projects. And there was one final visit to the scene of his childhood. On September 4, after some hesitation, he decided to attend an exhibition of Jaromír Funke's photography in Kolín, where they had met and become close friends more than a half-century earlier. On a beautiful summer afternoon, he visited the graves of Funke and of his long-dead mother and

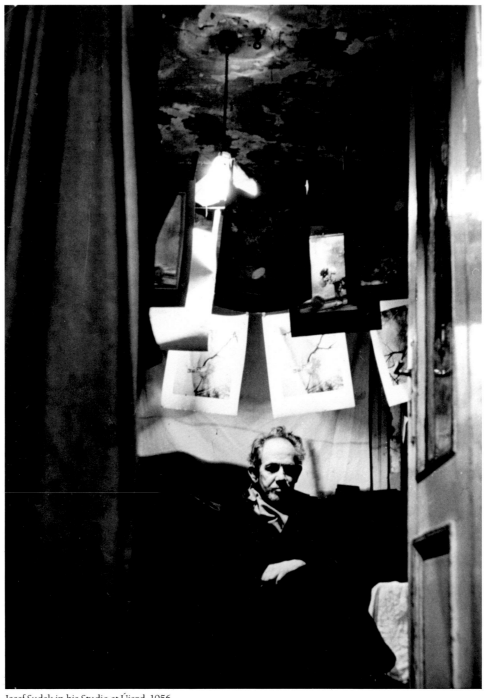

Josef Sudek in his Studio at Újezd, 1956.

father. In less than two weeks, Sudek was laid to rest beside them.

When Sudek's material was being catalogued, a photograph he had made of pages from a book, its author not given, was discovered—perhaps his final poem of love and light:

Yet, love, mere love, is beautiful indeed
and worthy of acceptance. Fire is bright,
let temple burn, or flax. An equal light
leaps in the flame from cedar-plank or weed.

And love is fire, and when I say at need
I love thee ... mark! ... I love thee! ... in the sight
I stand transfigured, glorified aright,
with conscience of the new rays that proceed
out of my face toward thine. There's nothing low
in love, when love the lowest: meanest creatures
who love God, God accepts while loving so.
And what I feel, across the inferior features
of what I am, doth flash itself, and show
how that great work of Love enhances Nature's.

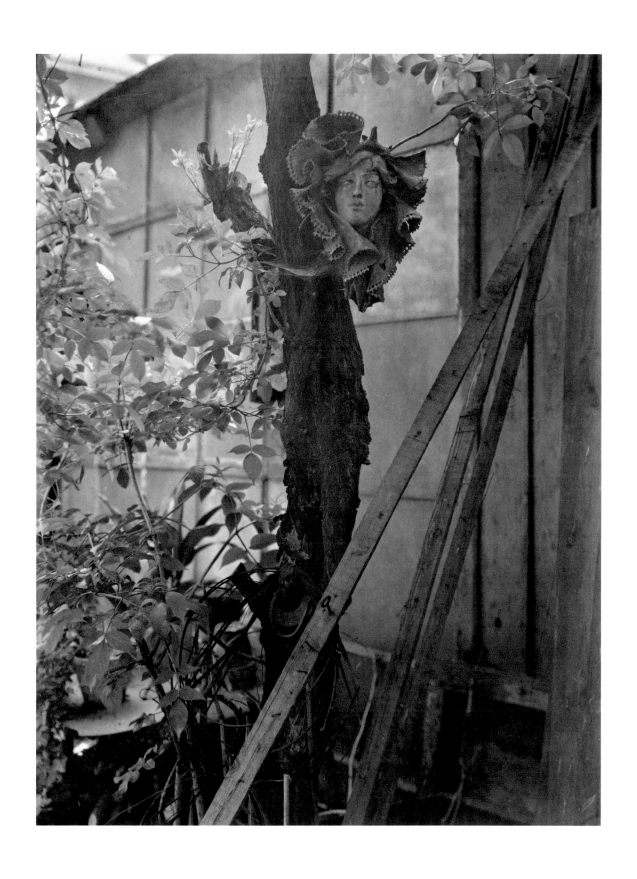

A Deepening Vision: The Later Photographs

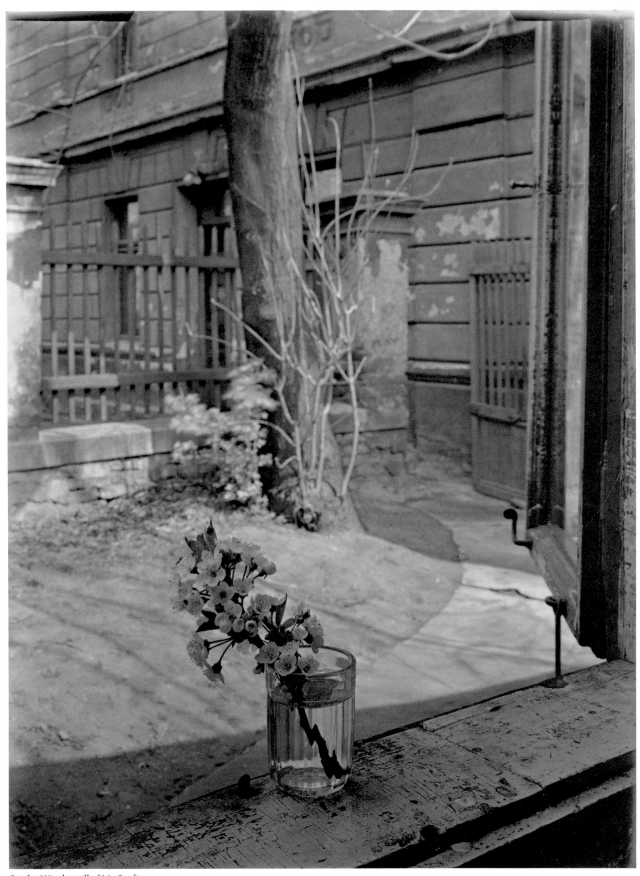

On the Windowsill of My Studio.

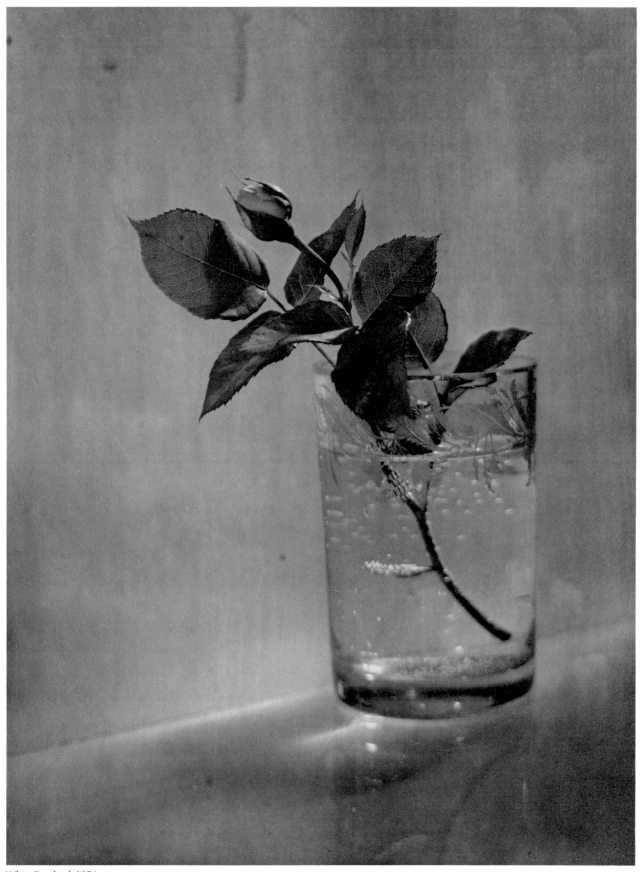

White Rosebud, 1954.

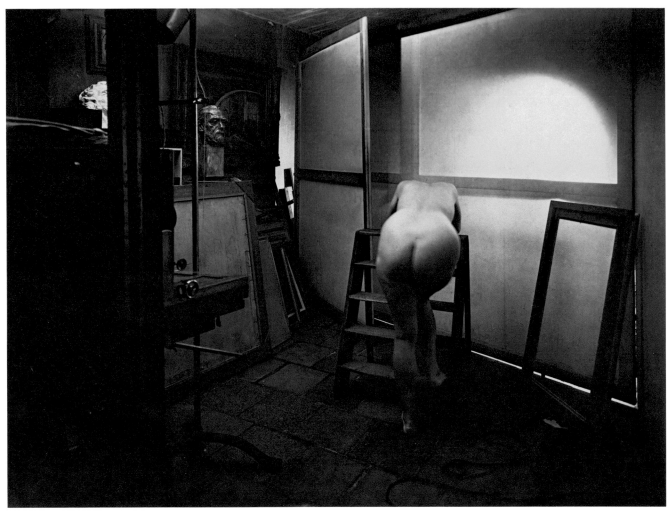

My Studio, 1951-54.

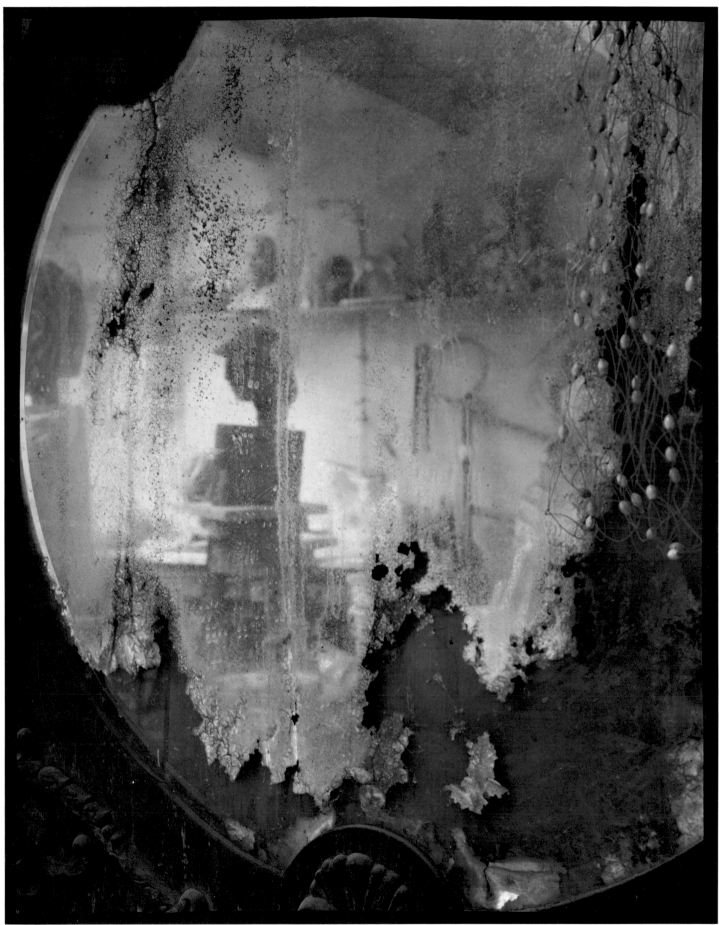

Reflection.

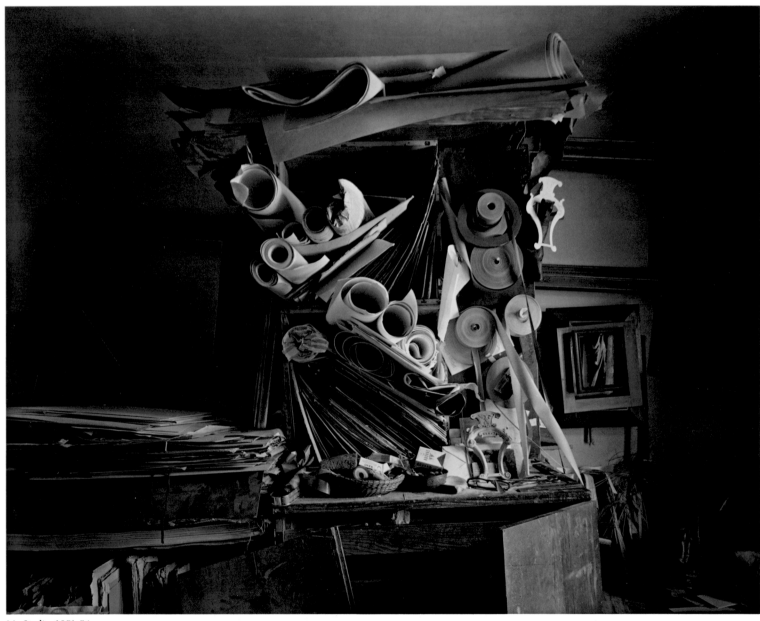

My Studio, 1951-54.

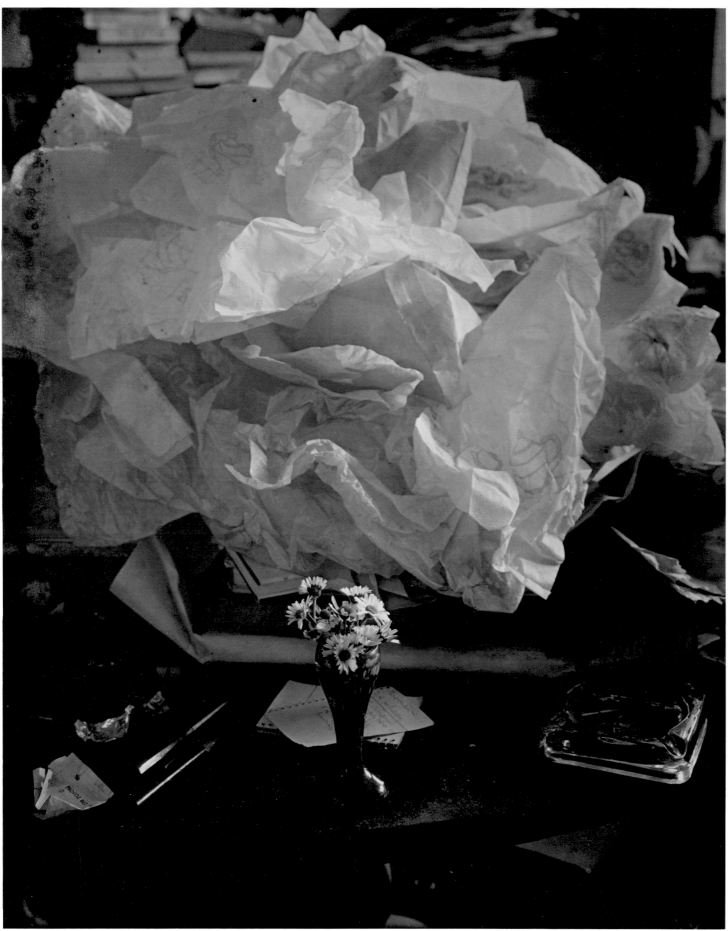

Memory of Hofman, 1975.

I have no particular leaning toward . . . the all-too-clearly defined; I prefer the living, the vital, and life is very different from geometry; simplified security has no place in life.

Memories, Lovers, IV Variations, 1948-64.

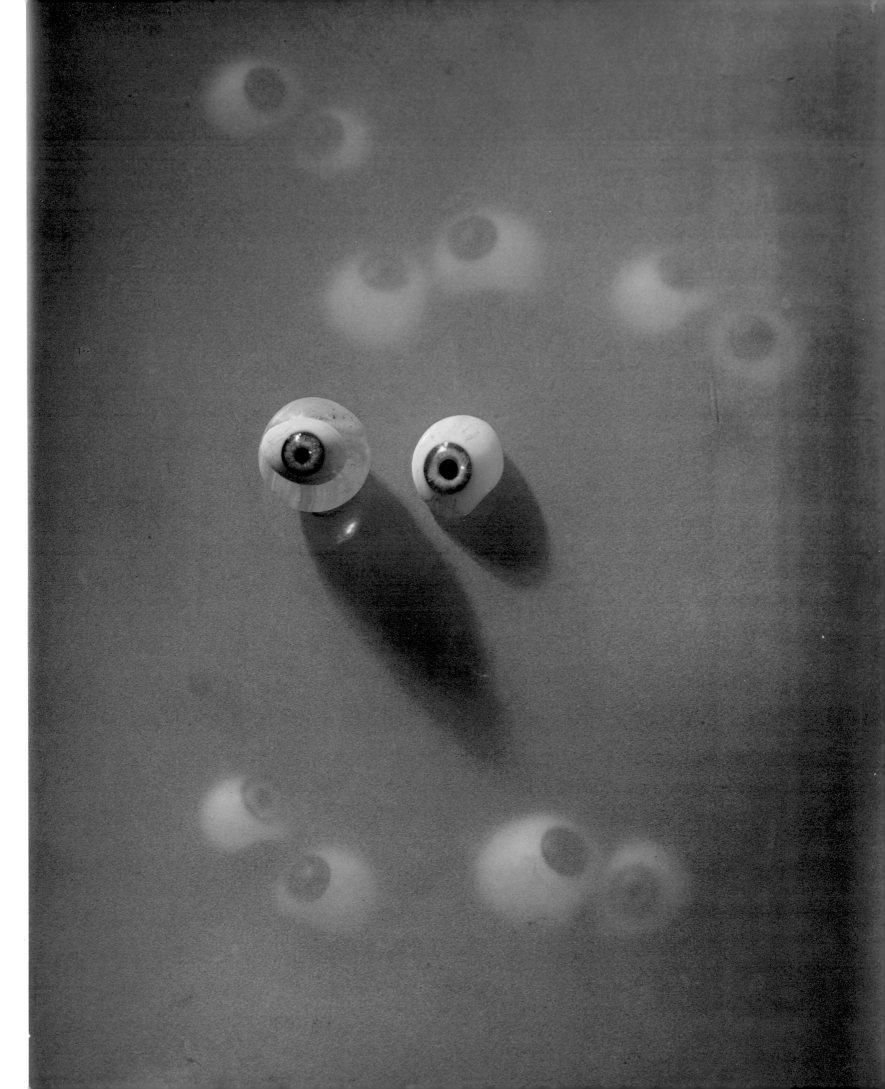

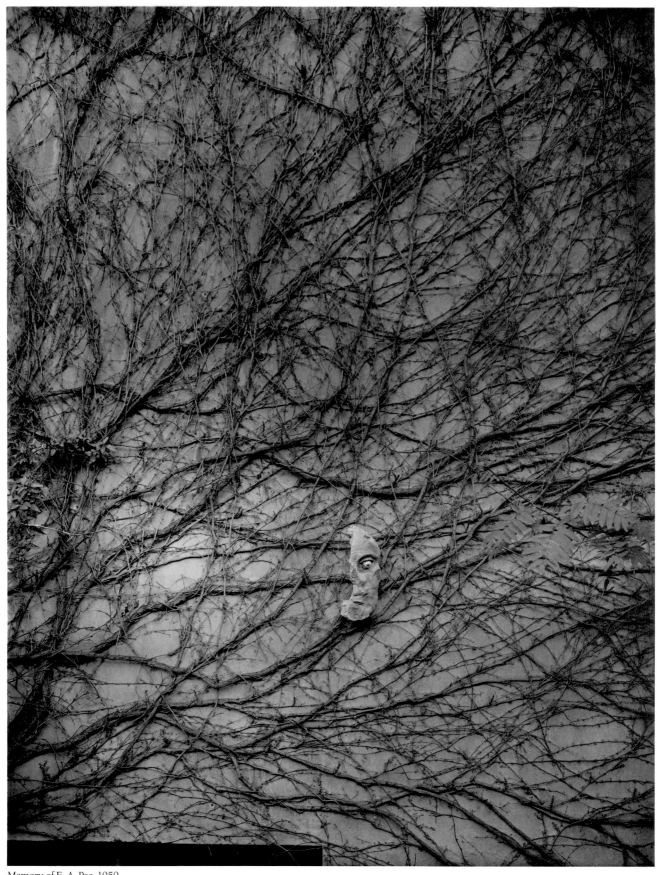

Memory of E. A. Poe, 1959.

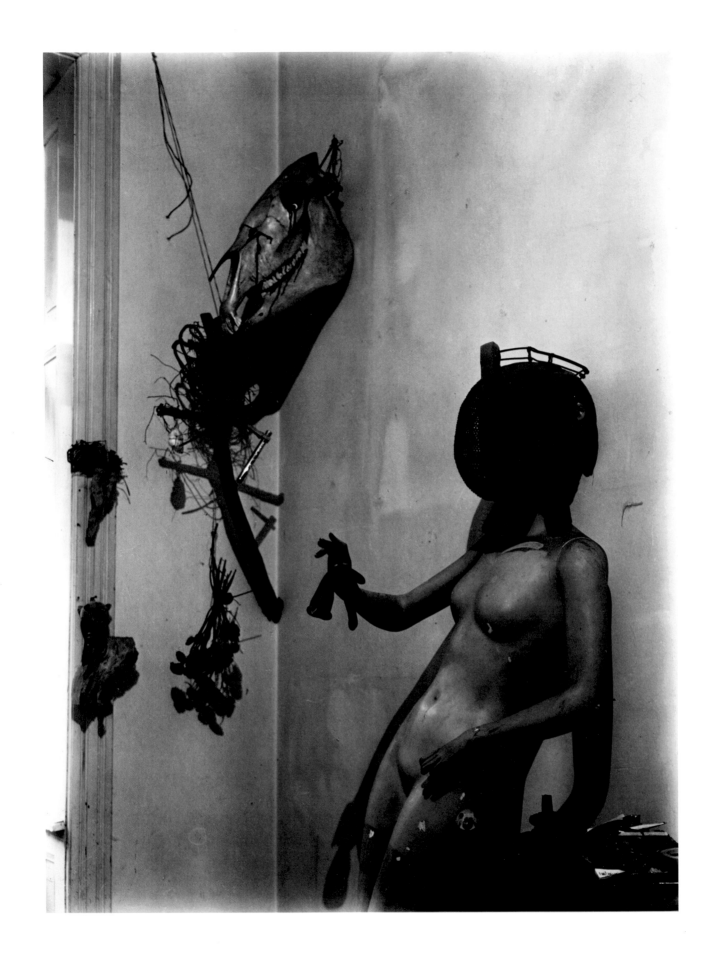

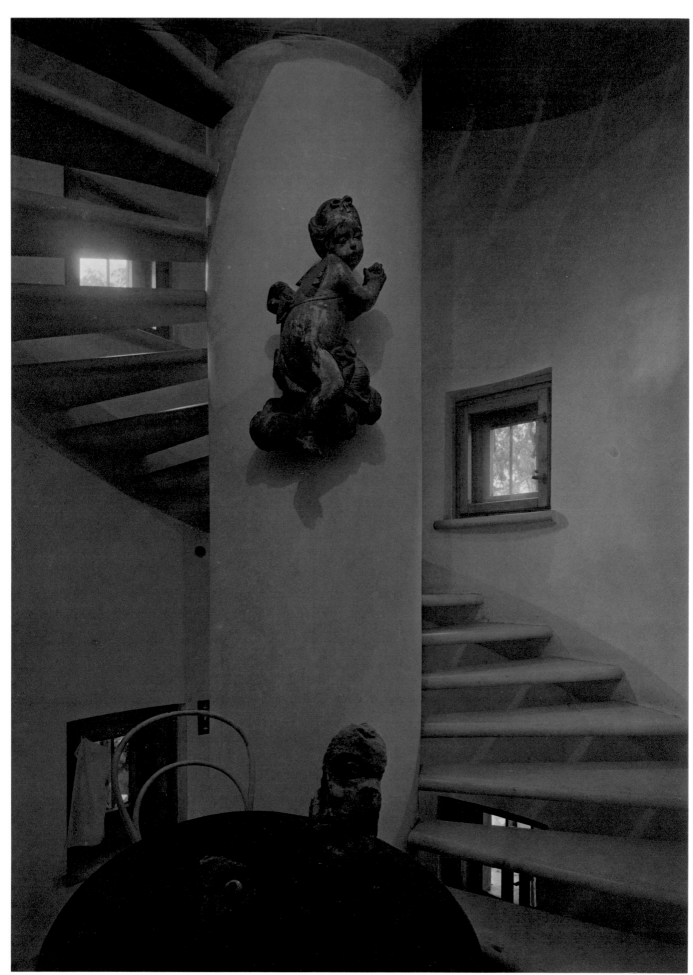

The Staircase of Rothmayer's House, ca. 1943. Opposite: My Garden, 1969-70.

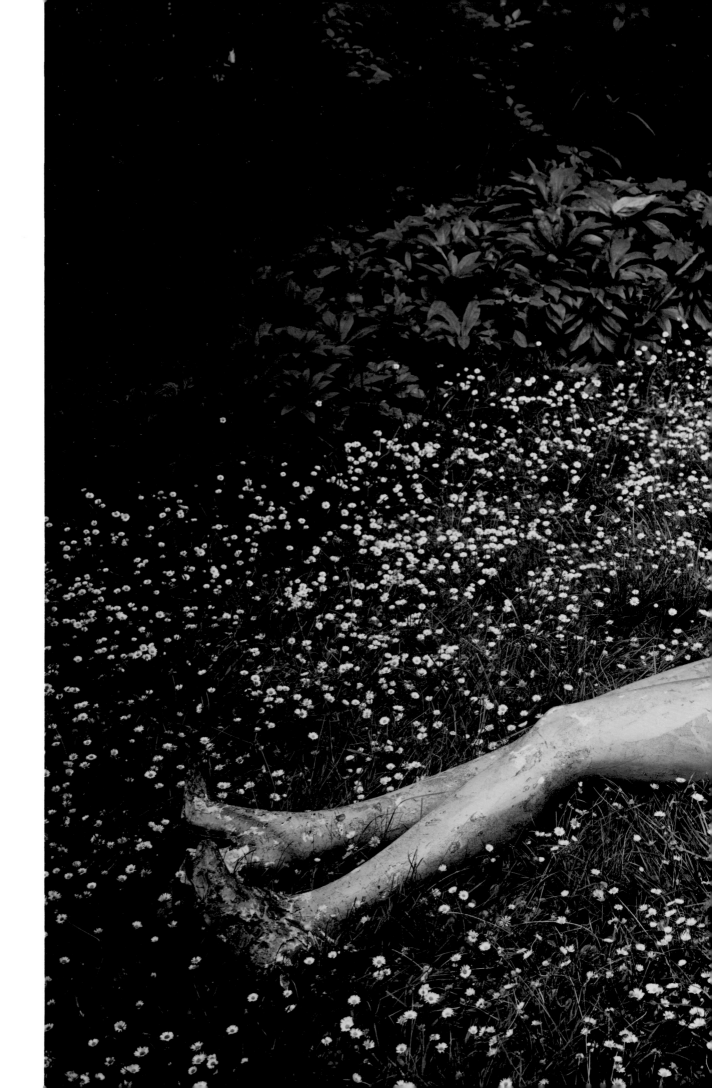

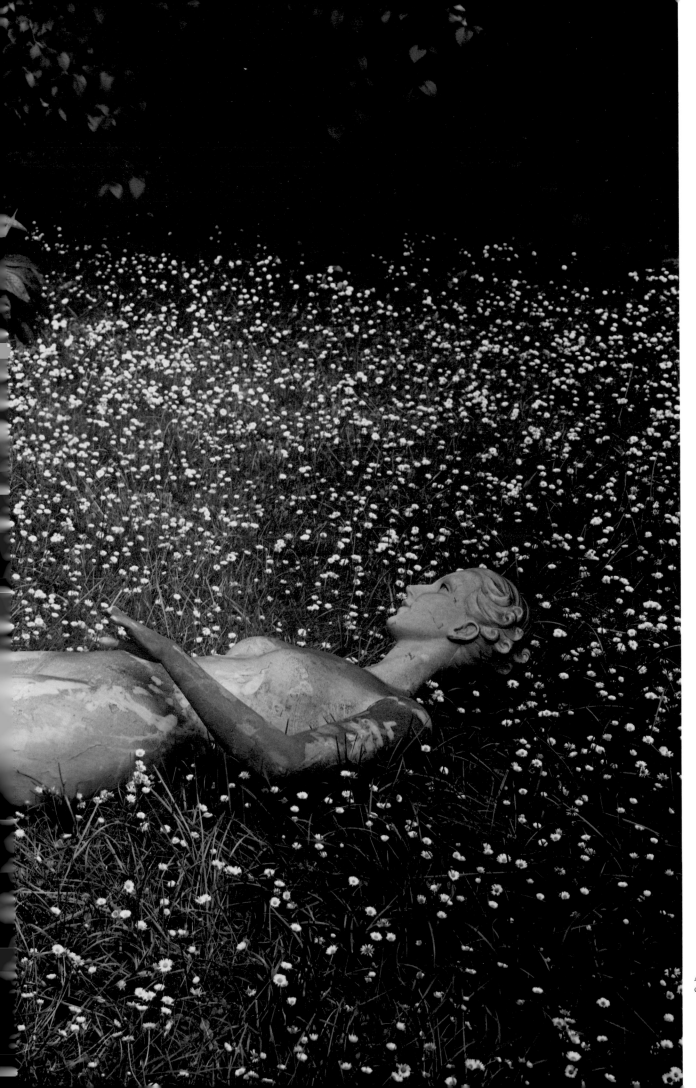

A Mannequin
on the Lawn.

Notes from the Garden of the Lady Sculptor, 1957.

My Garden. Page 110: The Garden of the Lady Sculptor, 1953-57. Page 111 : Malostranský Cemetery.

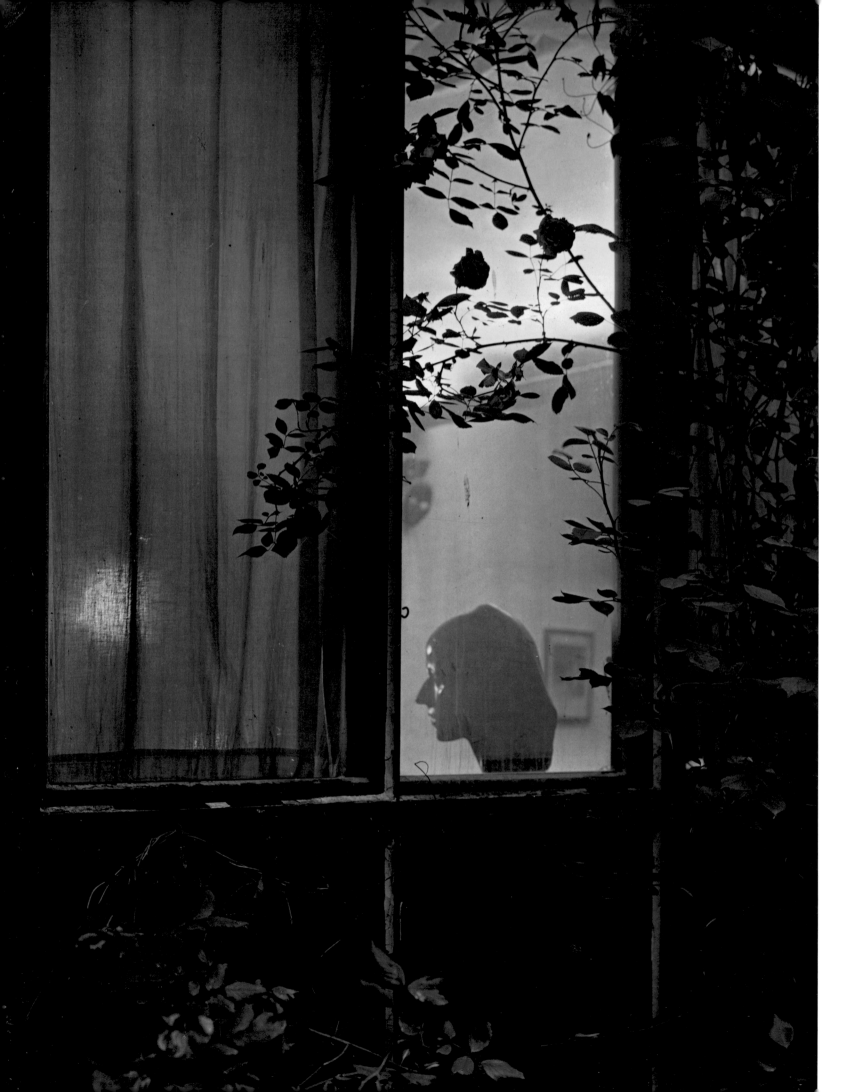

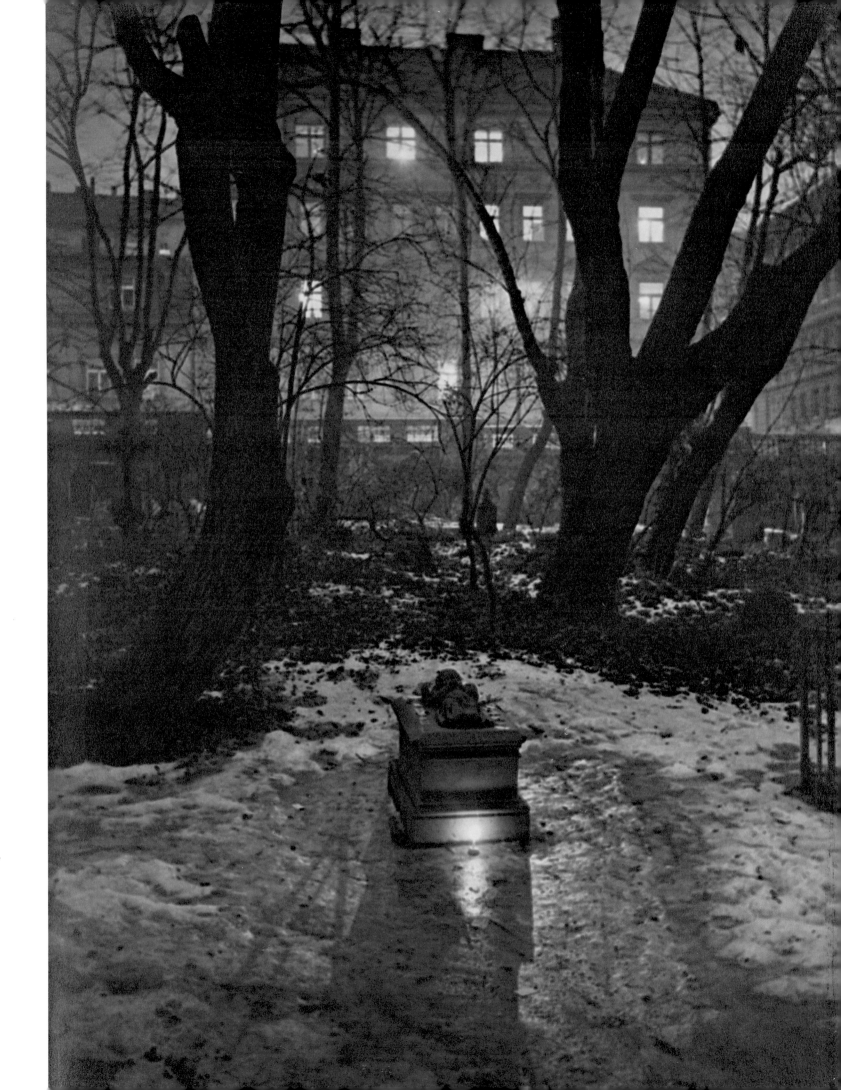

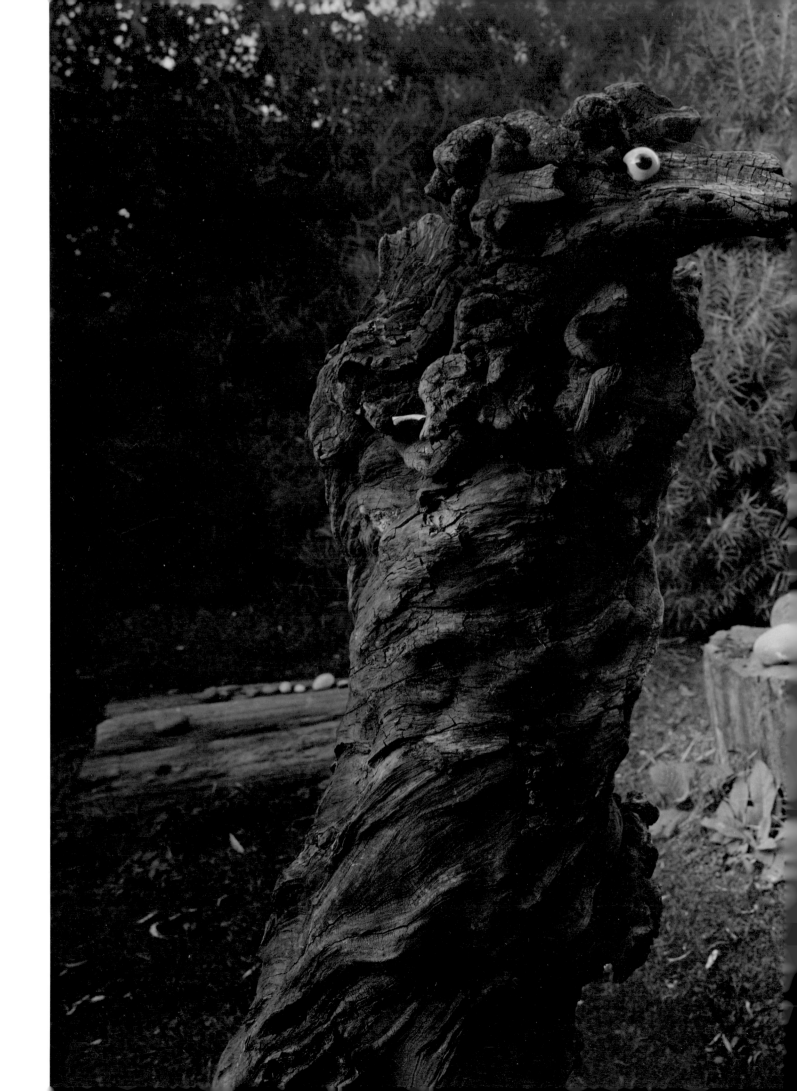

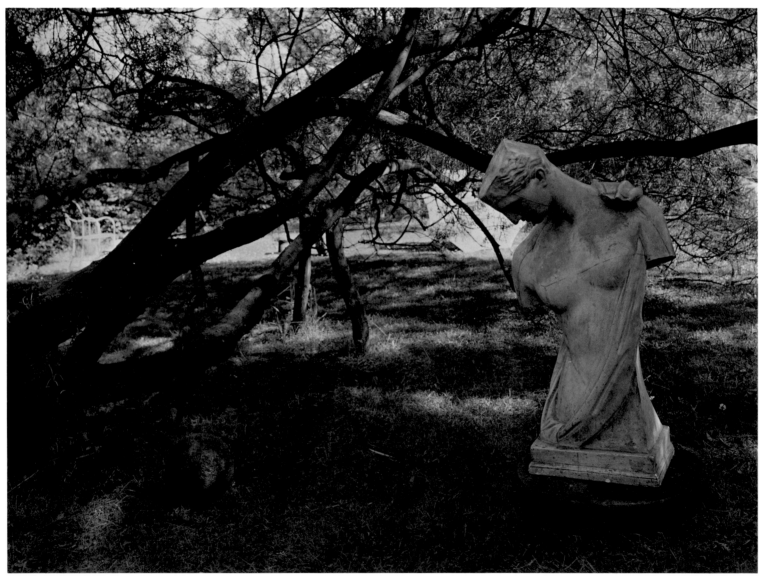

A Walk in the Magic Garden–Rothmayer's Garden, 1954-64. Opposite: A Walk in the Magic Garden–Rothmayer's Garden, 1955.
Page 112: A Walk in the Magic Garden–Rothmayer's Garden, 1959.

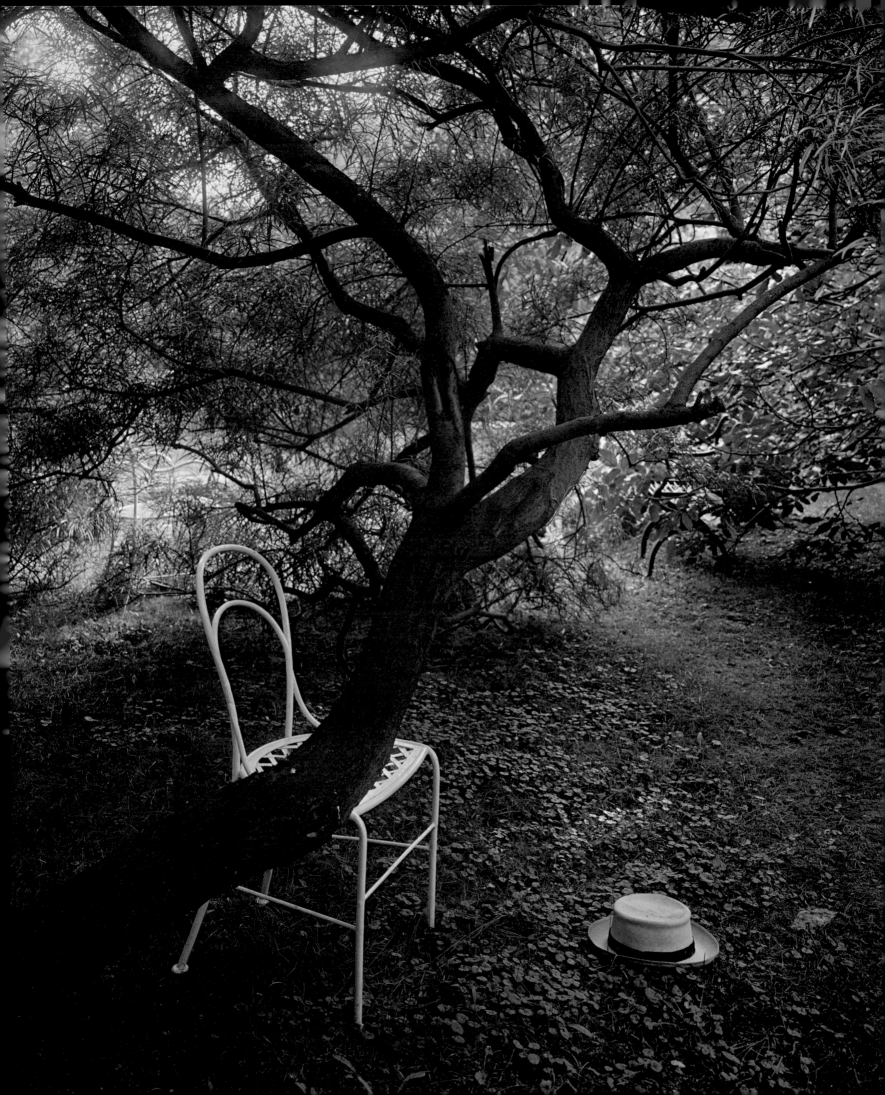

Lovers, 1960.

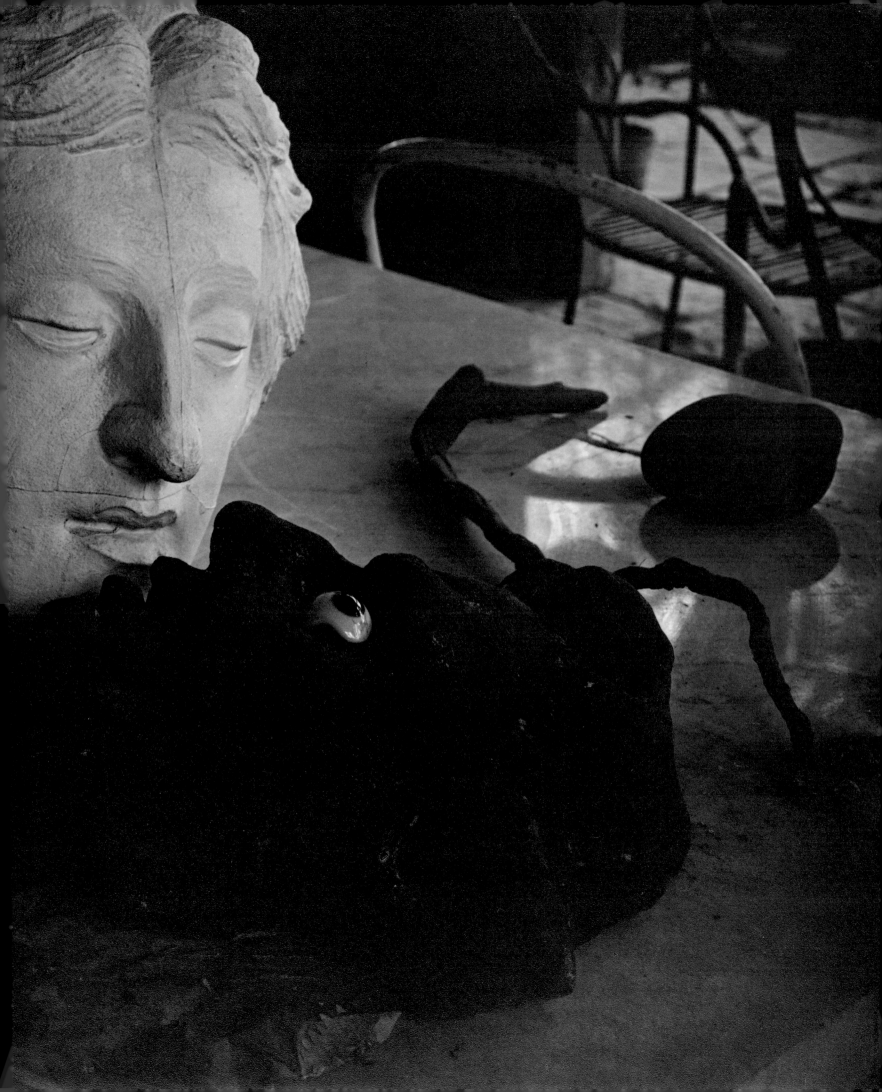

A Walk in the Magic Garden
– Rothmayer's Garden, 1954-64.

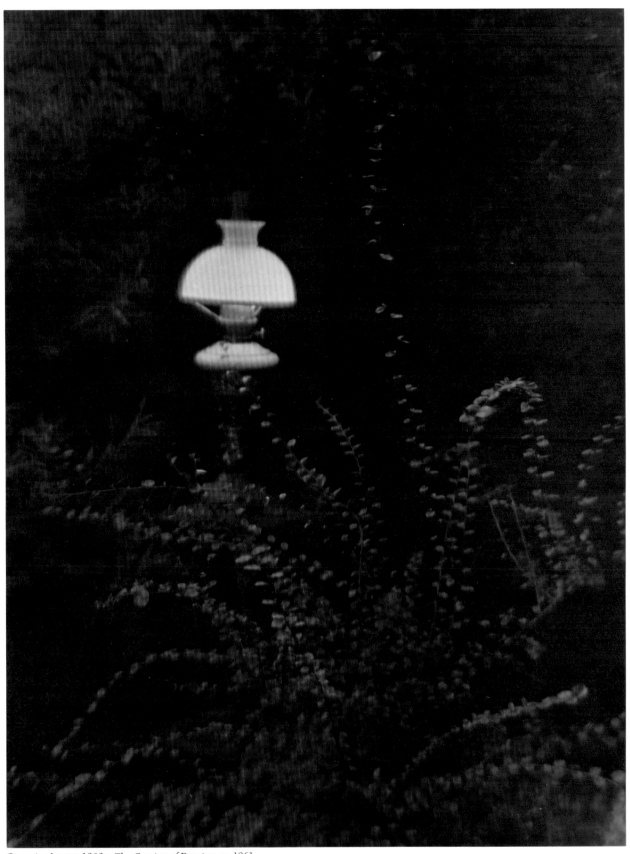

Opposite: Lovers, 1960. The Coming of Evening, ca. 1961.

I don't have many people in my photographs, especially in the landscapes. To explain this, you see, it takes me a while before I prepare everything. Sometimes there are people there, but before I'm ready they go away, so what can I do, I won't chase them back.

Vanished Statues in Mionší, 1969.

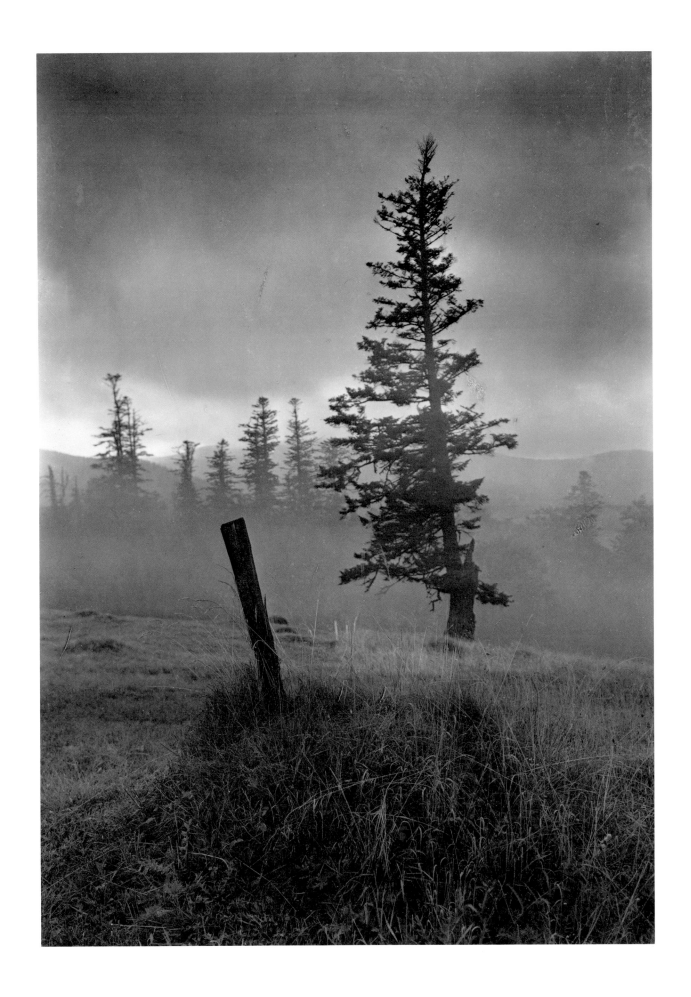

Vanished Statues in Mionší, 1952-70.

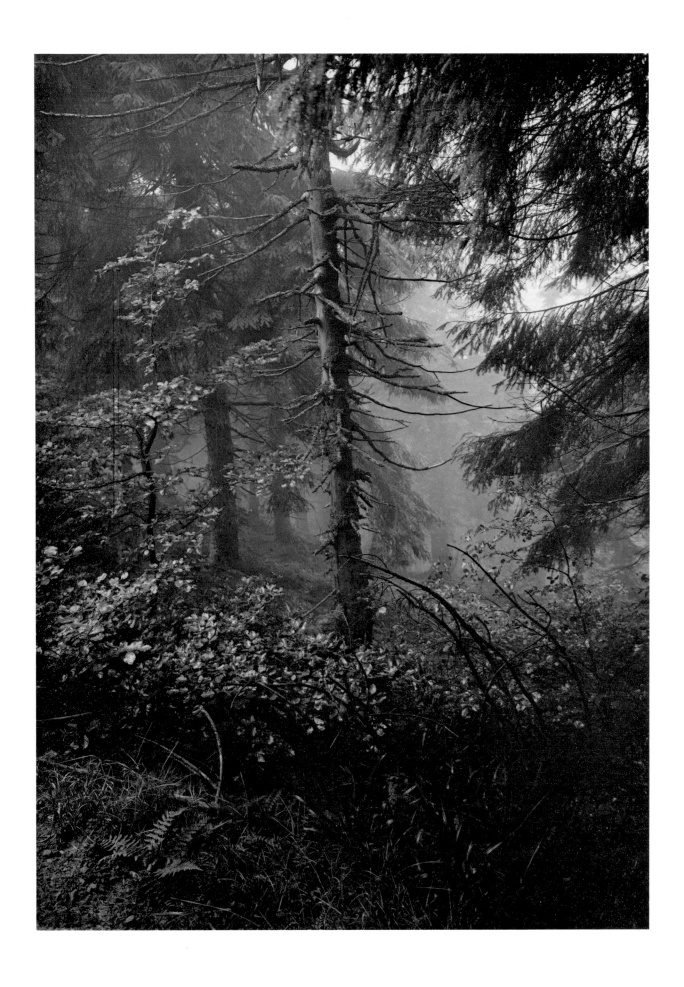

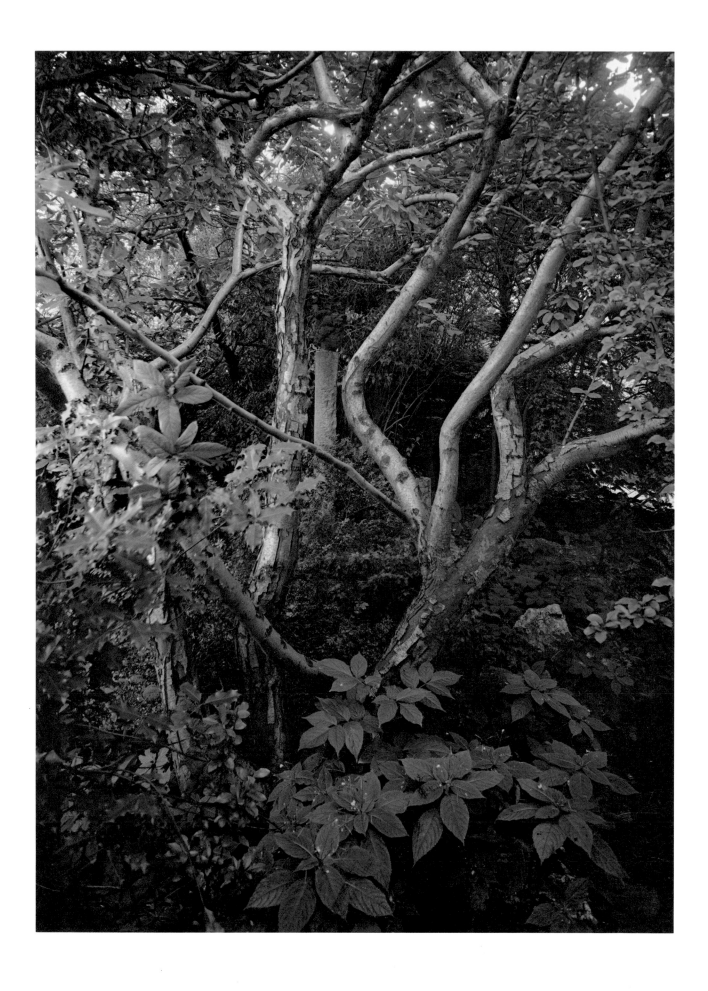

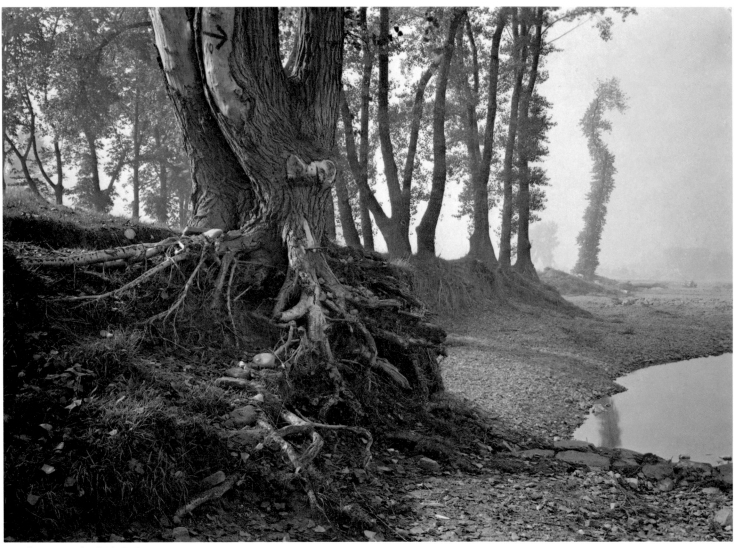

A Walk on Troja Island, 1940-45.

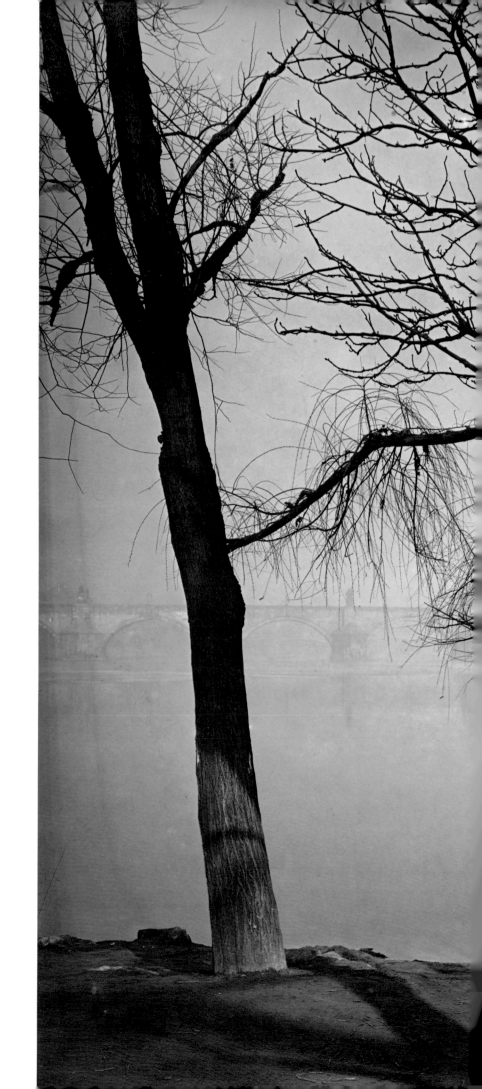

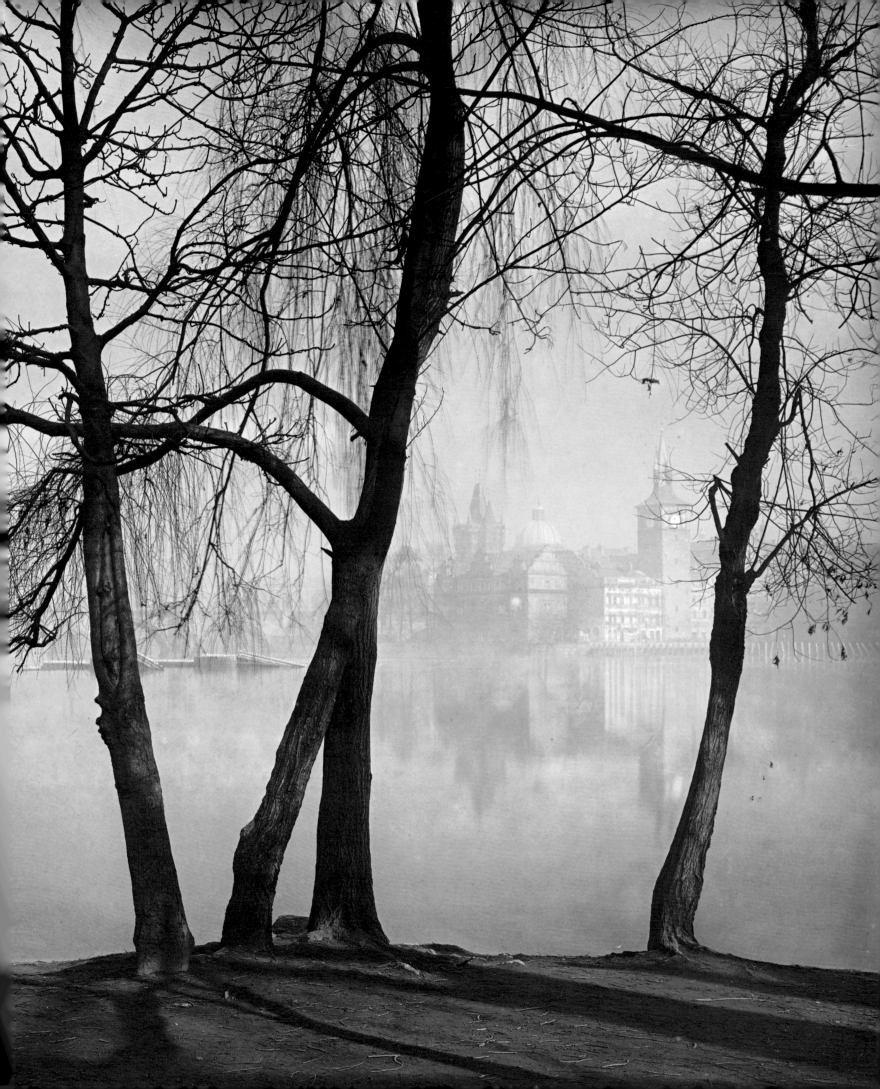

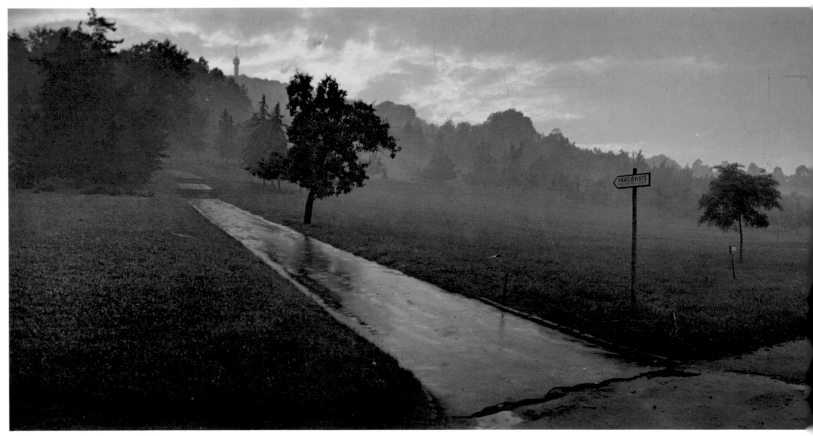

Early Evening in the Seminary Garden.

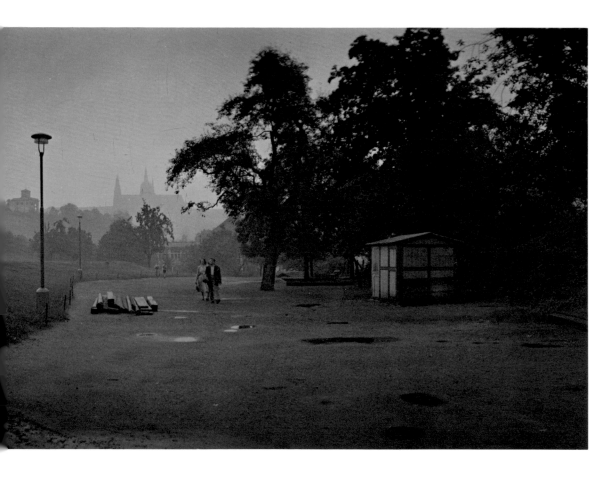

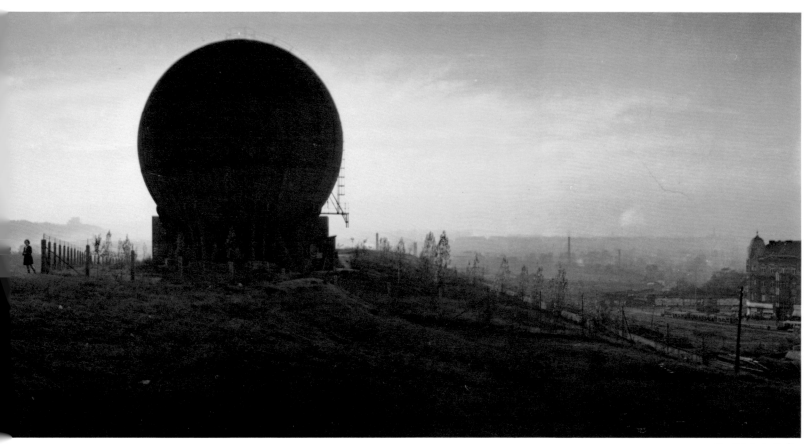

Gas Works in Karlín.

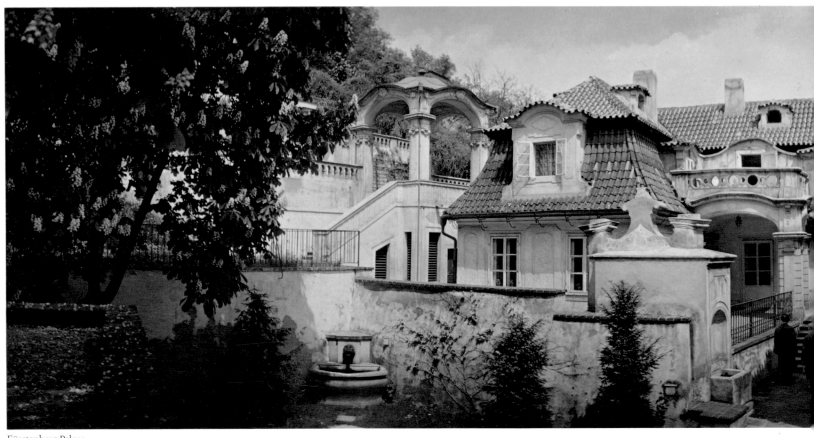

Fürstenberg Palace.

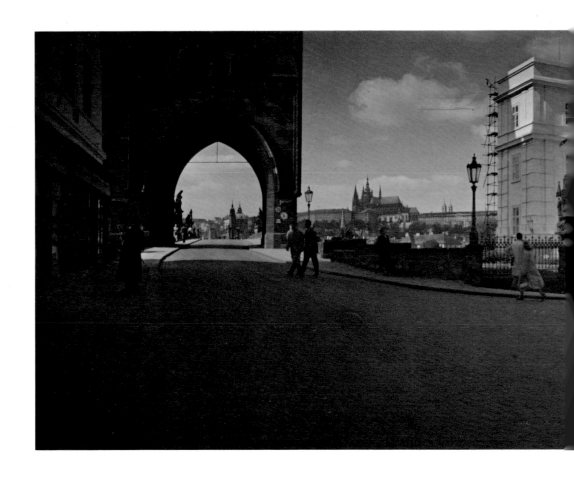

Křižovnické Quay.

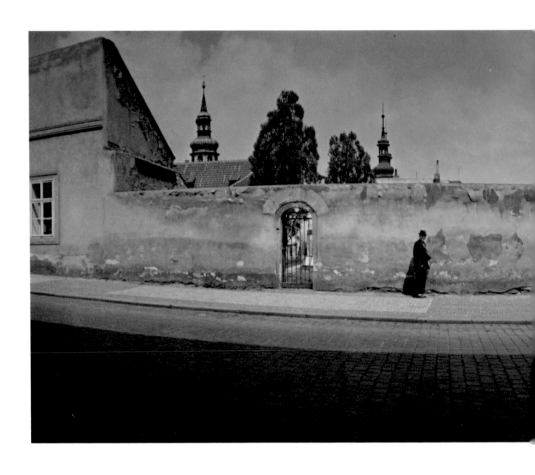

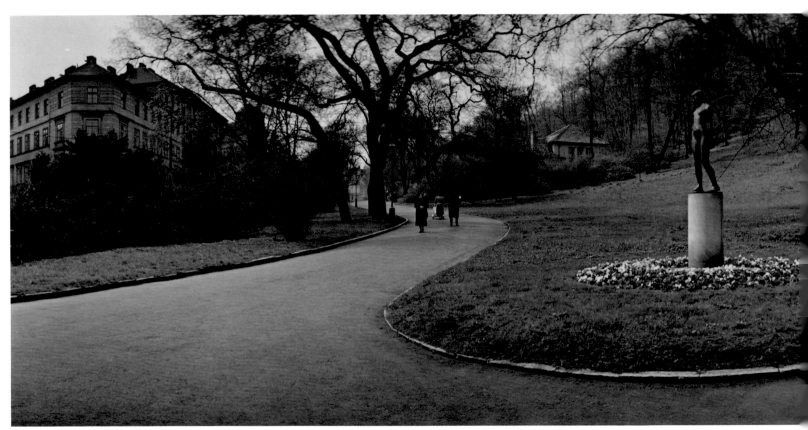

Spring in the Kinský Garden, 1948-54.

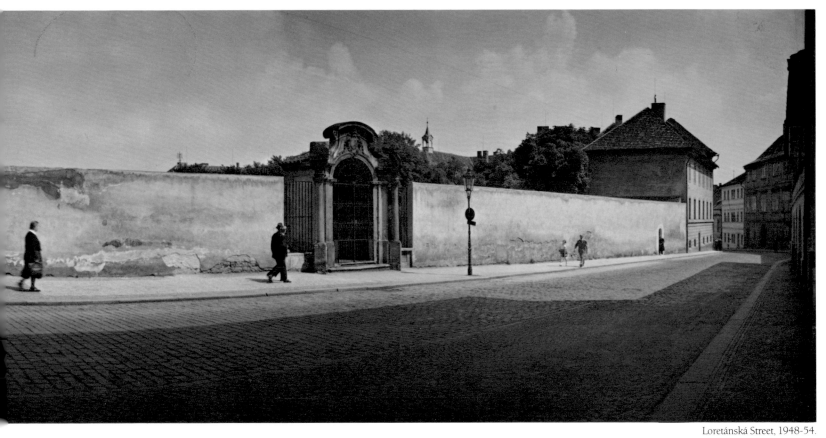

Loretánská Street, 1948-54.

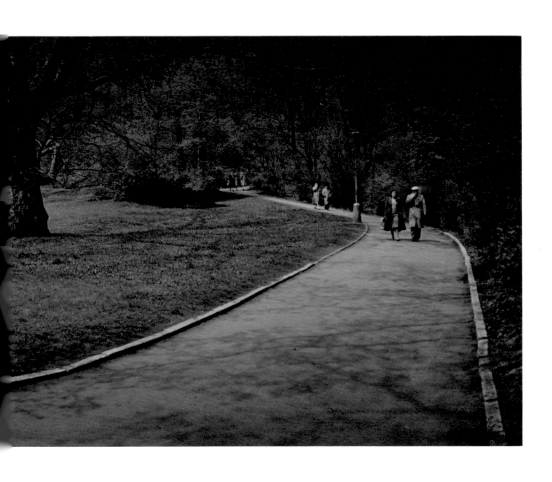

St. Mathew's Fair.

At the Ferry.

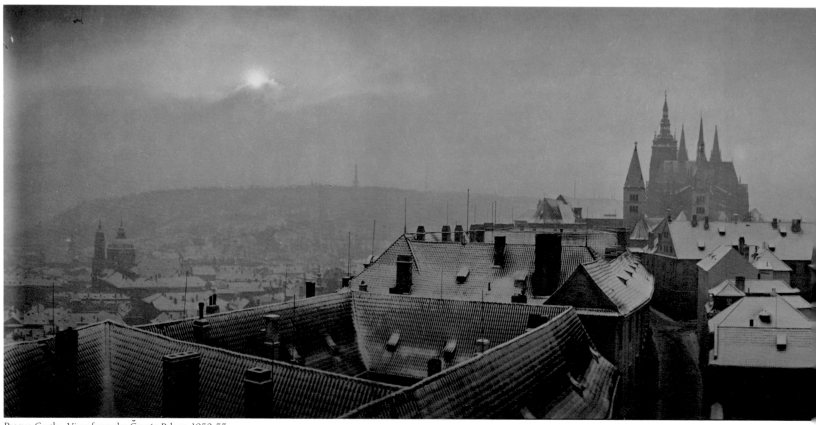

Prague Castle—View from the Černín Palace, 1950-55.

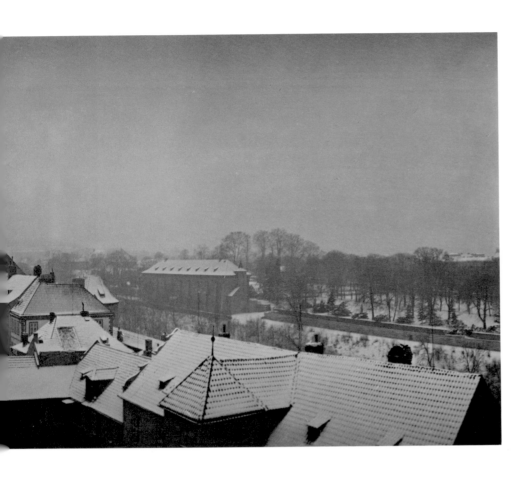

Středohoří, 1948-51(?)

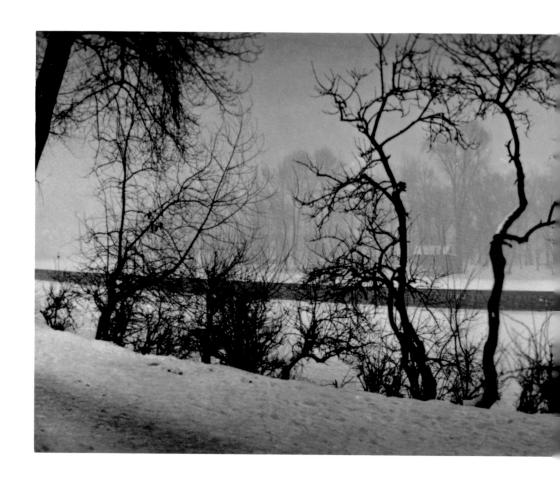

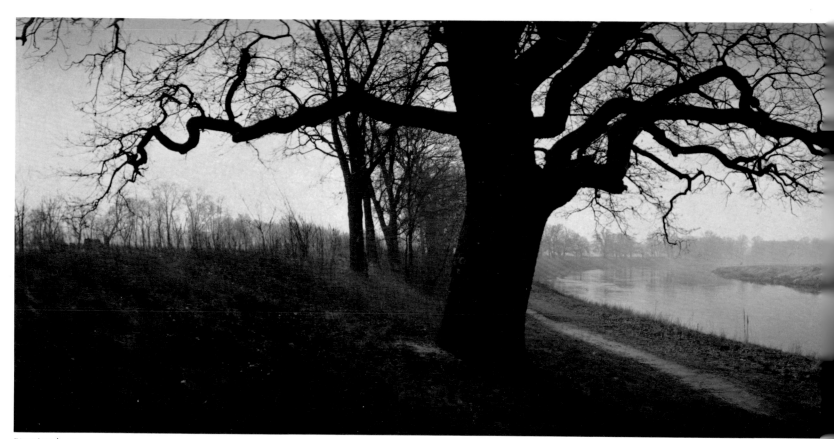

River Landscapes.

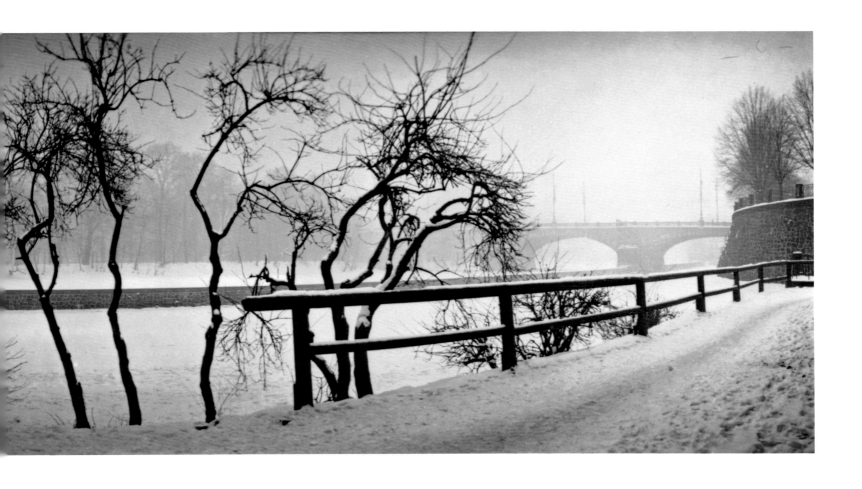

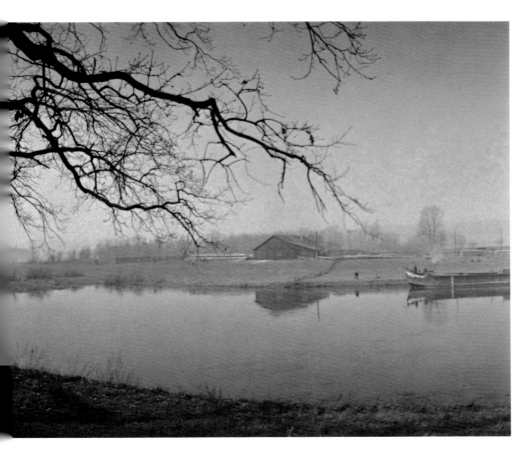

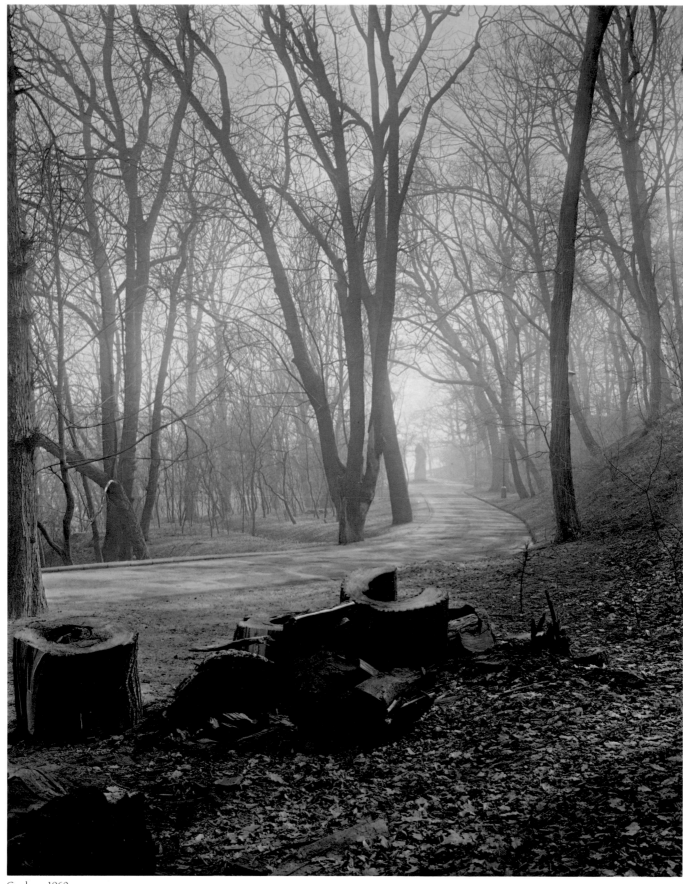

Gardens, 1960s.

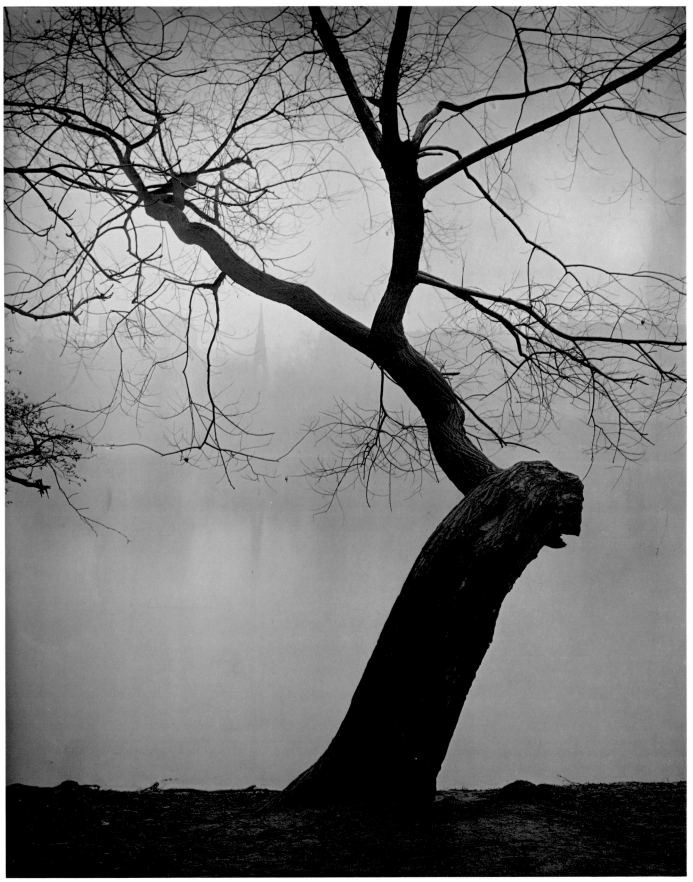

From Střelecký Island, 1946-66.

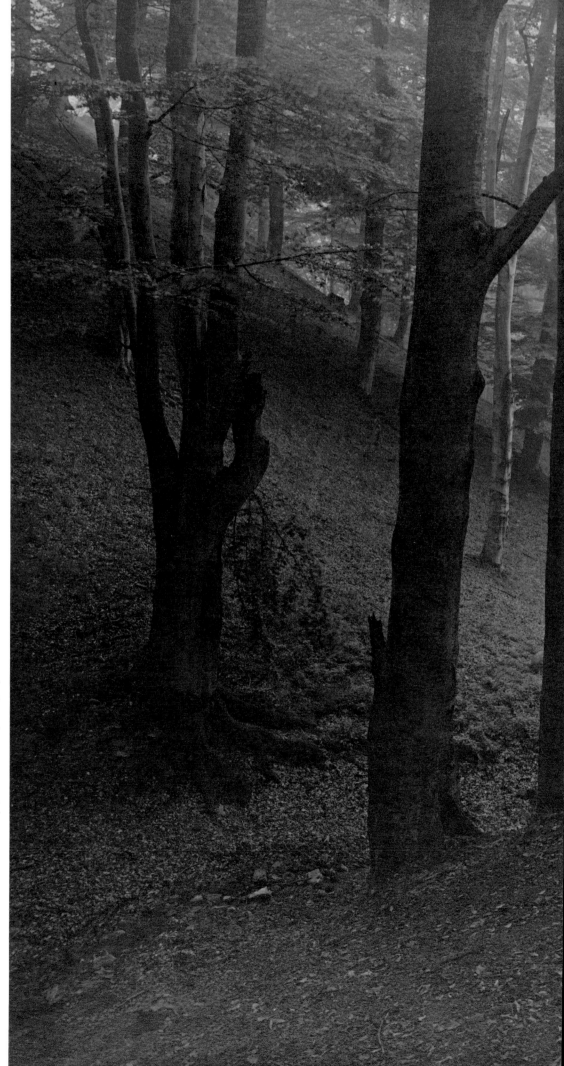

What would I be looking for when I didn't find what I wanted to find? At most I travel to Moravia to the region of Leoš Janáček, his Hukvaldy—but here I am again, talking about music. In music you find everything. . . . Music has to be inside you.

Forest Path Leading to the Lair of the Cunning Little Vixen–Janáček-Hukvaldy, ca. 1948.

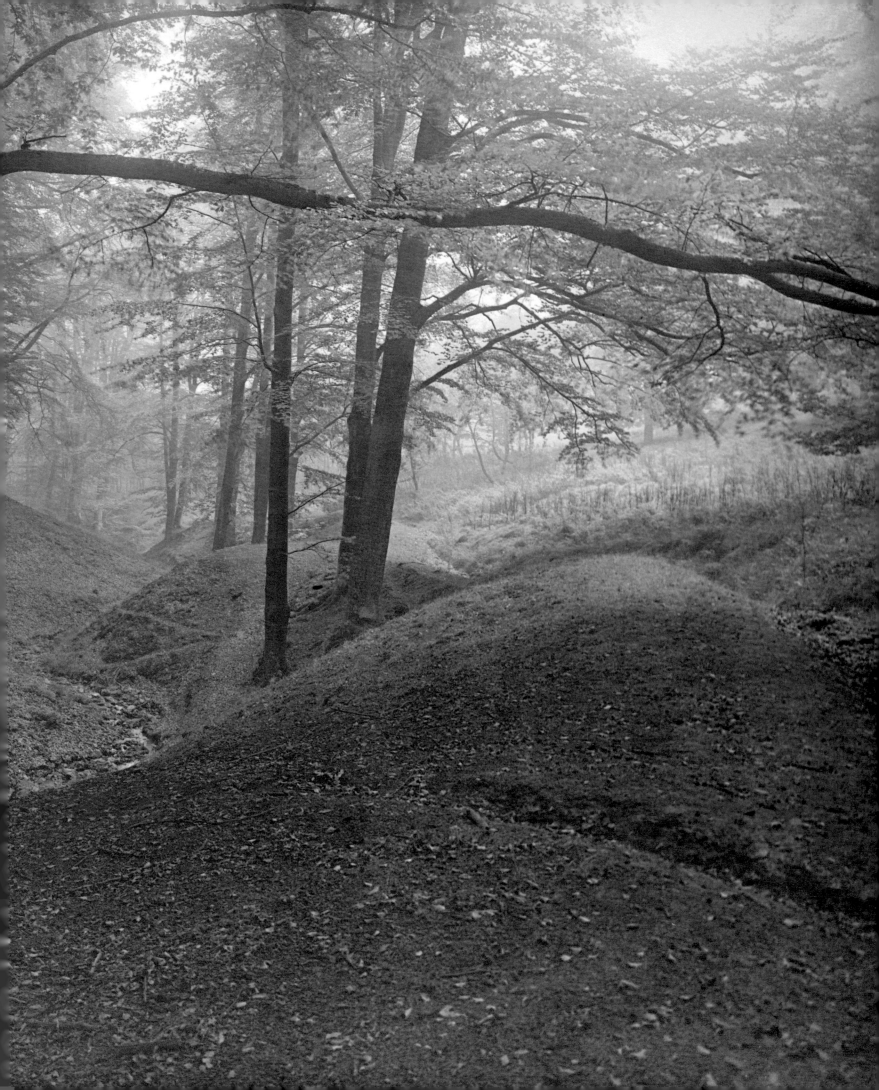

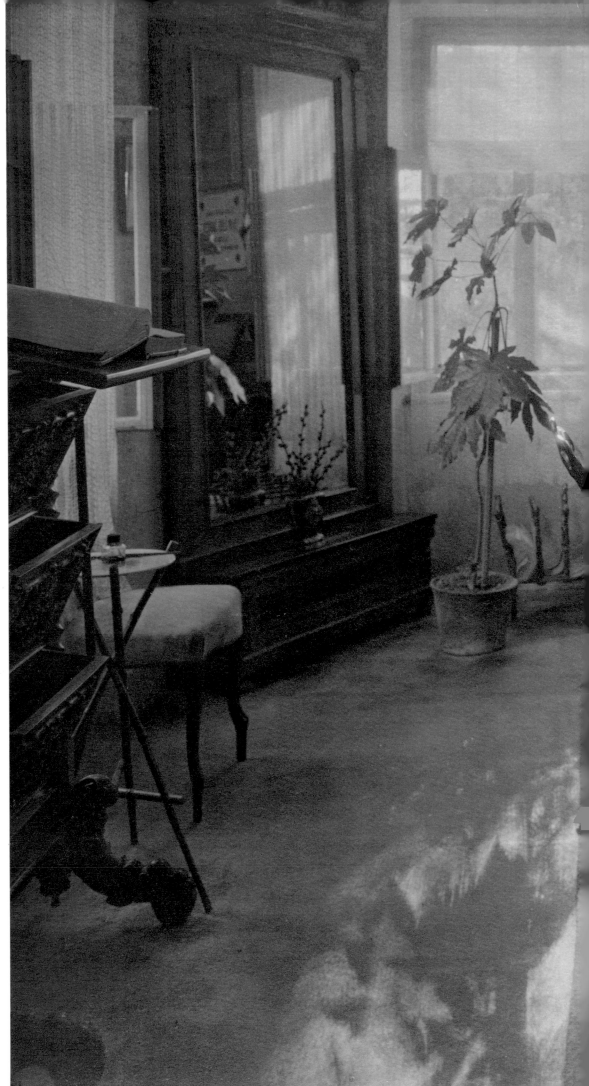

Interior—Janáček-Hukvaldy, 1948.

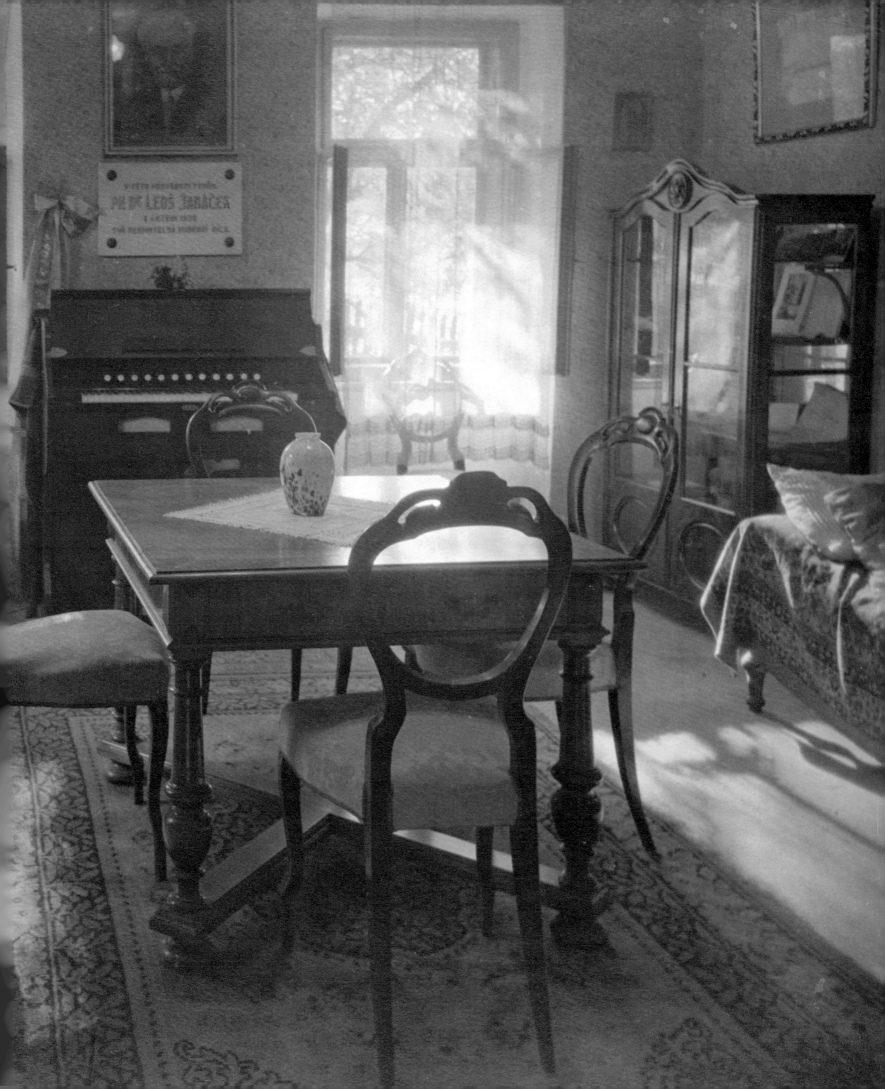

Early spring is at my window and so I go a bit to the gardens to see how spring is awakening. Till now Saint Peter has conducted everything very well and so maybe he'll succeed and it won't run away with itself too fast. . . . Maybe it's just an attack of spring fever—it will last about two weeks and after that I'll start to think straight again.

My Garden.

My Studio, 1950-54.

Afterword

I met Josef Sudek for the first time soon after World War II when my father, a musicologist, brought me along to one of Sudek's famous "music Tuesdays." Every week for many years, about fifteen of Sudek's artist friends crowded into his incredibly cluttered studio and listened to music from his extraordinary record collection. Sudek was an integral part of the cultural life in Prague, peppering it with his artistic personality as well as his unusual appearance: he reminded me of the gargoyles of St. Vitus cathedral, of the baroque statues on the Charles Bridge.

Over the years, as I began to feel closer to Sudek and protective of his privacy, I was a guide and interpreter to many visitors interested in his work. Slowly, unwittingly, I became more deeply involved in the story of Sudek's life, and eventually his death. Whenever he looked at me, stressing the point with the forefinger of his one hand, he would say "One day, this will be a lot of work for thee." In 1976, I organized a retrospective exhibition honoring Sudek's eightieth birthday, and our friendship grew even stronger. When he died later that year, I found myself not only taking care of Sudek's burial, but also helping his ailing sister, Božena Sudkova. Professionally, my involvement was even more unpredictable and demanding.

My first task was to go through the chaotic and nearly impenetrable layers of material accumulated in Sudek's second studio at Úvoz. From this work emerged a valuable contribution, donated to Prague's Museum of Decorative Arts in the name of Sudek's sister. In 1985, the photographer's original studio at Újezd began collapsing; then fire broke out. After that incident, I realized that the archival contents of the studio could only be saved through my intervention. During the following three years of salvaging, cleaning, and sorting the overwhelming amount of material, I discovered many new details of Sudek's life from old papers, photographs, and documents.

I've spent the last twelve years researching and classifying the contents of Sudek's two studios, deciphering his legacy. Since 1977, external circumstances, or my fate, forced me to do my research unnoticed, unacknowledged, and unpublished. Professionally I did not exist, I was a nonperson. Now that I have the opportunity to speak of Sudek's life and achievements, I hope that the fruits of my research will enrich the perception of Josef Sudek as an individual gifted with talent and indomitable spirit, an artist who made a remarkable contribution to twentieth-century photography.

Anna Farova

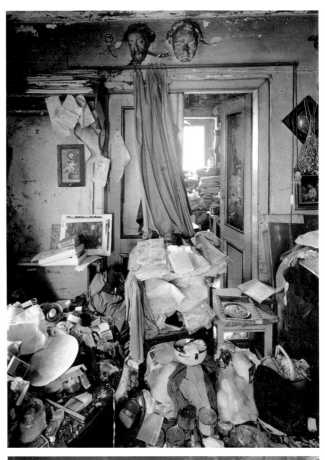

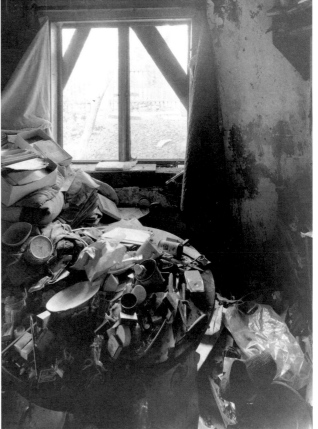

Josef Sudek's Studio at Újezd, 1985.

Exhibition Schedule

Josef Sudek, Poet of Prague: A Photographer's Life is published in a single volume catalog edition to accompany the exhibition of photographs by the same name, organized by the Alfred Stieglitz Center of the Philadelphia Museum of Art, under the direction of Adjunct Curator Michael E. Hoffman. At publication, the schedule is as follows:

March 3 – May 6, 1990
Philadelphia Museum of Art
Philadelphia, Pennsylvania

October 20 – December 30, 1990
North Carolina Museum of Art
Raleigh, North Carolina

March 7 – May 3, 1992
The Toledo Museum of Art
Toledo, Ohio

September 12 – December 6, 1992
The High Museum of Art
Atlanta, Georgia

Acknowledgments

After years of attempting to bring about a major publication and exhibition devoted to the photographs of Josef Sudek, the Philadelphia Museum of Art and Aperture Foundation were benefited by the generous guidance and assistance of Manfred Heiting, board member of the German Photographic Society and Director of the Fotografie Forum, Frankfurt. Mr. Heiting's own collection of Sudek prints, his familiarity with, and frequent visits to Prague, and his longtime friendship with the distinguished curator, teacher, and author, Anna Fárová were invaluable in realizing the successful completion of this unique project.

Anna Fárová, as agent and executrix of the Josef Sudek estate, brought to the project many long, difficult years of organizing, preparing, and analyzing the entire life's work of this great photographer. It was through her efforts and her devotion that this exhibition and publication were developed with such meaningfulness, providing an unprecedented depth of experience of Sudek's life and work.

Dr. Jaroslav Langr, Director, and Dr. Zdeněk Kirschner, Head Curator of Arts and Crafts, allowed access to the Sudek archive at the Uměleckoprůmyslové muzeum v Praze (Museum of Decorative Arts, Prague) and provided a number of important prints for the exhibition. The International Museum of Photography at George Eastman House loaned a panorama for the publication and exhibition.

Sudek's onetime assistant and longtime friend, Sonja Bullaty, whose 1978 book was one of the first English-language studies of Sudek, offered guidance, and made available her extensive correspondence with the photographer.

Anne d'Harnoncourt, Director of the Philadelphia Museum of Art, and Innis Shoemaker, Senior Curator of Prints, Drawings and Photographs, enthusiastically supported the project from its inception. Laura Griffith, exhibition coordinator, diligently prepared and organized the photographs for the exhibition, and Marie Carbo skillfully spotted the prints. Robert Hennessey made tritone negatives of the highest quality. At Aperture, Nan Richardson, Lisa Rosset, R.H. Cravens, and Jane Beck all provided superb contributions during various stages of the project.

Melissa Harris, Associate Editor of Aperture, the periodical, was responsible for the successful completion of the publication and especially for the superb editing of a complex manuscript originally written in Czech.

Anna Dvořák of the North Carolina Museum of Art was most generous with her time and her editorial work. Her assistance with the translation and bibliography as well as her formulation of Sudek's exhibition history proved invaluable. Roger Gorman provided an excellent design produced under a difficult schedule.

Michael E. Hoffman, Executive Director of Aperture Foundation and Adjunct Curator of the Alfred Stieglitz Center of the Philadelphia Museum of Art was responsible for all aspects of the development of the publication and exhibition.

The exhibition and publication were made possible by grants from the National Endowment for the Arts, a Federal agency, and the Pew Charitable Trusts.

The accompanying publication produced by Aperture Foundation was also supported by generous contributions from Manfred Heiting and Mr. and Mrs. Harold Honickman.

Bibliography

Books, Portfolios, and Calendars

1922–24 *Praha: 10 náladových fotografií* (Ten whimsical photographs). Prague: Ústřední ústav grafický, 1922–24. [Photographs signed by Sudek].

1928 Sudek, Josef. *Svatý Vít* (St. Vitus). Introduction by Jaroslav Durych. Prague: Družstevní práce, 1928. [Fifteen original silver prints, a limited edition of 120 signed and numbered copies].

1929 *Československo. Přírodní, umělecké a historické památnosti.* Vol 1. *Praha.* (Czechoslovakia. Natural, artistic, and historical monuments. Vol. 1. Prague). Photographs by Josef Sudek, graphic design by Slavoboj Tusar. Prague: Melantrich, 1929. [Published also in seven soft-bound issues, Prague, 1929].

1930 *Orbis A. S. 1931.* Prague: Orbis, 1930. [A calendar with twelve photographs of Prague, and a photo-montage on the cover by Josef Sudek].

1932 *Kalendář Družstevní práce 1933.* (A calendar of the work cooperative of Družstevní práce). Prague: Družstevní práce, 1932. [Twenty-seven photographs by Josef Sudek, selected and arranged by Ladislav Sutnar from the series Česká Galerie, no. 6. Photogravure V. Nojbert].

1933 *Josef Sudek—Vánoce 1933* (Christmas 1933). Prague: Družstevní práce, 1933. [A set of twelve postcards. Česká Galerie no. 10].

1938 Novák, Arne. *Praha barokní* (Baroque Prague). Prague: František Borový, 1938. [Published in Czech, English, and French editions. Eighteen photographs by Sudek, thirteen photographs by students at the State Graphic School].

1939 *Zemský ráj to na pohled . . .* (The earthly paradise . . .). Prague: Exportní ústav pro Čechy a Moravu, 1939. [A calendar for the year 1940 with twelve photographs by Josef Sudek. German edition *Ein Paradies auf Erden,* 1939].

1939 *Praze 1939* (To Prague 1939). Lis Knihomilův, vol. 7. [Edition of 150 numbered copies. Photographs by Josef Sudek, printed by photogravure.]

1943 Wirth, Zdeněk. *Pražské zahrady* (Prague gardens). Prague: Václav Poláček, 1943. [Published in one hardbound volume, and two paperback volumes. Photographs by Josef Sudek and others].

1943 *Moderní česká fotografie: Album deseti původních snímků* (Modern Czech photography: An album of ten original prints). Prague: Národní práce, 1943. [Ten original prints by Sudek, Ehm, Funke, Hák, and Plicka, published in a numbered edition of fifty copies].

1945 Sudek, Josef, and Rouček, Rudolf. *Pražský Hrad: Výtvarné dílo staletí v obrazech Josefa Sudka* (Prague Castle: The artistic creation of centuries in the images of Josef Sudek). Text by Rudolf Rouček. Prague: Sfinx, 1945. [First edition of 1945 included 105 photographs by Josef Sudek, second edition of 1947 contained 113 photographs].

1945 *Pražský kalendář: Kulturní ztráty Prahy 1939–45* (Prague calendar: The cultural losses of Prague 1939–45). Photographed by Josef Sudek. [Fifty-two photographs, and a cover picture].

1946 Kubíček, Alois. *Pražské paláce* (The palaces of Prague). Prague: Václav Poláček, 1946. [Czech and English editions. *Memorials of Art,* 8. 108 photographs by Josef Sudek].

1947 Sudek, Josef. *Magic in Stone.* Text by Martin S. Briggs. London: Lincoln-Praeger Publishers, 1947. [113 photographs identical with the second edition of *Prague Castle*].

1947 Novák, Arne. *Praha barokní* (Baroque Prague). Prague: F. Borový, 1947. [Second edition published in English. Fourth Czech edition included thirty-one photographs by Josef Sudek].

1948 Wenig, Adolf, and Sudek, Josef. *Náš Hrad* (Our Castle). Prague: J. R. Vilímek, 1948. [Second edition of Wenig's text with forty-eight photographs by Josef Sudek].

1948 Sudek, Josef. *Praha* (Prague). Editor of the textual part Vítězslav Nezval, preface by Arnošt Klíma. Prague: Svoboda, 1948. [128 photographs].

1949 *Toulky hudební Prahou* (Wanderings through musical Prague). Prague: Orbis, 1949. [Thirty-two photographs by Josef Sudek and other photographers].

1956 Linhart, Lubomír. *Josef Sudek: Fotografie* (Josef Sudek: Photographs). Prague: SNKLHU, 1956. [232 photographs, text by Lubomír Linhart, poems by Vladimír Holan and Jaroslav Seifert].

1958 Denkstein, Vladimír; Drobná, Zoroslava; and Kybalová, Jana. *Lapidarium Národního musea* (Lapidarium of the National Museum). Prague: SNKLHU, 1958. [176 photographs by Josef Sudek].

1958 Masaryková, Anna. *Josef Mařatka.* Prague: SNKLHU, 1958. [128 photographs of sculpture, twenty-seven reproductions, and twenty-four documentary photographs by Josef Sudek].

1959 Sudek, Josef. *Praha panoramatická* (Panoramas of Prague). Prague: SNKLHU, 1959. [284 panoramic photographs, introductory poem by Jaroslav Seifert].

1959 *Centrotex 1960.* Prague: Centrotex, 1959. [A calendar with fourteen panoramic photographs by Josef Sudek].

1961 *Pražské ateliery* (Prague studios). Prague: Nakladatelství Československých výtvarných umělců, 1961. [Featured ten artists' studios with photographs by Josef Sudek].

1961 Sudek, Josef, and Poche, Emanuel. *Karlův most ve fotografii* (Charles Bridge in photographs). Prague: SNKLHU, 1961. [Two introductory poems by Jaroslav Seifert, 160 photographs by Josef Sudek].

1962 *Josef Sudek.* Introductory text by Jan Řezáč. Prague: Orbis, 1962. [A set of twelve postcards, published in the series Profily].

1963 Strnadel, Josef. *Vyhnal jsem ovečky až na Javorníček* (I led the sheep up the mountain . . .). Prague: Státní pedagogické nakladatelství, 1963. [Twenty-two photographs by Josef Sudek].

1964 *Sudek.* Text by Jan Řezáč, photographs selected by Jan Řezáč and Josef Prošek. Prague: Artia, 1964. [Ninety-five photographs by Josef Sudek. Text in German, English, and French].

1966 Durbaba, Oldřich, and Budík, Jan. *Hudební výchova* (Music education). Prague: Státní pedagogické nakladatelství, 1966. [Polish edition *Wychowanie Muzyczne* published in 1970].

1969 Sudek, Josef. *Mostecko–Humboldtka.* Text by E. Juliš and D. Kozel. Most: Dialog, 1969. [A set of eleven panoramic postcards].

1971 Sudek, Josef. *Janáček–Hukvaldy.* Introductory text and selections from Janáček's writings by Josef Šeda. Prague: Supraphon, 1971. [Text in Czech, German, and English. 124 photographs].

1972 *Josef Sudek–10 Photographs 1940–1972.* Cologne: Galerie Rudolf Kicken, 1972. [Edition of fifty-seven numbered portfolios, each containing ten prints from original negatives].

1976 *Josef Sudek.* Introduction by Petr Tausk. Prague: Pressfoto, 1976.

1978 Bullaty, Sonja. *Sudek.* Introduction by Anna Fárová. New York: Clarkson N. Potter, 1978. Second edition 1986. [Seventy-six photographs].

1980 *Josef Sudek. Profily z prací mistrů československé fotografie,* 1. Text Petr Tausk. Selection of photographs J. Prošek, P. Zora, and P. Tausk. Prague: Panorama, 1980.

1981 Nezval, Vítězslav. *Pražský chodec: Fotografoval Josef Sudek* (Strolling through Prague: Photographed by Josef Sudek). Prague: Československý spisovatel (Slunovrat), 1981. [Thirty-two photographs. Epilogue to the fourth edition by Jan Řezáč].

1982 Kirschner, Zdeněk. *Josef Sudek: Výběr fotografií z celoživotního díla* (Josef Sudek: Selection of photographs from the oeuvre). Photographs—Personalities. Prague: Panorama, 1982. Second edition 1986. [157 photographs].

1982 Mrázková, Daniela, and Remeš, Vladimír. *Josef Sudek.* Leipzig: Fotokino Verlag, 1982. [Ninety-one photographs].

1983 Anna Fárová. *Josef Sudek.* Milan: Gruppo Editoriale Fabbri, 1983. [Fifty-seven photographs]. From the book series, "I Grandi Fotografi."

1984 Nezval, Vítězslav. *Der Praeger Spazierganger* (Strolling through Prague). Berlin: Verlag Volk und Welt, 1984. [Eleven photographs].

1985 Porter, Allan. *Josef Sudek: Photothek.* Translated by Dieter W. Portmann. Zurich: U. Baer Verlag, 1985.

Selected one-person and group exhibitions and catalogs

1921 *Český klub fotografů amatérů v Praze: 12..členská výstava uměleckých fotografů* (Czech Club of Amateur Photographers in Prague: 12th members' exhibition of art photographers). Catalog and text by A. Škarda. Prague, 16 October–2 November.

1923 *2. výstava Českého klubu fotoamatérů v Českých Budějovicích* (2nd exhibition of the Czech Club of Amateur Photographers in České Budějovice). Catalog and text V. Burger. České Budějovice: Městské muzeum.

1923–24 *1. výstava Svazu čs. klubu fotografů amatérů v Praze* (1st exhibition of the Association of the Czechoslovak Club of Amateur Photographers in Prague). Catalog and text by V. Fanderlík. Prague: Krasoumná jednota pro Čechy v Praze, December 1923–January 1924.

1926–27 *Česká fotografická společnost: 1. členská výstava* (Czech Photographic Society: 1st members' exhibition). Catalog and text by Adolf Schneeberger. Prague, 19 December, 1926–2 January, 1927.

1932 *Josef Sudek.* Prague: Krásná jizba Družstevní práce. Travelling exhibition. Opening dates: Prague, 15 October, 1932; Bratislava, 25 March, 1933; Chrudim, 24 April.

1938 *Členská výstava fotosekce SVU Mánes* (Members' exhibition of the photo-section SVU Mánes). Catalog and text by L. Linhart. Prague.

1958 *Josef Sudek.* Catalog and text by J. Řezáč. Prague: Alšova síň Umělecké besedy.

1959 ———. Catalog by Jan Ruška. Vysoké Mýto: Okresní galerie.

1961 *Josef Sudek.* New York: Bullaty-Lomeo Studio.
———. Catalog with an introduction by R. Skopec. Opava: Slezské muzeum.
Fotografie Josefa Sudka a kresby Václava Sivka. (Photographs by Josef Sudek and drawings by Václav Sivko). Catalog and text by Jiří Kotalík. Frenštát pod Radhoštěm.

1963 *Josef Sudek.* Catalog and text by Jan Řezáč. Prague: Výstavní síň nakladatelství Československý spisovatel.

1966 ———. Catalog and text by Karel Dvořák. Liberec: Severočeské muzeum.

1968 *Five Photographers: An International Invitational Exhibition.* Lincoln, Nebraska: University of Nebraska, The Sheldon Memorial Art Gallery, 7 May–2 June.

1971 *Československá fotografie 1968–70 ze sbírek Moravské galerie v Brně* (Czechoslovak photography 1968–70 from the collection of the Moravian Gallery in Brno). ["Výstavní medailon," a section with twenty-one photographs by Sudek, in honor of his seventy-fifth birthday]. Brno: Moravská galerie.

1972 *Josef Sudek.* New York: The Neikrug Gallery, opening date 17 March.

1973–74 *Osobnosti československé fotografie* (Personalities of Czechoslovak photography). Catalog and text by Anna Fárová. Roudnice nad Labem: Galerie výtvarného umění; Prague: Uměleckoprůmyslové muzeum; Brno: Dům umění.

1974 *Josef Sudek: A Retrospective Exhibition.* Rochester, New York: International Museum of Photography, George Eastman House, 8 May–30 June.
Josef Sudek. New York: Light [Gallery], 5 March–30 March.

1974–75 ———. Washington, D.C.: Corcoran Gallery of Art, 7 December, 1974–6 January, 1975.

1976 *Josef Sudek: Souborná výstava fotografického díla* (Josef Sudek: A retrospective exhibition of photographic oeuvre). Catalog and text by Antonín Dufek. Brno: Moravská galerie, 9 April–16 May.
Fotograf Josef Sudek (Photographer Josef Sudek). (In honor of Sudek's eightieth birthday). Catalog and text by Anna Fárová. Prague: Uměleckoprůmyslové muzeum, opening date 22 April, 1976. Roudnice, August.
Josef Sudek. Catalog by Rudolf Kicken and Wilhelm Schürmann, Edition Lichttrophen. Aachen: Neue Galerie Sammlung Ludwig, September–October, 1976. Travelled to Bochum: Museum Bochum; Zurich: Kunsthaus Zurich; and Vienna: Künstlerhaus Wien.
Fotografie Josefa Sudka (Photographs by Josef Sudek). Olomouc: Divadlo hudby, 15 September–4 October.

1977 *Josef Sudek Retrospective: 1896–1976.* New York: International Center of Photography, 12 May–3 July.
Documenta 6. Catalog and text by Klaus Honnet and Evelyn Weiss. Kassel: Museum Fridericianum, 24 June–2 October.
Concerning Photography. Catalog and text by Jonathan Bayer and others. London: The Photographer's Gallery, 6 July–27 August, 1977. Travelled to the Spectro Workshop, Newcastle upon Tyne.
Panoramic Photography. Essay by Diana Edkins. New York: Grey Art Gallery and Study Center, New York University 1977.

1978 *Josef Sudek a výtvarné dílo* (Sudek's photographs, and his art collection). Text by Václav Formánek. Prague: Národní galerie.
Josef Sudek. Geneva: Canon Photo Gallery.
———. Chicago, Illinois: Allan Frumkin Gallery.
Tusen och En Bild/1001 Pictures. Stockholm: Moderna Museet.

1979 *Photographie als Kunst: 1879–1979* (Photography as art: 1879–1979). Innsbruck: Tiroler Landesmuseum Ferdinandeum, 1979. Travelled to Neue Galerie am Wolfgang Gurlitt Museum, Linz; Neue Galerie am Landesmuseum Joanneum, Graz; and Museum des 20. Jahrhunderts, Vienna.
Fotografie z pozůstalosti Josefa Sudka. (Photographs from Josef Sudek's estate). Text by Zdeněk Kirschner. Prague: Uměleckoprůmyslové muzeum.

1981 *Josef Sudek.* Daytona Beach, Florida: Daytona Beach Community College Gallery of Fine Arts, 15 May–5 June.
Josef Sudek: Zahrady (Josef Sudek: Gardens). Catalog and text Zdeněk Kirschner. Prague: Uměleckoprůmyslové muzeum; Liberec: Okresní kulturní středisko, 25 June–19 July, 1981.
Josef Sudek. Los Angeles, California: Stephen White Gallery, 15 September–17 October.
———. Toulouse: Galerie Municipale du Château d'Eau, October.

1982 *Josef Sudek, 1896–1976.* Chicago: Jacques Baruch Gallery, 23 February–3 April.
The Contact Print. Catalog by James Alinder. Carmel, California: Friends of Photography.

1982–86 *Josef Sudek: Cykly fotografií.* (Josef Sudek's photographic series. Exhibitions from the collection of the Museum of Decorative Arts in Prague). Five exhibitions and catalogs by Zdeněk Kirschner. Státní zámek Kozel, June, 1982; May–June, 1983; September–October, 1984; September–October, 1985; September–October, 1986.

1983 *Saudek/Sudek: Images From Czechoslovakia.* Iowa City: The University of Iowa Museum of Art, 5 February–3 April.
Fotografie Josefa Sudka a Jana Svobody (Photographs by Josef Sudek and Jan Svoboda). Komparace I. Catalog by Zdeněk Kirschner. Roudnice nad Labem: Galerie výtvarného umění, 14 April–22 May.
Photographes tchèques 1920–1950 (Czech photographers 1920–1950). Catalog by Zdeněk Kirschner and A. Dufek. Organized by the Museum of Decorative Arts in Prague. Paris: Musée National d'Art Moderne, Centre Georges Pompidou, 8 July–4 September.

1986 *Josef Sudek: The Poet of Prague.* New York: Ledel Gallery, 5 March–29 March.

1987 *Josef Sudek/Jaromír Funke/Adolf Schneeberger: Photographs From Czechoslovakia 1919–1970's.* Chicago: Jacques Baruch Gallery, 30 January–11 March.
Sudek–Funke. Exhibition and catalog by Zdeněk Kirschner, Státní zámek Kozel, September–October.

1988 *Josef Sudek.* Los Angeles, California: Jan Kesner Gallery, 5 February–1 March.
Josef Sudek. Organized by the Ministries of Culture of the ČSR and SSR, under the auspices of the *Arts America* program of the U. S. Information Agency. San Francisco, California: Museum of Modern Art, 15 April–29 May; Chicago: Art Institute of Chicago, 15 June–5 September.

1988–89 *Josef Sudek/Albín Brunovský.* (Photographs by Josef Sudek, prints and paintings by Albín Brunovský). Organized by the Ministries of Culture of the ČSR and SSR, under the auspices of the *Arts America* program of the U. S. Information Agency. Pittsburgh, Pennsylvania: University of Pittsburgh Gallery, 9 October–6 November, 1988; Cleveland, Ohio: Cleveland Museum of Art, 7 December, 1988–5 February, 1989.

Selected articles

Anděl, J. "Josef Sudek: Ein verdienter Künstler der ČSSR" (Josef Sudek: The Artist of Merit of ČSSR). *Fotografie* (ĐDR), no. 2 (1974): 21–27.

—————. "Obrazová kvalita ve fotografiích Josefa Sudka" (Image Quality in the photographs of Josef Sudek). *Fotografie '73* 17, no. 2 (1973): 18–19.

Altschul, Pavel. "Fotograf Josef Sudek." *Žijeme* (1932): 183.

Bergerová, E. M. "Vyprávění pana Sudka ve filmu 'Fotograf a Muzika' " (Refections of Josef Sudek in the film 'A Photographer and Music'). *Fotografie '79* 23, no. 1 (1979): 53–61.

Bullaty, Sonja. " . . . and there is music." *Infinity* 18 (December 1969): 7.

—————. "Sudek." *U. S. Camera Annual* (1971): n. p.

Chaloupka, Otakar. "Hovoří zasloužilý umělec Josef Sudek" [Interview with Josef Sudek, Artist of Merit]. *Československá fotografie,* no. 11 (1963): 373.

Ellis, A. "Talking of Landscape." *British Journal of Photography* 129 (March 1982): 274–5.

Fárová, Anna. "Josef Sudek." *Camera* (Lucerne) 55, no. 4 (1976): 6–37; 40–42.

Ginsberg, Paul. "Josef Sudek." *Popular Photography* 75 (November 1974): 151–2. [Review of Sudek exhibition at GEH, Rochester, N. Y.].

Goldberg, Vicki. "Josef Sudek, a Monk of Photography: Transforming the Ordinary into the Rare." *American Photographer* 2, no. 3 (March, 1979): 12; 16.

Goto, John. "The Silent Labyrinths of Mr. Sudek." *British Journal of Photography* 126 (February 1979): 128–32.

Halas, František. "Josef Sudek." *Panorama* (Czech.) 10 (September 1932): n. p.

Jedlan, J. "Josef Sudek a jeho místo v české fotografii" (Josef Sudek and his place in Czech photography). *Fotografie,* no. 1 (1976): n. p.

Jeníček, Jiří. "Josef Sudek." *Československá fotografie,* no. 3 (1955): 26–28.

Jírů, V. "Josef Sudek šedesátníkem " (Josef Sudek at sixty). *Výtvarná práce,* no. 5 (1956): n. p.

—————. "Josef Sudek." *Československá fotografie,* no. 1 (1957): 5.

"Josef Sudek." *Creative Camera,* no. 109 (July 1973): 234–5.

"Josef Sudek." *Creative Camera,* no. 190 (April 1980): 126–32. [Portfolio].

"Josef Sudek–A Monograph." *Camera* (Lucerne) 55, no. 4 (April 1976). [An issue dedicated to Sudek, with major articles by Anna Fárová and Allan Porter].

"Josef Sudek: Panoramas." *Creative Camera,* no. 113 (November 1973): 364–73.

"Josef Sudek: The Birthplace of Janáček." *Creative Camera,* no. 136 (October 1975): 328–9; 348–53.

Keledjian, Chris. "Josef Sudek: An Alliance with Light." *Artweek* 12 (10 October 1981): 11. [Exhibition review—Stephen White Gallery, Los Angeles, California].

Linhart, Lubomír. "60 let Josefa Sudka" (Josef Sudek at sixty). *Československá fotografie,* no. 1 (1956): 30.

—————. "Josef Sudek a Jaromír Funke." *Československá fotografie,* no. 2 (1956): 64–65.

Mašín, Jiří. "Josef Sudek 75." *Československá fotografie,* no. 3 (1971): 84.

Normile, Ilka. "Josef Sudek: A Backyard Romantic." *Afterimage* (Rochester, N. Y.) 5 (May/June 1977): 8.

Pangerl, Franz. "Böhmische Romantik Josef Sudek: Altmeister der tschechoslowakischen Fotografen" (Czech romantic Josef Sudek: Old master of Czech photographers) *Foto Magazin,* no. 10 (1971): n. p.

Pečírka, J. "Fotografie Josefa Sudka" (Photographs by Josef Sudek). *Nový život,* no. 4 (1957): 446–8.

Porter, Allan. "A Mysterious Light." *Camera* (Lucerne) 55, no. 4 (1976): 4–5; 38–39.

—————. "Panoramas of the Czechoslovakian Landscape: Josef Sudek." *Camera* (Lucerne) 46, no. 7 (1967): 22–23.

—————. "Sudek." *Camera* (Lucerne) 45, no. 3 (1966): 6.

Puvogel, R. "Josef Sudek." *Kunstwerk* 29 (November 1976): 84.

Ratcliff, Carter. "Josef Sudek: Photographs." *Print Collector's Newsletter* (U. S. A.) 8 (September–October 1977): 93–95.

Remeš, V. "Josef Sudek." *Fotografie '73,* no. 2 (1973): 12–17.

Řezáč, Jan. "Sudek." *Camera* (Lucerne), 45, no. 3 (1966): 6; 15.

Sage, James. "Josef Sudek: A Portfolio." *Infinity* 18 (December 1969): 6–19.

Sawyer, Charles. "Josef Sudek: The Czech Romantic." *Modern Photography* (New York) 4 (September 1976): 108–117.

"Sedmdesát let Josefa Sudka" (Josef Sudek at seventy). *Československá fotografie,* no. 2 (February 1966). [An issue dedicated to Sudek, with articles and interviews by twelve contributors, including Karel Dvořák, V. Reichmann, J. Toman, M. Novotný, and J. Řezáč].

[Sivko, Václav]. "Josef Sudek vystavoval" (Josef Sudek exhibited). *Československá fotografie,* no. 4 (1958): 132. [Václav Sivko's speech at the opening of Sudek's exhibition].

Skopec, R. "Josef Sudek: Ein Kapitel Photogeschichte" (Josef Sudek: A chapter in the history of photography). *Im Herzen Europas* (September 1964): 17–19.

—————. "Výtvarný fotograf Josef Sudek" (Artistic photographer Josef Sudek). *Mladý Polygraf,* no. 9 (1963): n. p.

Spencer, Ruth. "Josef Sudek: A Tribute to His Life, His Work." *The British Journal of Photography* 123 (December 1976).

"Stilleben—Portfolio." *Du,* no 4. (1987); 100–5.

Sturman, John. "Josef Sudek." *Art News* 85 (Summer 1986): 132. [Review of the exhibition at the Ledel Gallery, New York].

Sudeberg, Erika. "The Father of European Modernism." *Artweek* 19 (March 1988): 10.

"Sudek at Work." *Creative Camera,* no. 3 (March 1975): 76.

Tausk, Petr. "Josef Sudek, ein wahrer Klassiker der tschechoslowakischen Fotografie" (Josef Sudek: A true classic of Czechoslovak photography). *Fotoprisma,* no. 4 (1970): n. p.

—————. "Josef Sudek: His Life and Work." *History of Photography* 6 (January 1982): 29–58.

—————. "Josef Sudek—80 let" (Josef Sudek—eighty years). *T 76,* no. 2 (1976): n. p.

—————. "Josef Sudek 75-ročný" (Josef Sudek at seventy-five). *Výtvarnictvo, Fotografia, Film,* no. 4 (1971): n. p.

—————. "The Roots of Modern Photography in Czechoslovakia." *History of Photography* 3 (July 1979): 253–271.

Westerbeck, C. L. "Taking the Long View." *Artforum* 16 (January 1978): 56–59.

Wigh, L. "Josef Sudek: Czech Photographer/Josef Sudek: Tjeckoslovakisk Fotograf." *Fotografiska Museet* (Sweden), nos. 3–4 (1978): 1–4.

Biographical Profile © 1990 by Anna Farova
Photographs by Josef Sudek © 1990 Estate of Josef Sudek
Copyright © 1990 Aperture Foundation, Inc.
All rights reserved under International and Pan-American copyright conventions. No parts of this book may be reproduced without written permission of the Publisher.

The staff at Aperture for *Josef Sudek, Poet of Prague: A Photographer's Life* was:

Michael E. Hoffman:	Executive Director and Editor
Melissa Harris:	Associate Editor
Roger Gorman:	Designer
Stevan Baron:	Director of Production
Linda Tarack:	Production Assistant
Diana C. Stoll:	Proofreader
Anna Dvořák:	Translator
Simon Pellar:	Translator
Daniel Simko:	Translator

Library of Congress Catalog Number: 89-082545
Clothbound ISBN: 0-89381-386-9
Paperbound ISBN: 0-89381-432-6
Museum Catalog Edition ISBN: 0-89381-418-0

Aperture publishes a periodical, books, posters and portfolios to communicate with creative individuals everywhere. A complete catalog will be mailed upon request from Aperture, 20 East 23rd Street, New York, New York 10010.

Composed by David Seham Associates Inc. in Berkeley Oldstyle

Plates printed in tritone offset; text illustrations in duotone offset at H. Stürtz AG, Würzburg, West Germany. Tritone negatives made by Robert Hennessy, Middletown, Connecticut. Printed and bound in West Germany